THE CHRISTMAS
Crèche

THE CHRISTMAS
CRÈCHE

TREASURE OF FAITH, ART, & THEATER

by

Matthew Powell, O.P.

Pauline
BOOKS & MEDIA

Boston

Powell, Matthew, O.P.

 The Christmas creche : treasure of faith, art, and theater / by Matthew Powell.

 p. cm.

 Includes bibliographical references.

 ISBN 0-8198-1544-6 (hardback)

 1. Crèches (Nativity scenes) 2. Christian art and symbolism. I. Title.

GT4989.5.P69 1997

394.2663—dc21 96-40501

 CIP

Printed and published in the U.S.A. by Pauline Books & Media, 50 St. Paul's Avenue, Boston, MA 02130.

http://www.pauline.org E-mail: PBM_EDIT@INTERRAMP.COM

Pauline Books & Media is the publishing house of the Daughters of St. Paul, an international congregation of women religious serving the Church with the communications media.

1 2 3 4 5 6 7 03 02 01 00 99 98 97

DEDICATION

To my mother,
Nancy (Nunziata) Rocco Powell
(1914-1990)

and my grandmother,
Rosalba Amicucci Rocco
(1886-1962)

who came from the Abruzzi,
a land of shepherds.

CONTENTS

INTRODUCTION

I was seven or eight years old when, with my mother, I bought my first Christmas crèche, inexpensive plaster figures and a cardboard stable, at Woolworth's in Springfield, Ohio. Even at that age I knew that the little statues were not toys and that they were more than Christmas decorations. Somehow I perceived that those brightly painted shepherds and kings were sacred.

During my seminary study, I discovered the theological explanation for what I had instinctively known as a child—the importance of images and symbols for the Christian life. These images and symbols we Catholics call "sacramentals." But sacramentals have their basis in the reality and mystery of the Incarnation, that God the Son, the Second Person of the Trinity, became a human being in the person of Jesus Christ. And when the invisible God became visible in Jesus, Christian imagery naturally had to follow. Christ was, and is, the living icon or image; the heavenly Father has shown him-

self to us through Jesus. Jesus, in fact, tells Philip in St. John's Gospel (14:9): "Whoever has seen me has seen the Father." We Christians not only can, but need, to portray visually the person of Jesus and his earthly life as well as his angels and saints. The human personality has a real need for image, sign and symbol and is often starved for them.

Sacramentals are sacred signs which signify spiritual effects that are obtained through the prayer of the Church. Holy images are sacramentals given to illuminate our minds, direct our feelings and draw us toward the heavenly kingdom.

Laurence F. X. Brett points out in his book, *Sacramentals: Redeemed Creation*, that an image is a sacramental when it remembers the past, declares a present truth, obliges us in an ongoing way and foresees the future (p. 27).

The crèche is certainly a visual remembrance of the birth of Jesus, the first manifestation of the Incarnation to human eyes. It recalls the truly human circumstances of Christ's birth, his humble beginnings in a stable, his relationship to the poor. It reminds us of his reception by the lowly shepherds, the stately wise men and even the animals: he had come to redeem and transform all of creation. It reaffirms that God so loved us that he would withhold nothing from us, even sending his only begotten Son to become a man, to live among us as an example of how he wants us to live, to suffer and die for our sins, to rise from the dead and to offer us eternal life. The Nativity scene reminds us that God, in his infinite love, did not wait for struggling humanity to reach out to him, but by the Incarnation rushed out and, as it were, threw his arms around us.

The Christmas crib declares the present truth that humanity has been redeemed and transformed. Not only have we been created in the image and likeness of God, but God himself has become one of us and has dwelt among us. The Savior himself is our brother and therefore the human race has supreme dignity. The Christmas crib proclaims God's boundless love for us. It further declares that every person, of whatever condition or situation, is welcomed and wanted by Christ, and that each of us has his or her place at the stable of Bethlehem and in the Body of Christ. The crib also presents to us Mary and Joseph as examples of the acceptance of God's will and of human holiness.

The Christmas manger obliges us to thanksgiving for all that God has done for us, especially in the gift of his incarnate Son, Jesus, who continues to be present among us in the Christian community, in the Sacred Scriptures and in the Holy Eucharist. The crèche should impel us to respect all of God's creation, the lowly as well as the stately, to love all our brothers and sisters. After viewing the scene in the stable of Bethlehem, we should be moved to read the Scriptural accounts and to meditate on them. As the shepherds and the wise men came to worship the Child Jesus, the manger should prompt us to the worship of Christ present-among-us in the Blessed Sacrament and to frequent reception of the Holy Eucharist.

The crèche foresees the future, when we hope to be united eternally with Christ, with Mary, Joseph and all who have responded to God's invitation to come to his Son.

The Christmas crib is a powerful symbol and sacramental that continues to visually preach a sermon of good news, joy, promise and challenge.

My interest in crèches never disappeared and was renewed in later life by my study of theater and my interest in religious art and symbol. Perhaps it was also nurtured by my Italian background (the original family name was Paoletti) and the fact that I was ordained in the Church of the Holy Nativity

in Dubuque, Iowa. Later I discovered that my fellow Dominican friar, the great but little known Father Gregorio Rocco (with the same surname as my mother) was both an expert maker of Christmas cribs and the renowned preacher of the crèche devotion in eighteenth-century Naples. All of these factors came together and resulted in this book.

In addition to the history of the development of the crèche, this book will look at the origins of the feast of Christmas and the influence that visual art, drama, and devotion to the Infant Jesus had on the creation of three-dimensional Nativities. Lastly, but very importantly, the book examines the Christmas crib as Christian art and sacramental.

Since purchasing my first Nativity figures over forty years ago (they cost twenty-nine cents each then), I have seen famous antique crèches in museums that were sculpted by great artists. The basic concept behind the figures remains the same, however. Human beings use their God-given talents and the simple materials of creation—such as wood, clay and stone—to represent visually one of Christianity's most cherished events, the birth of the Savior. Whether it is an inexpensive manger from the five and dime store or a priceless antique work of art, the Christmas crèche is a Christian symbol filled with meaning. I hope that this book will renew the reader's appreciation of it.

THE CELEBRATION
OF CHRISTMAS

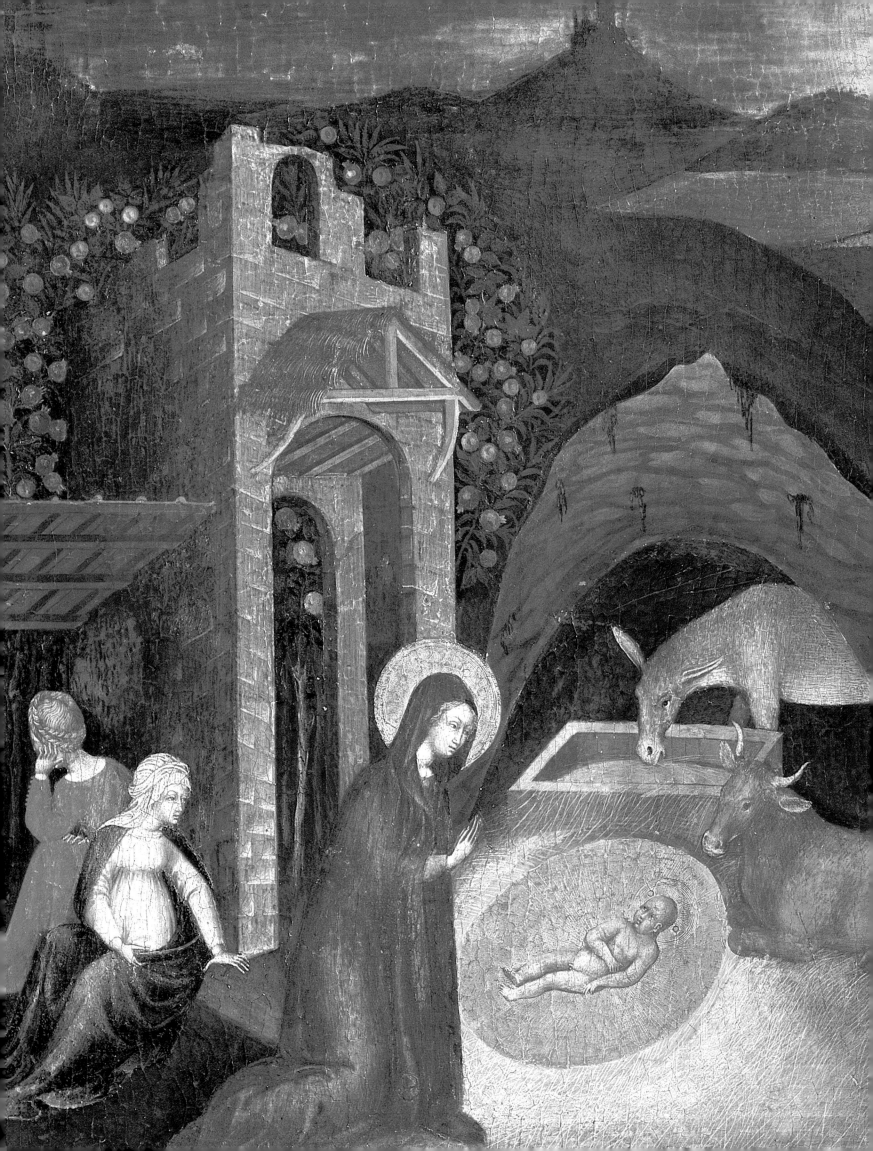

evotion to the site and physical circumstances of the birth of Jesus began even before the celebration of a feast of the Nativity. Veneration for Christ's purported birthplace at Bethlehem had already begun in the early second century A.D. In order to wipe out this Christian practice, the Roman Emperor Hadrian built a pagan place of prayer on the spot in 136, with a sacred wood and a temple dedicated to the god Apollo. This temple was destroyed by the newly Christianized Emperor Constantine in the early fourth century, and in 326 he and his mother, Saint Helena, began construction of the Basilica of the Nativity. In his letters in the fourth century, Saint Jerome describes Bethlehem and how he and his companions entered the church and adored "the place where the ox had known his master and the ass the cradle of the Lord." Numerous pilgrims, among them Saint Augustine, made the journey to Bethlehem. The greater part of the present basilica was built by the

Saint Joseph silently ponders the wonders of recent events while Mary adores her newborn Son in "The Nativity" by Giovanni Di Paolo.

21

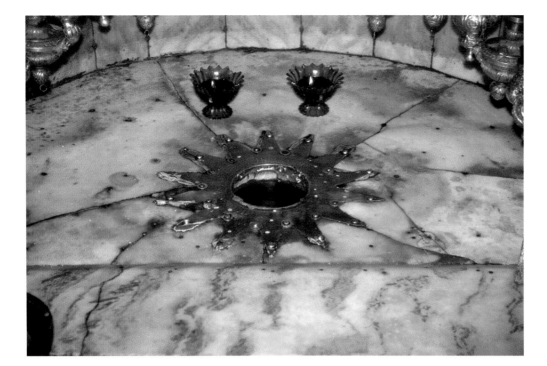

Emperor Justinian, who reconstructed the damaged basilica of Constantine in about 540. During the Persian invasion in 614, the basilica was not destroyed because on the facade the Persians saw representations of the magi wearing pants and Phrygian caps, typical Persian dress. The invaders mistook the magi for worshipers of Mithras, bringing gifts to his altar. In the time of the Crusaders, the monumental portal (with three doors) was narrowed to prevent the Turks from bringing horses into the church.

The grotto chapel of Bethlehem still remains one of the holiest Christian shrines, with its silver star set in the floor and the inscription: "*Hic de Maria Virgine Jesus Christus natus est*—Here Jesus Christ was born of the Virgin Mary."

In Rome in 440 Pope Sixtus III had erected in the Church of Santa Maria Maggiore an oratory containing a manger, which was considered a faithful replica of the crib at Bethlehem. This chapel was also probably the site of the first Christmas midnight Mass. In the seventh century this chapel became the

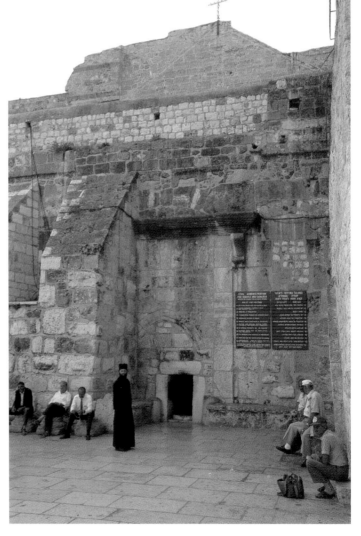

The entrance of the Church of the Nativity in Bethlehem has been progressively blocked up through the centuries.

repository of five small boards of sycamore wood, reputed to be relics of Christ's manger, discovered by Saint Helena. We do know that Saint Jerome and his companions in Bethlehem collected numerous relics and some of them, which passed to others, gradually made their way to the West. The authenticity of the boards, however, is highly questionable and the manger Jesus rested in was probably made of stone. At any rate, the chapel has come to be known as *Sancta Maria ad Praesepe*—Saint Mary at the Stable (*praesepe* being the Latin word for stable), and it has become a center of devotion to the birth of Jesus. Toward the end of the thirteenth century Arnolfo di Cambio sculpted for the chapel the first nativity scene consisting of free-standing figures. Unfortunately, only a few of the figures remain. At about the same time the body of Saint Jerome was transferred to this chapel from Bethlehem. Roman devotion to the Infant Jesus in the manger became so great that other Roman churches, Santa Croce in Gerusalemme, Santa Maria in Trastevere and Saint Peter's, set up chapels with replicas of the manger.

Nesta de Robeck in her book, *The Christmas Crib* (p. 21), notes:

> There is no doubt that the cult of the Crib took form first in Bethlehem, then in Rome, and it has been said that there existed an ancient custom of placing figures in the manger. However that may be, it is evident from early Christian writings that the imagination of the faithful saw them there.

The actual celebration of a feast day of the Nativity of Jesus developed in a separate but related way. In the Roman Empire it was the general custom to celebrate the birthdays of rulers and other famous persons. We read in Matthew 14:6: "Then on Herod's birthday Herodias' daughter performed a dance before the court." Such birthdays were often celebrated even after the death of the individual. The day of the celebration did not always coincide with the actual date of the person's birth. The birthday of Plato, for example, was celebrated on the feast of the god Apollo.

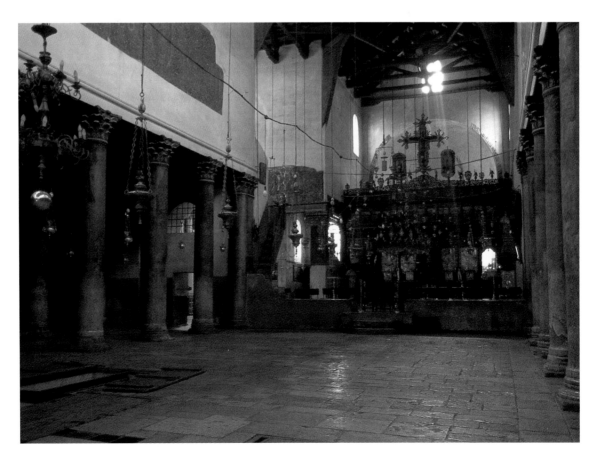

Nave of the Church of the Nativity in Bethlehem.

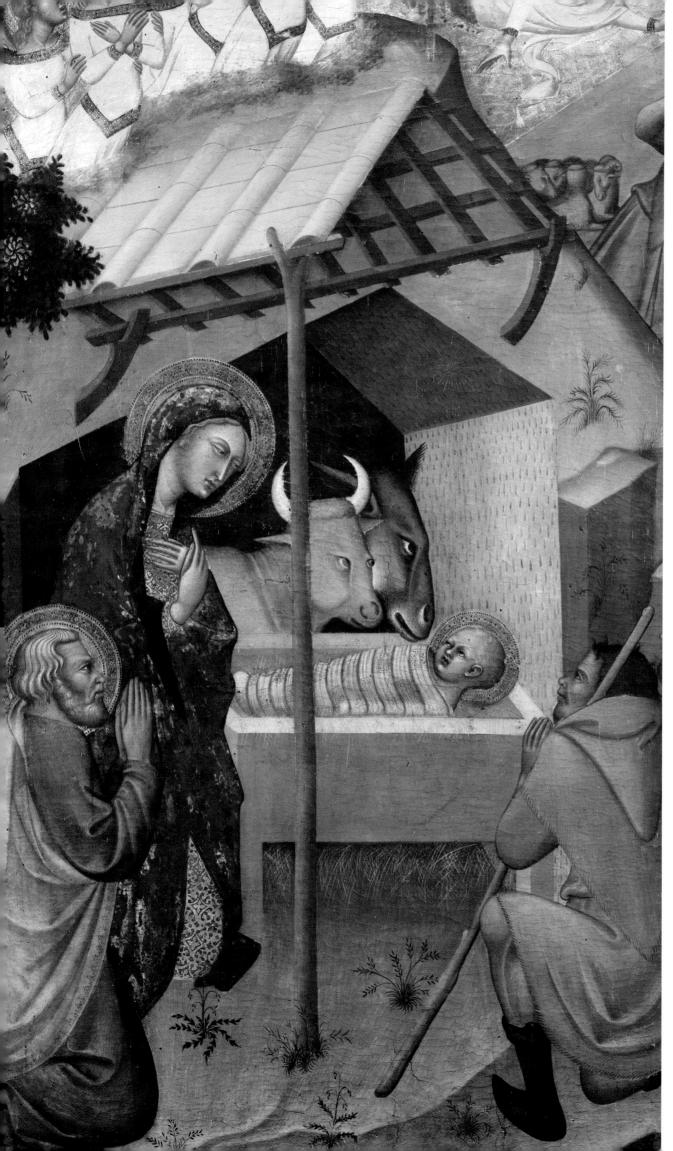

The Scriptures do not tell us the date of Jesus' birth. However, since early Christians attributed to Christ not only the title, *Kyrios* or Lord, but also many of the other honors paid to the divinized Roman emperors, they felt naturally inclined to celebrate the birth of Jesus. Pope Telesphorus had apparently declared a local and very movable feast of the Nativity for Rome in A.D. 136. It was celebrated anywhere from May to December. As a universal feast the Epiphany (January 6), the celebration of Christ's manifestation to the magi and, hence, to all Gentiles, is actually an older feast than Christmas. The Feast of the Epiphany originated in Egypt in the third century. It came about as a Christian reaction to a pagan festival in honor of the sun god, celebrated at the time of the winter solstice in early January. Christian authorities felt that the true light of the world was the divine Savior, Jesus Christ, and that his manifestation should be celebrated on that day. Besides the visit and adoration of the magi, the feast also commemorated the birth of Jesus. The Feast of Epiphany was additionally a response to the heretical Gnostics, who taught that Christ was merely human until his baptism in the Jordan. On that day, they mistakenly claimed, the divinity united itself with the human Jesus, and therefore the first truly divine manifestation of Christ, visible to the human eye, did not happen at his birth, but at his baptism. The celebration of Epiphany affirmed Christ's divinity from the beginning. This doctrine, generally referred to as the Incarnation (from the Latin *incarnatus*—made flesh), is the belief that the Second Person of the Trinity, the Son, became a human being ("took on human flesh") in Jesus Christ. It has been the traditional belief of orthodox Christians from apostolic times that Jesus Christ was both truly human and truly divine from the moment of his conception.

Soon after the last great persecution of Chris-tians, in about A.D. 330, the Church in Rome set December 25 as the date for the celebration of the birth of Christ. By the end of the fourth century the Roman custom had become standard in the West. No official explanation has been handed down in Church documents for the choice of the date. Various explanations have been given to explain the choice of December 25. Some early Fathers and writers, such as Saint John Chrysostom, claimed that December 25 was the actual date of Jesus' birth and that the fact could be established from the official records of the Roman census that had been taken at the time of Christ's birth. However, all such claims were discounted early on, and scholars are in general agreement that the actual date of the Savior's birth is unknown.

Another explanation was of theological and symbolic character. Since the Bible (Malachi 3:20) calls the Messiah "the sun of justice" ("But for you who fear my name, there will arise the sun of justice with its healing rays"), it was argued that Christ's birth had to coincide with the beginning of a new solar cycle. Therefore, Jesus must have been born at the time of the winter solstice. Confirmation for this opinion was found by calculating six months from the annunciation of the birth of John the Baptist (assumed to have happened on September 24) and thus arriving at March 24 or 25 as the date of the annunciation to Mary and the Incarnation. Nine months later, December 25, would, it follows, be the birthday of the Lord. This explanation, though interesting, depends on too many assumptions that cannot be proven. It lacks any historical basis.

The most probable explanation, and the one held by most scholars, is that the choice of the present date was influenced by the celebration of a pagan feast. From the time of the Emperor Aurelian

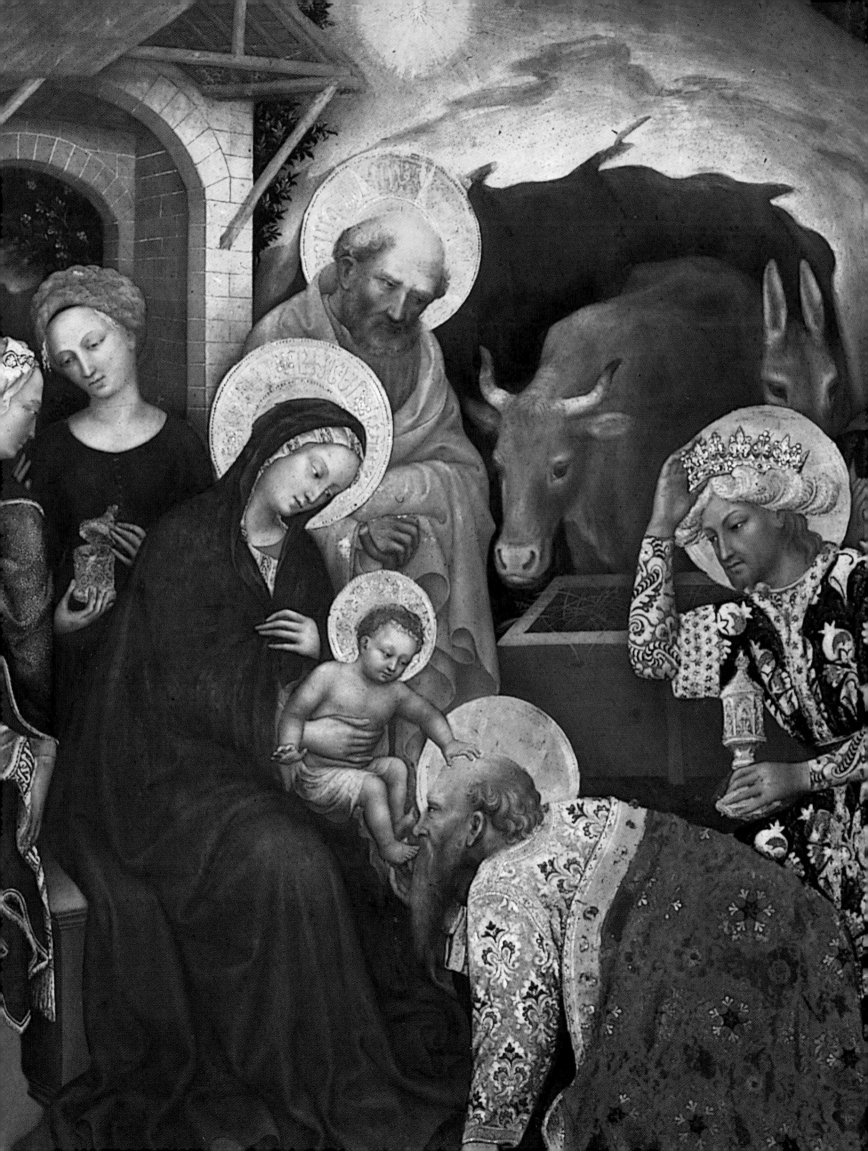

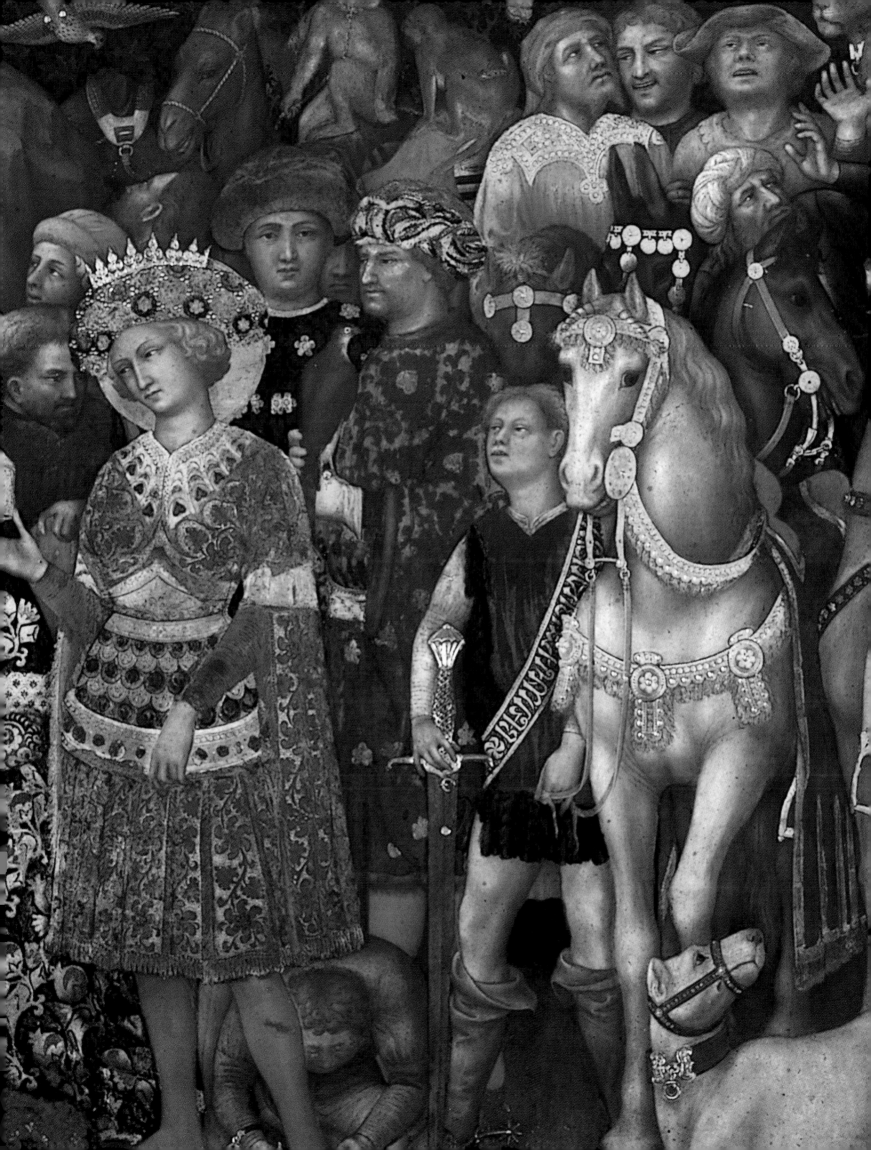

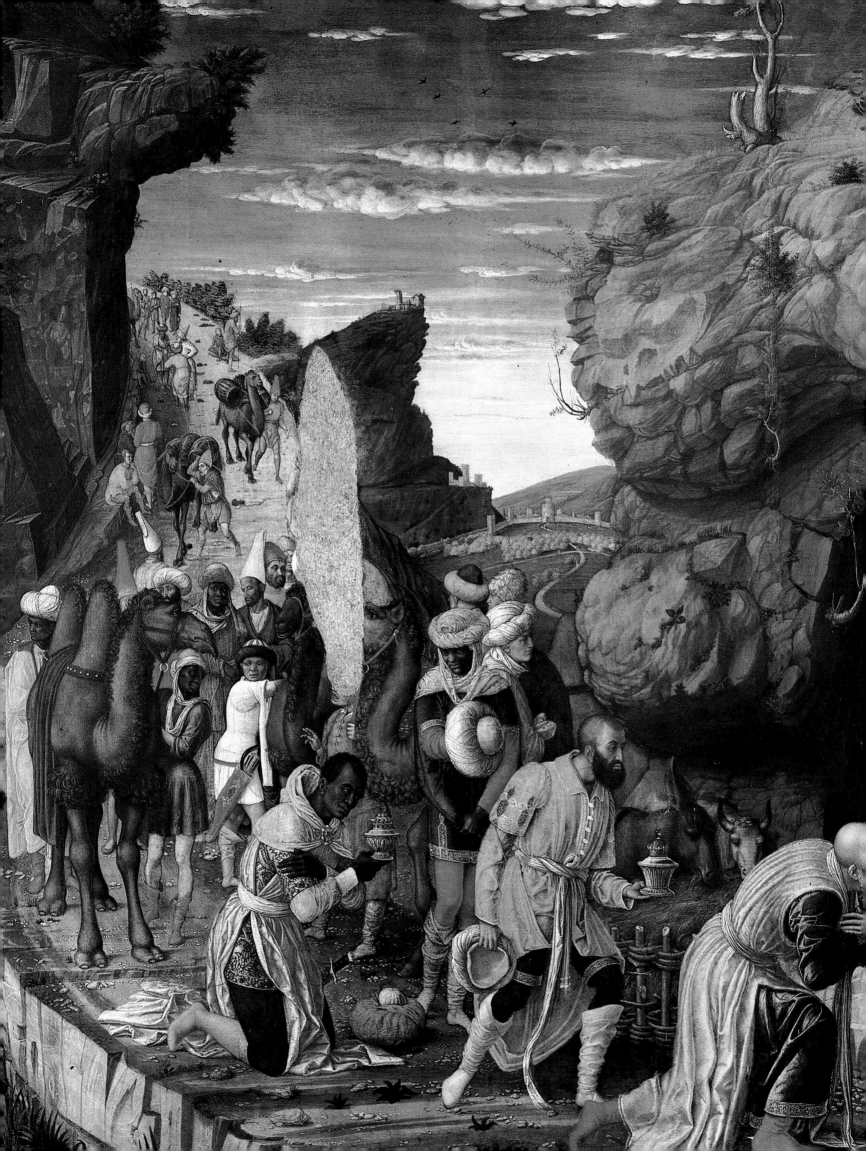

PRECEDING PAGE:

The oldest wiseman pays homage to the Infant Jesus by kissing his foot in "The Adoration of the Magi" (1423) by Gentile da Fabriano. The two legendary midwives stand to the left; to the right we see a small portion of the magi's large amd sumptuous retinue.

The three Kings arrive with their gifts, camels and exotic retinue in "The Adoration of the Magi" by Andrea Mantegna.

(A.D. 275) the Romans had celebrated the feast of the sun god (*Sol Invictus*—Unconquered Sun) on December 25. They believed that the sun was at its weakest on that date and that it had to be born anew with the help of bonfires, lights, processions and prayers. December 25 was called the "Birthday of the Sun," and great pagan religious celebrations were held throughout the empire. It was natural that the Christians wanted to celebrate the birth of him who was, for them, the "Light of the World" and the true "Sun of Justice." The popes seem to have chosen December 25 precisely for the purpose of inspiring people to turn away from the worship of the sun and to the adoration of Jesus, the Light of the World.

The New Testament, of course, contains numerous references to Jesus as the light. Jesus himself says in John 8:12: "I am the light of the world; he who follows me will not walk in darkness, but will have the light of life." As early as 200, before the connection of the Roman emperors with the sun, the comparison of Christ with the sun was becoming quite frequent in Christian writings: what the sun is to the universe, Christ is to salvation. Saint Clement of Alexandria (third century) called Christ the "Helios (sun-god) that traverses the universe." A mausoleum under the present Saint Peter's in Rome, completed before the time of Constantine, contains a damaged mosaic of Christ as the sun-god.

In an agrarian society a winter celebration of Christmas had a practical advantage. People were not involved with the important tasks of tilling, planting and harvesting in December and would have more free time for the Christmas-Epiphany celebrations.

It has sometimes been stated that Christmas is only a Christianized pagan festival. However, Father Francis X. Weiser, in his book, *Christian Feasts and Customs* (pp. 60-61), states:

Christians of those early centuries were keenly aware of the difference between the two festivals—one pagan and one Christian—on the same day. The coincidence in the date, even if intended, does not make the two celebrations identical. Some newly converted Christians who thoughtlessly retained external symbols of the sun worship were immediately and sternly reproved by their religious superiors, and those abuses were suppressed. Proof of this are the many examples of warnings in the writings of Tertullian (third century) and the Christian authors of the fourth and fifth centuries, especially the sermons of Saint Augustine (430) and Pope Leo I (461).

The Council of Agde (506) urged all Christians to receive the Eucharist on Christmas. The Council of Tours (567) proclaimed the twelve days from Christmas to Epiphany as a sacred and festive season and also established the duty of Advent fasting as a preparation for Christmas. In 529, the Emperor Justinian forbade work and public business by declaring Christmas a civil holiday. Christmas soon became a feast of such great importance that from the fifth century on it marked the beginning of the Church year. After the tenth century, however, the season of Advent became such an integral part of the Christmas cycle that the beginning of the Church year was advanced to the first Sunday of Advent.

As Christianity spread throughout Europe, so did the celebration of Christmas. Saint Patrick introduced it into Ireland in 461. Saint Augustine of Canterbury brought it to England in 604, and Saint Boniface instituted the feast in Germany in 754. The brothers Saints Cyril and Methodius introduced it to the Slavic peoples in the ninth century. Scandinavians received it from Saint Ansgar in 865 and Hungarians from Saint Adalbert in 997.

By the year 1100, all of the peoples of Europe had accepted Christianity, and Christmas was celebrated everywhere with great joy and devotion. The period from the twelfth to the sixteenth centu-

ries was the peak of the Christian celebration of the Nativity, not only in churches, monasteries and convents, but also in homes. Christmas carols and plays were written and performed. It was also in this period that most of the delightful Christmas customs of various countries—such as the crèche, the Christmas tree and gift-giving—developed and spread.

The Protestant Reformation brought a great change in the celebration of Christmas in many European countries. In many places the Mass, the very heart of the feast of Christmas, was suppressed. So were sacramentals, processions and devotion to the Virgin Mary and the saints. In 1524, under the leadership of the Protestant reformer Ulrich Zwingli, the council of the Swiss city of Zurich removed all statues and paintings from local churches. In 1529, in neighboring Basel, a mob, impatient with local Protestant authorities' slow pace of change, went on a rampage and destroyed virtually every crucifix, statue and religious painting in the city. In some areas all that remained of the once rich and glorious celebration were a sermon and prayer service on Christmas day. German Lutherans, on the other hand, preserved devotion to the Christ Child and celebrated Christmas exuberantly in both their churches and their homes. From them have come down to us the Christmas tree, the Advent wreath and several wonderful carols.

In England, however, the Puritans rejected even the reduced religious observances that the Anglican Church had kept after its separation from Rome. They seemed determined to abolish Christmas completely as both a religious and a popular feast. They contended that Christmas was of human origin and that no day should outrank the Sabbath. When the Puritans finally came to political power in 1642, they issued the first edicts forbidding church services and civic celebrations on Christmas. Parliament passed a series of laws forbidding both public and private Christmas celebrations and even ordered town criers to go through the streets a few days before December 25 to remind people of the fact. The law was widely ignored and in 1647 riots actually broke out in several English cities protesting the bans. Such was the people's strong feeling about Christmas! It was not until the monarchy was restored in 1660 that Christmas regained some of its former glory in Britain.

When the Spanish came to Florida and the Southwest they, of course, brought their rich observances of Christmas with them. The French did likewise in Canada. In the British colonies, however, especially in New England, the Puritans continued to oppose Christmas as a pagan or "Popish" holiday. Their first New World Christmas in 1620 was a regular work day for the Pilgrims. In 1659 the Massachusetts Bay Colony ruled that "whosoever shall be found observing any such day as Christmas, or the like by forbearing of labor, feasting or in any other way, shall be fined five shillings." Even as late as 1856 Christmas was a common workday in Boston and those who refused to work (especially Irish Catholic immigrants) were discharged. Until 1870 classes were held in the Boston public schools on Christmas day. It was only when vast numbers of Irish, Italian, German, Polish and other Eastern European immigrants arrived in America that the celebration of Christmas became commonplace. And then, it seems, Americans embraced its celebration with great fervor. They became the recipients of Christmas customs brought here from many nations. Among them was the manger scene or crèche.

THE INFLUENCE OF
RELIGIOUS ART
ON THE CRÈCHE

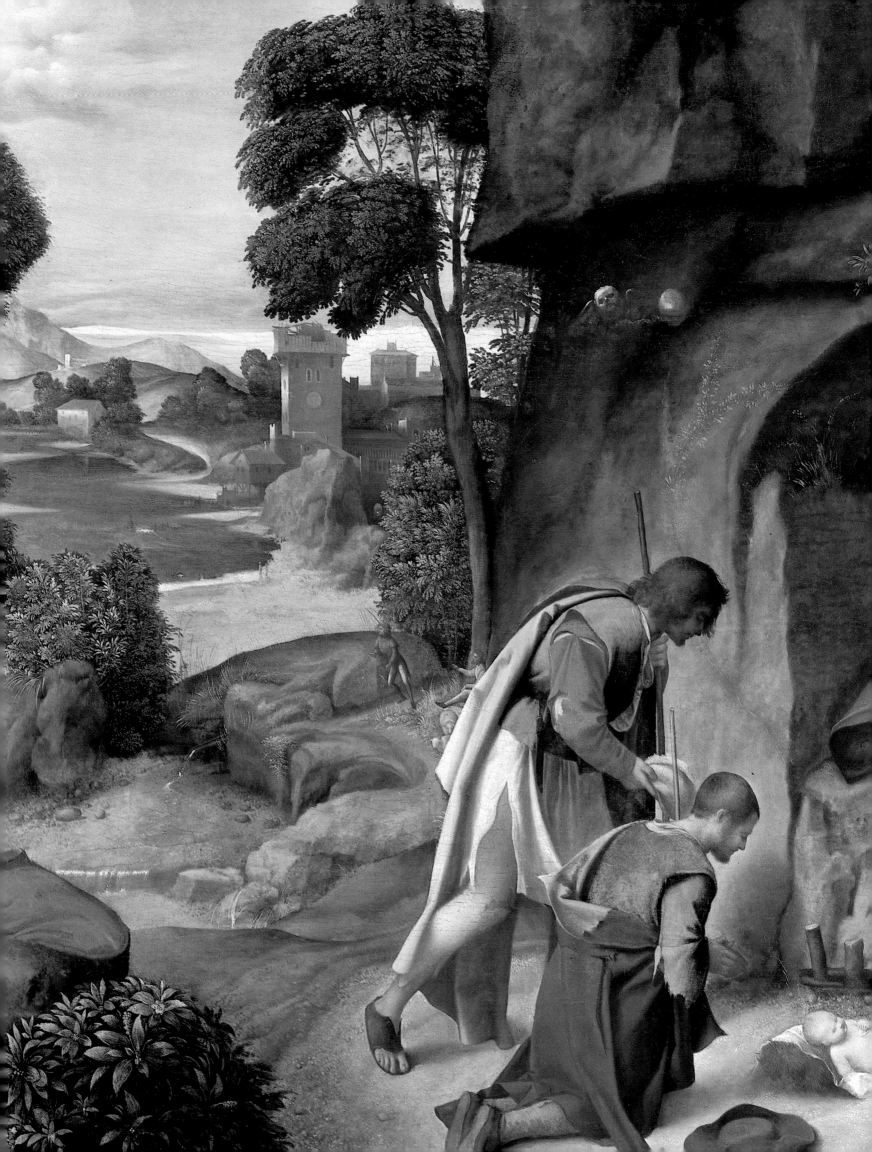

The depiction of the birth of Jesus began in the fourth century. The Word has been made flesh, says one of the oldest of such pictures, a faded fresco in the catacombs of San Sebastiano in Rome.

Much that we associate with the manger scene today comes to us from the New Testament—the Infant Jesus, Mary, Joseph, the angels and shepherds. However, other common, almost indispensable figures, such as the ox and ass, are not mentioned in the gospels. Certain apocryphal books exerted an influence here. These were the so-called "hidden" books for which divine authorship was falsely claimed. The early Church did not accept them into the canon, the official list of books recognized by the Church as inspired and proposed to the faithful as the Word of God and a source of revealed doctrine. Apocryphal writings were generally characterized by their fanciful content, fantastic tenor, unknown origin or even doubtful teaching. But one, the *Protoevangelium of James*, became especially popular

The Infant Jesus resting on the ground in front of a cave emphasizes his humanity in "The Adoration of the Shepherds" by Giorgione. The abundant vegetation connotes new life.

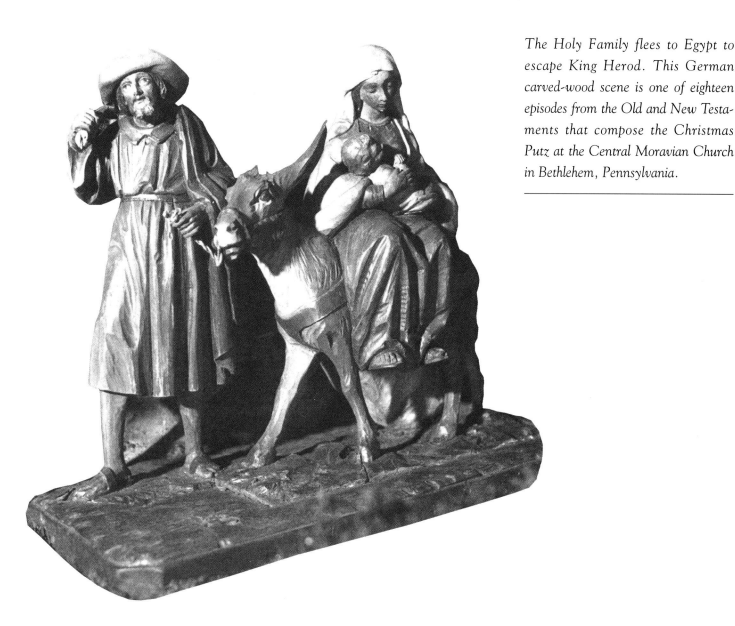

despite lack of Church approval because of its charming, though improbable legends, many of them about the childhood of Jesus. Although of little or no historical value, this writing is the source of the names Joachim and Anne for the parents of Mary, the choice of Joseph as Mary's husband by the blossoming of his staff, the tradition that Joseph was an old man when he married Mary, and the mention of the presence of two midwives at the Nativity.

Other images have come down to us through tradition, legend, and popular piety and devotion that were expressed in Christian art. The ox and ass attending the Baby Jesus in the manger, for example, have become almost essential elements for the depiction of the Nativity, even though they are not mentioned in the Bible. In fact, one of the earliest depictions of the Nativity, a relief dated 343, shows the Child Jesus in the manger between an ox and an ass, *but without Mary and Joseph.* For their images early Christians were looking to what they considered the Old Testament's prophecies of the Messiah. Isaiah 1:3 states: "The ox knows its owner and the ass its master's crib." An early mistranslation of Habakkuk 3:2, confusing the similar Greek words for year or age and animal, had, instead of "In the midst of the years will you be known," "In the midst of two beasts will you be known." In *The Golden Legend,* the thirteenth-century Dominican writer, Blessed James of Voragine, offered a different explanation for the presence of the two animals. He explained

that the Virgin Mary, being pregnant and unable to walk a long distance, rode the donkey to Bethlehem. (In pictures of the flight into Egypt Mary was always depicted on a donkey.) Joseph brought the ox with them in order to sell it and pay the tax decreed by the Romans. Others have presented an earthier explanation; the animals were there to warm the Divine Infant with their breath. Some have seen the ox as a symbol of the Church and the donkey the symbol of the Synagogue—the Old and New Testaments coming together in the person of Jesus. Still others have pointed out that the presence of the animals indicates that this Child is king of all creation, human and animal.

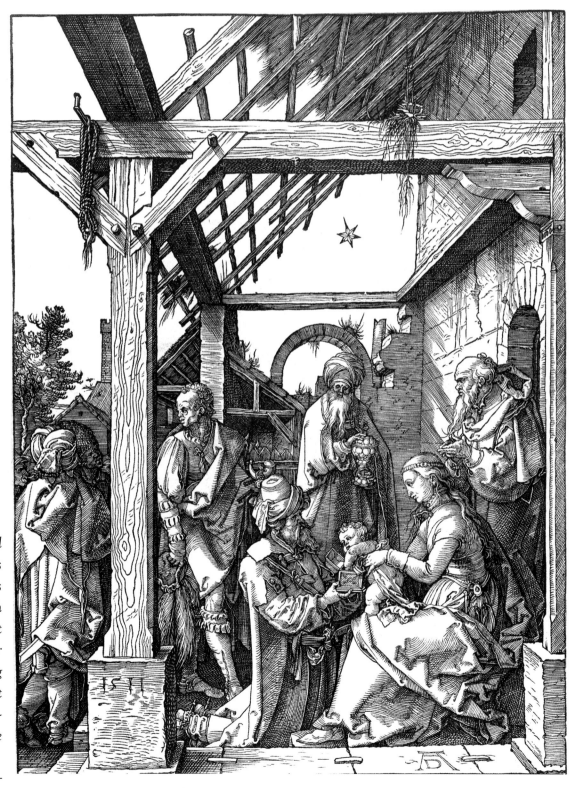

Albrecht Dürer depicted the Child Jesus with his hand in the Wiseman's box of gold. Though some people thought it inappropriate, Dürer was merely attempting to indicate the Christ Child's eagerness to accept the homage of the Gentiles.

James of Voragine wrote that the birth of the Savior was revealed even to plants and trees, declaring that on the night of Jesus' birth, the vines of Engedi bloomed, bore fruit and produced wine! In fact, the artists Giorgione, Andrea Mantegna and Petrus Christus all gave a prominent place to vegetation in their Nativities (compared to the complete lack of grass or plants in Giotto's). Whether this was symbolic or merely decorative is impossible to say.

In much medieval and Renaissance Christian art the Baby Jesus was depicted as wearing little or no clothing. Crèches even today, especially those made in Italy, generally portray the Infant with only scanty clothing. The Scriptures state clearly that Mary wrapped the Baby Jesus in swaddling clothes, long narrow bands of cloth that were typically wound tightly around newborns. In fact, the earliest Christian art shows the Infant bound in this fashion. In the icons of the Eastern Church the swaddling clothes took on symbolic meaning; they were seen as prefiguring the burial clothes of Jesus. The manger, usually painted as a rectangular wooden box, was viewed as foreshadowing Christ's coffin. However, very early on in the West, the Christ Child was depicted nude or wearing only a simple white loin covering. This was in marked contrast to Mary, Joseph, the shepherds and the magi, who were not only fully clothed, but apparently dressed warmly.

Early Christian art of the Nativity, especially in the East, often included a scene of the bath of Christ where, according to the legend in the *Protoevangelium of James*, the two midwives who attended Mary at the birth washed the newborn Child. It would hardly have been possible, then, to show him clothed. Christian artists, though, were not concerned that the newborn Child might appear cold or freshly bathed, but sought to make three important statements. One was that Christ was born in poverty and lowliness, with very few material possessions.

He had come for the poor and dispossessed. The second was that the Son of God did not just *appear* to be human, but was human in every way. His body had all of the parts of any human child. His lack of clothing or scanty clothing was an affirmation of the Incarnation. Thirdly, the unclothed human form of Jesus emphasized that his body and blood would be sacrificed on the cross and offered up in the Mass. The Eucharistic symbolism of the Nativity was often made explicit by showing the Baby Jesus lying, not on a bed of straw, but on sheaves of wheat (from which the communion host is made). In some fifteenth-century paintings, artists even showed the divine Child lying on a corporal, the rectangular piece of white cloth upon which the consecrated bread and wine are placed during the Mass. The cloth can easily be identified as a corporal by the crosses embroidered at the corners. Antonio da Correggio in his *Nativity* and Peter Paul Ruebens in his *Adoration of the Magi* both have the tiny Jesus resting on a bed of shafts of wheat. Nuns in Quebec still make small wax figures of the Infant Jesus lying on a small white cloth, edged in lace and embroidered with crosses. These are placed in small wooden cribs filled with stalks of wheat.

The wise men are, of course, mentioned in Saint Matthew's Gospel 2:2: "Now when Jesus was born in Bethlehem of Judea in the days of Herod the king, behold, wise men from the East came to Jerusalem, saying, 'Where is he who has been born king of the Jews? For we have seen his star in the East and have come to worship him.'" The exact identity and number of the magi, however, are

Angels, humans, and animals rejoice in the birth of Jesus in "The Mystical Nativity" by Sandro Botticelli. The artist depicted the stable as a wooden lean-to in front of a cave.

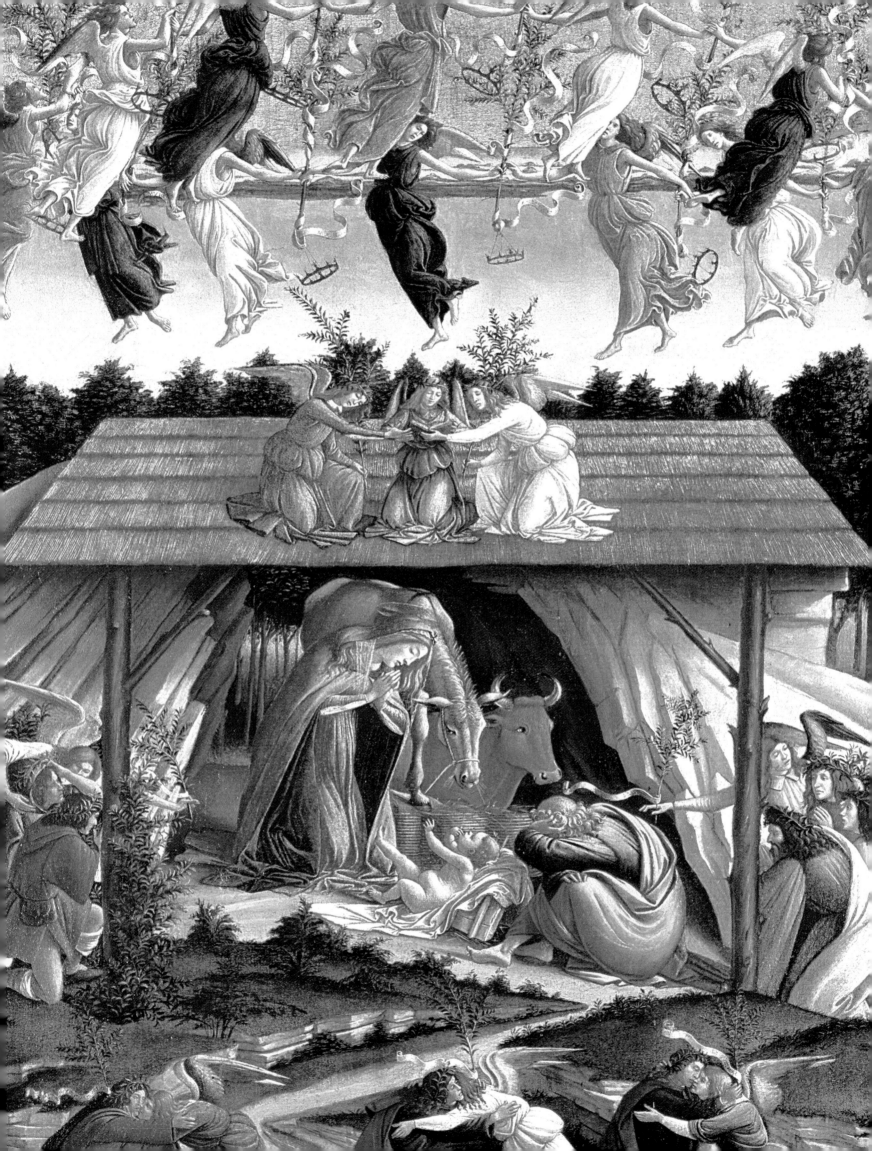

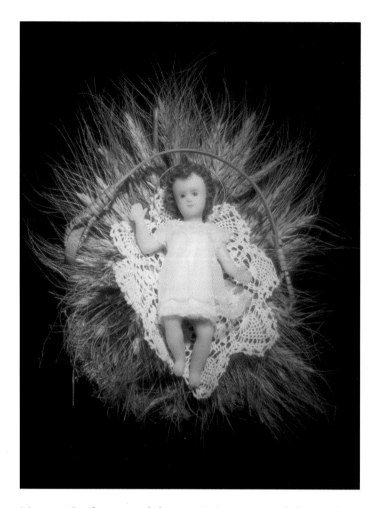

Nuns in Quebec created this wax Infant Jesus with human hair. The bed of wheat and the corporal-like cloth symbolize Christ's presence in the Eucharist.

and with exotic animals. The Dominican, Saint Antoninus, archbishop of Florence, complained:

> Painters are to be blamed when they paint things contrary to the Faith... [or] when they paint apocryphal matter like midwives at the Nativity.... Also, to paint curiosities in the stories of the Saints and in churches—things which do not serve to arouse devotion, but laughter and vain thoughts—monkeys and dogs chasing hares and so on, or gratuitously elaborate costumes—this I think unnecessary and vain.

The journey of the magi provided ample opportunity for such "curiosities."

The number of the wise men varied greatly in early art. Since the Gospel says only "wise men," their number varied from as few as two to as many as twenty-four! Some used the previously mentioned text, Psalm 72:10-11 to argue that there were four magi, since the psalm mentions the kings of Tarshish, the isles, Sheba and Seba. By the tenth century the number was widely established at three. Since the wise men brought three gifts—gold, frankincense and myrrh —people assumed that each wise man brought a different gift. The gifts also took on symbolic meaning. Gold indicated that the Child was a king. Incense symbolized his divinity. And myrrh, which was used, among other things, in the preparation of the dead, referred to the death of Jesus for the sins of humanity. John 19:39 relates that, at the death of Jesus, Nicodemus came "bring-

left shrouded in mystery by Matthew. In the Greek text the word *magoi* is used; from this we get the Latin (and later English) term *magi*. Originally the term designated the learned priestly caste of the Persians; later it came to mean anyone skilled in occult knowledge or power. Matthew was probably using the word in a loose sense. Very early, however, Christian art depicted them as royal persons. This is probably because Psalm 72:10-11 says: "May the kings of Tarshish and of the isles render him tribute, may the kings of Sheba and Seba bring gifts! May all kings fall before him, all nations serve him." The fact that they were presumed to be kings led to their often sumptuous portrayal in art. They were depicted in lavish dress, accompanied by great retinues

Peter Paul Rubens depicted one of the wisemen incensing the Infant Jesus with a medieval-looking thurible usually used in adoration of the Eucharist.

FOLLOWING PAGE:

The ox and donkey warm the Baby Jesus with their breath in "The Adoration of the Shepherds" by Jacopo Bassano. The stable is apparently a lean-to built against a classical building.

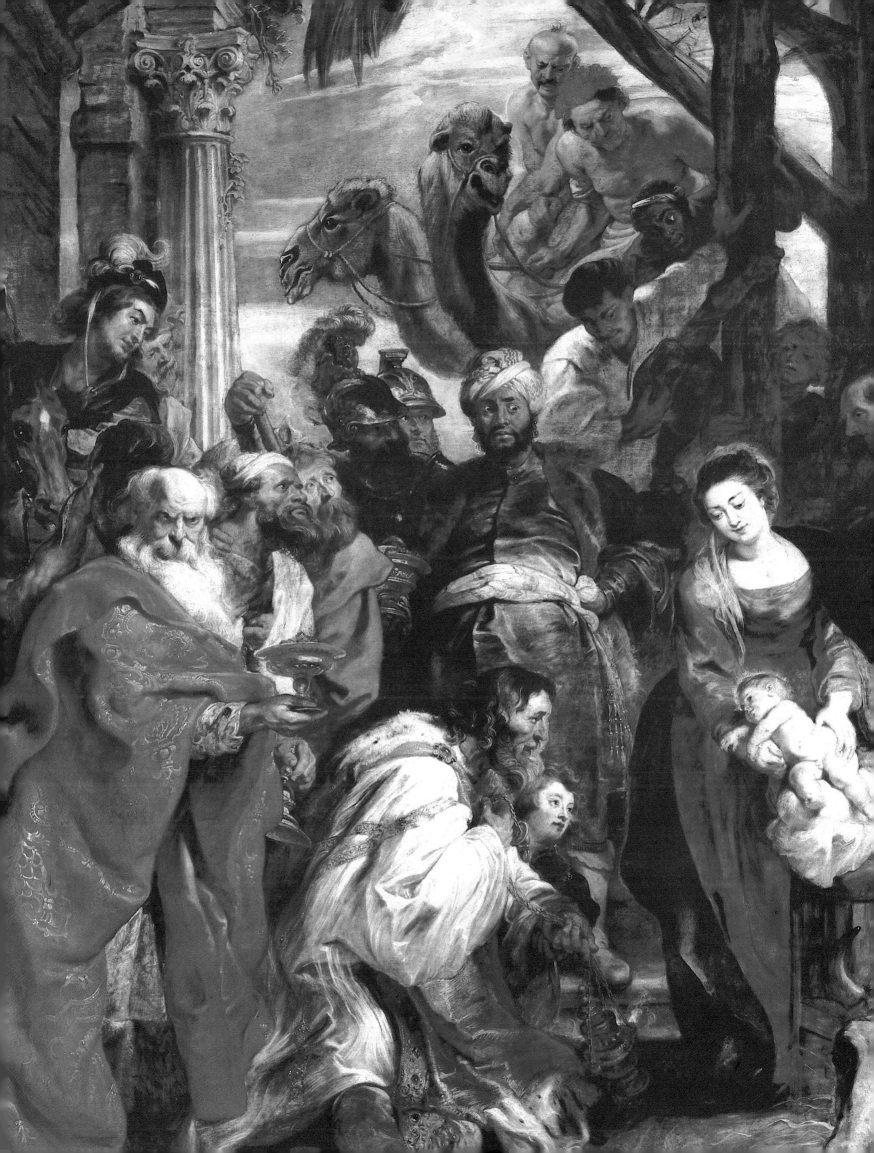

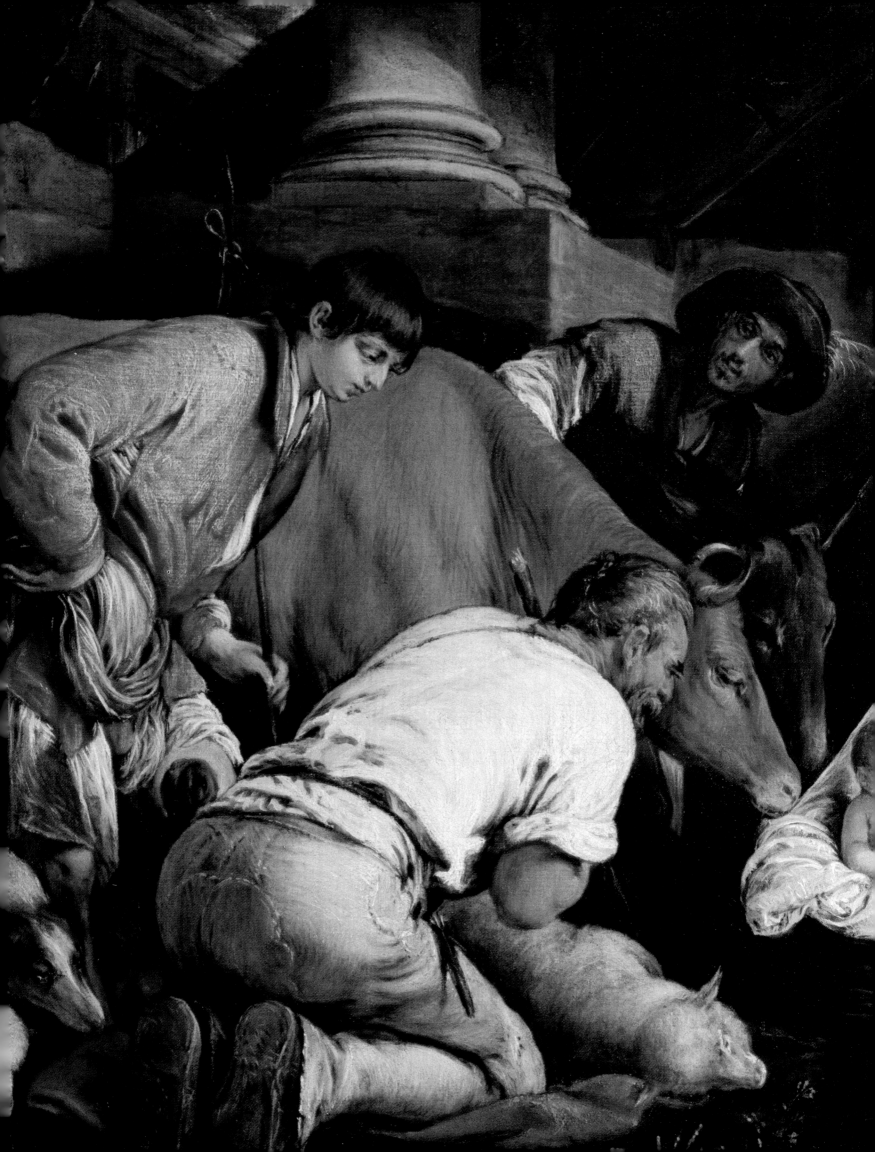

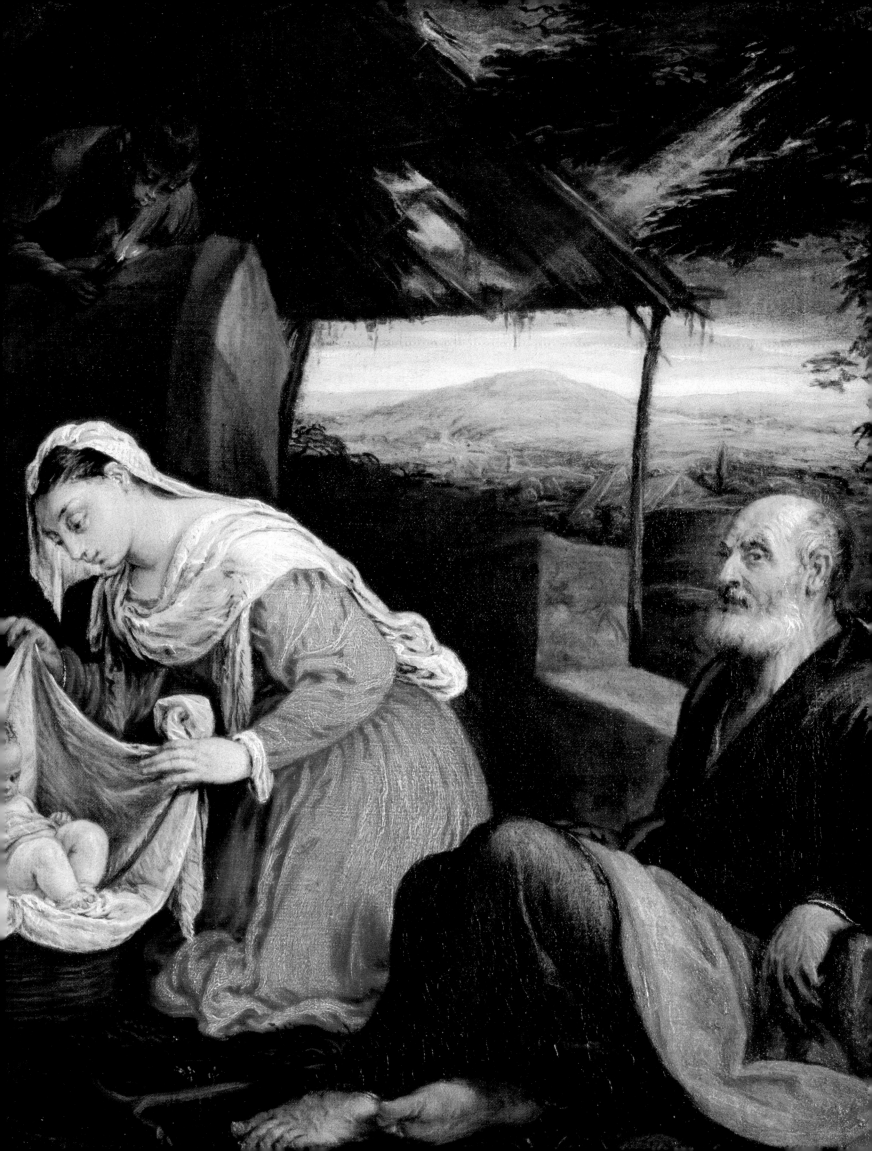

ing a mixture of myrrh and aloes" to prepare the body for burial. Myrrh also had a mild narcotic effect and was often given to condemned prisoners. Mark 15:23 tells us that on the cross Jesus was offered "wine and myrrh, but he did not take it."

The Dominican writer, Blessed James of Voragine, quotes Saint Bernard, who saw more practical uses for the gifts. The gold indicated the poverty of Mary and Joseph. Joseph would use the money for the flight to, and stay in, Egypt. The incense would eradicate the odor of the stable and the myrrh would be rubbed on the Child to make him strong.

A trio of wise men was also seen as representing the three then-known continents—Europe, Asia and Africa. In other words, representatives from the corners of the earth had come to recognize Jesus as Lord. Just as the annunciation of the angels to the shepherds meant the manifestation of Christ to the Jews, so the adoration of the magi celebrated his manifestation to the Gentiles, and, therefore, to the whole world. And since one had come from Africa, he was depicted as black. Those who held this opinion found confirmation in Psalm 68:32, "Let Ethiopia stretch out her hands to God." Often artists depicted the three magi as young, middle-aged and elderly, respectively, representing the three major stages of a person's life. By the tenth century the wise men had also acquired names: Caspar, Melchior, and Balthazar.

Saint Matthew also makes no mention of the wise men's mode of transportation to Jerusalem and Bethlehem. They may well have walked. Again some scholars and artists looked to presumed prophecies of the Old Testament. They found Isaiah 60:6: "A multitude of camels shall cover you, the young camels of Midian and Ephah; all from Seba shall come. They shall bring gold and frankincense, and shall proclaim the praise of the Lord." The scholars concluded that the magi must have traveled on camels. It is interesting to note, however, that in paintings of the adoration of the magi by many Renaissance artists such as Gentile da Fabriano, Filippo Lippi, Fra Angelico, Botticelli, Sassetta, Benozzo Gozzoli, Bartolo di Fredi and Giovanni di Paolo, the magi are mounted on or accompanied by magnificent horses. The carvers of *santos* (wooden religious statues) in Puerto Rico still place their magi on horses because camels are foreign to the island. In some Neapolitan crèches of the seventeenth and eighteenth centuries it is common to find elephants in the magi's entourage. Sometimes the mounts were seen as depicting the three known continents— a horse from Europe, a camel from Asia and an elephant from Africa.

Saint Luke's Gospel (2:7) tells us only that Mary laid Jesus in a manger "because there was no place for them at the inn." From the mention of the manger, we can conclude that Jesus was born in some sort of stable. The "stable" was most likely a cave directly behind and attached to a wooden structure that served as a lodging for travelers. In art the stable is visualized as a *cave* (*The Adoration of the Shepherds* by Giorgione), a free-standing stable (Bladedin *Nativity* by Rogier van der Weyden) and sometimes a wooden lean-to in front of a cave (*The Mystic Nativity* by Botticelli). Of the three, the cave is the oldest depiction, having appeared in the earliest Christian art. The Eastern Churches still retain the image of the cave because of its rich symbolism. Like other Nativity symbols, the cave affirms the Incarnation—that the Son of God came down into the heart of the earth. He did not float above earthly life, but came down into the dirt, as it were. The cave also symbolizes the womb of the Virgin Mary, where the Son of God dwelt for nine months. Lastly, it refers to the tomb (which was also probably a

The tiny shops in the Via San Gregorio Armeno in Naples offer a wide range of Nativity figures in size and price, as well as an array of miniature scenic pieces for home crèches. The shops are family run businesses and the art is passed down from one generation to another.

Jacopo Bassano created a warm picture of the newborn God-man, humans and animals huddled together in his painting, "The Adoration of the Shepherds." The painting stresses God's intimate relationship with his creation.

cave) where Jesus would later be buried and from which he would rise. Many Italians still prefer a miniature replica of a cave in a hillside, rather than a wooden stable, for their crèches. The "stable" for Albrecht Durer's *The Nativity*, on the other hand, is an anachronistic, elaborate two-story barn, similar to the sixteenth-century Northern European structures that he knew. All artists, of course, made the stable very open so that the viewer could see inside. Makers of crèches would follow the example of artists and create a variety of open-front stables. Occasionally artists would picture classical ruins near the stable. This was symbolic of the passing away of the old classical (pagan) world. Neapolitan crèche makers have traditionally included classical ruins in their creations.

Sometimes a well was also presented in Nativity paintings, symbolic of the purity of Jesus, Mary, and Joseph. It also represents the waters of baptism in which one is united with Jesus. If a palm tree was pictured, it was seen as a prefiguration of Palm Sunday when Jesus would enter Jerusalem in glory before completing his earthly mission by his death and resurrection. Crèche makers, again, often made use of both the well and the palm trees.

The Bible mentions only the wise men bringing gifts to Jesus, but a few artists expanded the idea to include the shepherds. In some depictions of the subject, such as those by the Spanish painter Jusepe de Rivera and the Italian Andrea Mantegna, the shepherds bring gifts to someone who is even poorer then they, carrying baskets of eggs, bread, or a lamb. Neapolitan crèche makers later got "carried away" by this notion and had shepherds bringing the Baby Jesus gifts of every imaginable kind of produce, including great quantities of garlic!

Medieval and Renaissance artists had no objec-tion to the use of anachronism—placing something outside of its proper time. In fact, they relished it. The Dominican painter Blessed Fra Angelico placed Saint Dominic (thirteenth century) at the Transfiguration and the Crucifixion. Angelico in-cluded Saint Peter Martyr (also thirteenth century) at the Annunciation, the Nativity and the Presenta-tion of Jesus in the Temple. Piero di Cosimo placed Saint Nicholas of Bari (fourth century) and Saint Anthony the Abbot (third century) alongside Mary and Elizabeth at the Visitation. Duccio di Buonin-segna placed the Old Testament prophets Ezekiel (cir. seventh century B.C.) and Isaiah (cir. eighth century B.C.) alongside his Nativity. These were not mistakes, but were done deliberately. The artists wished to show that we exist both in time and eter-nity. The world of the supernatural—heaven, hell, and purgatory—exists beyond time, yet exists now. In a real sense Saints Nicholas and Anthony are now with Mary and Elizabeth. It should also be re-membered that religious works of art were intended not merely for decoration. They were seen as affir-mations of faith and aids to prayer and meditation. And just as Saint Peter Martyr knelt at the manger and Saint Dominic at the foot of the cross in the paintings of Fra Angelico, so should Christians, in their prayer and meditation, place themselves at these sacred events and ponder their wonder.

Often the contemporary donors—those who paid for an art work—were included in religious paintings alongside the Virgin Mary, the Child Jesus and favorite saints. It was no problem for the artist and the viewers that the figures in one painting lived in five or six different centuries. Later on, cre-ators of crèches would continue the practice and freely place out-of-time characters at Bethlehem. The *santons* of the Provence region of France, for instance, commonly include a *gendarme,* the village priest, Napoleon, and the Pope at the stable!

lothing was also frequently anachronistic. Although Mary and Joseph were usually dressed in something approximating first century Middle Eastern clothing, the shepherds and wise men wore a wide array of garments. The shepherds were usually dressed as typical peasants of the artist's time. Robert Campin, for example, dressed his as fifteenth-century French shepherds, complete with bagpipes. The shepherds in Jacopo Bassano's *Annunciation to the Shepherds* perfectly exemplify sixteenth-century Italians. Fra Angelico clothed his magi in a style similar to Mary and Joseph. However, Fabriano, Gozzoli, Bassano, di Paolo, Quentin Massys and others dressed their wise men like Italian Renaissance princes. Paolo Veronese has his kings looking more like sixteenth-century Venetian merchant-princes (complete with armored military escort) than first-century Persian seers. The same continues today. Figurines of shepherds, imported from Italy, still resemble seventeenth and eighteenth-century (the heyday of Italian crèche-making) southern Italian shepherds more than first-century Israelites.

In addition to painting, the carving of bas-reliefs, three-quarter figures and carved scenes on a flat background became increasingly popular in the Middle Ages and Renaissance. One of the earliest reliefs had been an *Adoration of the Magi* on the side of a fourth-century tomb. Beginning in the thirteenth century, however, numerous reliefs of the Nativity-Epiphany cycle were carved for walls, altars, and even doors. Among the most famous Tuscan reliefs were Giovanni Pisano's in Pisa, Andrea della Robbia's and Niccolo Pisano's in Siena, Andrea Orcagna's in Florence, and Antonio Rossellino's and Benozzo Gozzoli's in Volterra. For the Volterra relief Rossellino created three-quarter figures while Gozzoli painted a perspective background. Hans Degler's Nativity altar in Augsburg is a striking German example.

Another phenomenon was the *sacri monti* (sacred mounts), series of outdoor shrines containing groups of statues representing scenes from the life of Christ. They resembled still-life devotional plays and were a popular place for pilgrimages. The largest and most famous was the *Sacro Monte at Varallo*, northwest of Milan, where Christ's life was presented in fifty small chapels, eleven of them dealing with the Nativity cycle.

These reliefs and groupings of statues were important in the development of the crèche because they gave three-dimensionality to the Nativity scene.

The Christmas crèche was the recipient of many centuries of religious art that had been influenced not only by theology and the Bible, but also by legend, popular piety and devotion, and local and contemporary culture and fashions.

THE INFLUENCE
OF MEDIEVAL
RELIGIOUS DRAMA
ON THE CRÈCHE

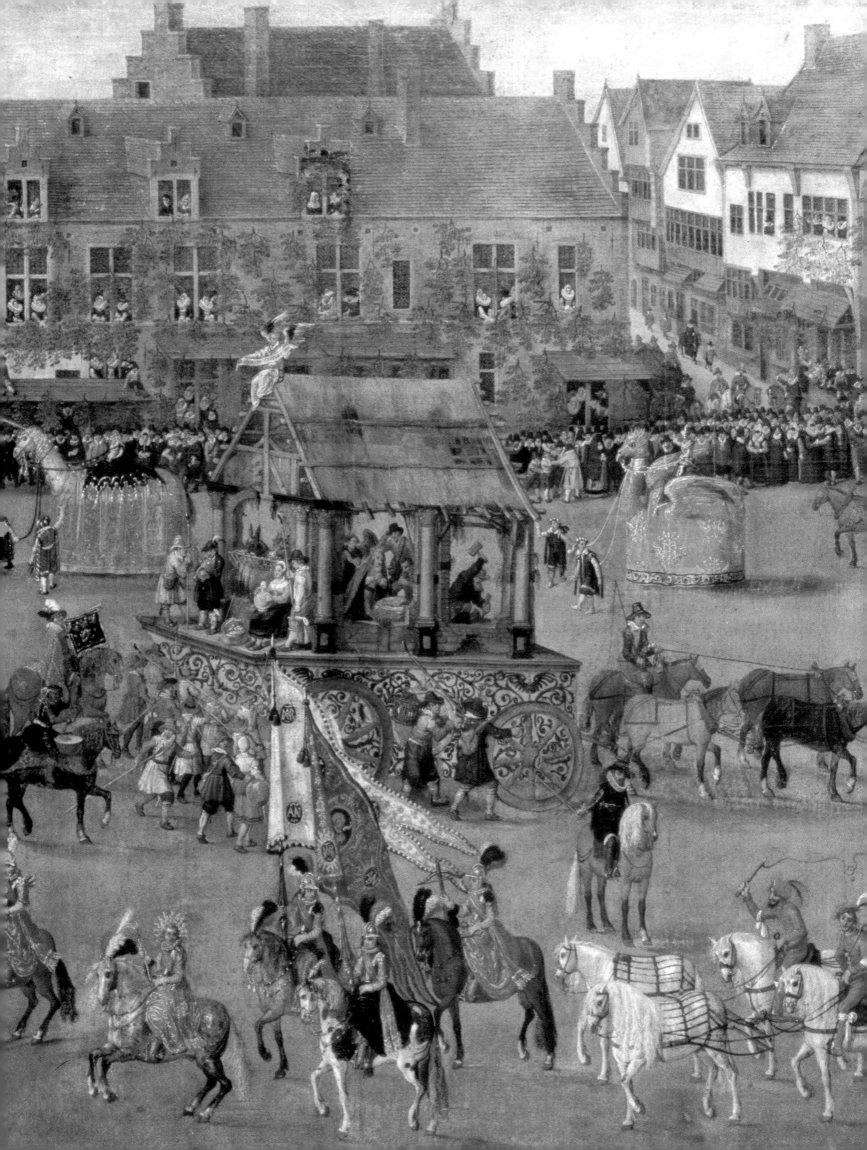

Drama was reborn in the early medieval period through the efforts of the same Church that had so strongly opposed the theater in the Roman period. Early Christians had opposed the theater for a variety of reasons. First, Roman drama, especially the comedies, was often bawdy and lascivious. Sometimes it ridiculed Christian beliefs and sacraments. Second, the Church objected to the statues of pagan gods and goddesses that usually adorned Roman theaters. Third, the fact that men played the women's roles offended many Christians. And lastly, Christians thought that such frivolous activities as the theater, chariot races, etc., were a waste of time for people who should be devoting themselves to works of mercy.

Ironically, theater was reborn in the Christian liturgy through the use of tropes, musical passages added to the official worship services. The first record we have of it is in the *Concordia Regularis* of Saint Ethelwold, bishop of Winchester, England, in

Pageant wagons, including one of the Nativity in the lower left, announce a medieval cycle of religious dramas.

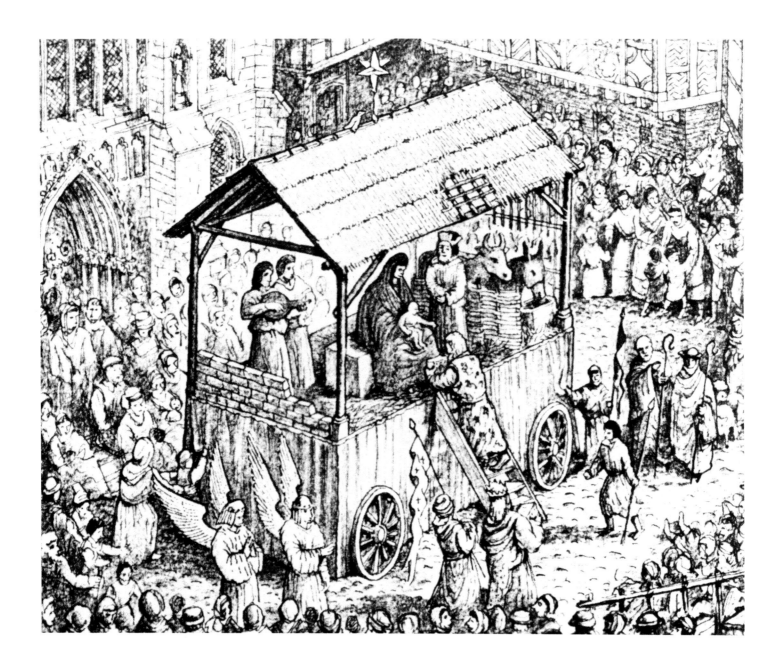

about 925. In this document he describes the proper way to celebrate the *Quem quaeritis* trope for Matins—early morning prayer—for Easter. Three clerics, carrying censers and representing the three Marys, process to the altar where they meet another cleric representing the angel at the tomb. The angel sings, *"Quem quaeritis?"* (Whom do you seek?) The three Marys answer *"Ihesum Nazarenum"* (Jesus of Nazareth). The angel then tells them, *"Non est hic, surrexit sicut praedixerat. Ite, nunciate quia surrexit a mortuis"* (He is not here; he is risen as he foretold. Go announce that he is risen from the dead). The angel then indicates the tomb (the altar) and sings *"Venite et videte locum"* (Come and see the place).

The Marys lift the cloth from the "tomb" and sing *"Surrexit Dominus de sepulchro"* (The Lord is risen from the sepulchre). The congregation then sings the hymn *Te Deum Laudamus* (We Praise You, O God).

The play was brief and sung by clerics in Latin, but drama had entered the Catholic liturgy. The faithful loved the tropes and the clergy realized that drama was an effective way of catechizing a mostly illiterate population. The little dramas gradually expanded, became more elaborate, and were often performed in the vernacular. They expanded

to other major feasts and saints' days. Eventually the religious drama would be accepted in all of Christian Europe. The plays were called by various names in different countries. In general, however, the distinction was made among mystery plays, which dramatized biblical events including the life of Jesus; miracle plays, which dealt with the lives of saints; and morality plays, which taught a moral lesson.

It was not long before the celebration of the Nativity would also include drama. The early Nativity drama, called *Officium Pastorum*—Office of the Shepherds— followed much the same formula as the Easter drama and took place along with Matins on Christmas morning or as an Introit (entrance hymn) for Midnight Mass. A veiled picture or statue of our Lady and the Child Jesus was placed on the altar. A lighted candle above the altar served as a star. Two groups of clerics, representing the shepherds and the midwives, entered from different doors, met and processed to the altar. A small boy dressed as an angel was either near the altar or sometimes even suspended above it. The angel sang "good tidings" and then asked them, "Whom do you seek in the manger?" They responded, "We seek Christ our Lord, a Child wrapped in swaddling clothes." The angel pointed to the altar and the midwives pulled back the veil to reveal the Mother and Child and announced the birth of Jesus. The shepherds then sang a threefold *Alleluia*. The Nativity play had been born! The shepherds then remained for the rest of the liturgy, either the Office of Matins or the Mass, and read or sang a considerable part of liturgical text.

PRECEDING PAGE:

Plays about the Nativity of Jesus were second in popularity only to the Passion-Resurrection plays with medieval audiences.

The first epiphany plays followed close behind. In the *Officium Stellae* or Office of the Star, the three "kings" enter from the east, south and north doors of the church, bearing their gifts of gold, frankincense and myrrh. They encounter a star above the altar and sing *Ecce Stella in Oriente* (Behold a Star in the East). The choir then sings a narrative which describes the magi's encounter with King Herod. The kings "discover" the picture or statue of Mary and the Child Jesus placed behind the altar. After singing their praises of the Virgin and Child, the kings fall asleep in the sanctuary and a boy, dressed as an angel, enters and warns them to return home by another way.

The marionettes of the Holy Family, by John Wright of the Little Angel Marionette Theater of London, are reminiscent of Nativity puppet plays popular in many parts of Europe since the Middle Ages.

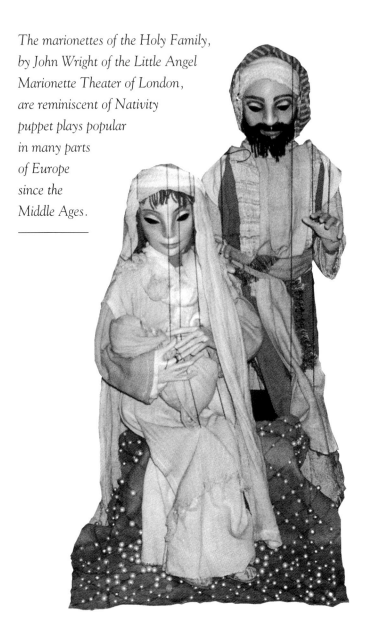

In some places this little play took place along with the offertory procession. After the people had offered the bread and wine for the Eucharist as well as their contributions, the kings came with their gifts.

From a simple, dignified ceremony the magi play developed into a boisterous affair when the story of Herod was acted out rather than narrated. King Herod was usually introduced as a raging maniac who stormed about the sanctuary and, in his anger, even "beat" the clergy and laity who composed the audience. In fact later, the role of Herod was associated with over-acting. Shakespeare refers to it in *Hamlet*. In act III, scene 2, in his famous advice to the players, Hamlet warns them against over-acting ("o'er-doing") and says "it out-herods Herod: pray you, avoid it."

Another popular drama of the Christmas season was the prophets' play. In this play Old Testament witnesses are called one by one and each gives his prophecy concerning Christ. The number of characters could vary from two to twenty-eight and in some versions pagan figures like the Roman poet Virgil were included.

We cannot be sure of the scenic arrangements for such plays and how closely they resembled the crèches of today. In some places the congregation was apparently asked simply to imagine that the altar area was the stable. In other places we have indications that something resembling a stable or cave was built for the occasion, possibly from wood or papier-mâché. In Padua, for instance, the "stable" stood in the middle of the choir in front of the altar. At Rouen, France, it stood behind the altar. The *praesepe* (stable) and altar may have been one and the same in many places since we know that Mass was celebrated on the replica of the manger at Santa Maria Maggiore in Rome. The custom was followed in other places. We also know that multiple scenic locations, called *mansions*, were set up around the church for the presentation of religious plays. Since medieval churches did not have pews, there was plenty of room for stage settings. A play about the crucifixion and resurrection of Jesus, for instance, would usually have at least ten *mansions*, including the garden of Gethsemane, Caiaphas' house, Calvary and the sepulchre. The settings most likely varied from place to place, given that the dramas were presented in every country of Christendom.

The image of the Virgin Mary and the Child Jesus also varied greatly. In some places it was a picture, in others a statue or two separate statues. We know that in some places marionettes were used. In fact the term *marionette* (little Mary) may come from the fact that stringed puppets were used to portray the Virgin Mary in Nativity plays and the three Marys at the tomb in Easter plays. This theory is supported by the existence in the Middle Ages of a street in Paris called the Rue des Marionettes where, not puppets, but religious statues were sold.

We learn from a twelfth-century writer the exact degree of realism that was permissible in the Nativity plays. The crying of the Baby Jesus was imitated, as well as Mary nursing the Child. (Christians of the medieval period felt a great devotion to the nursing Madonna.)

The animals also made their inevitable appearance in the plays. In an old French mystery play the cock crows "*Christus natus est*" (Christ is born); the ox moos "*Ubi?*" (Where?). The lamb answers "Bethlehem," and the ass brays "*Eamus!*" (Let us go!). Live animals may have been introduced into the Nativity and epiphany plays at the Abbey of Saint Benoit in Fleury-sur-Loire, France, in the thirteenth century. The *praesepe* (stable) was situated near the doorway, so as to suggest that they had the quick entrance and exit of animals in mind. We do know that real animals (horses) and images of animals

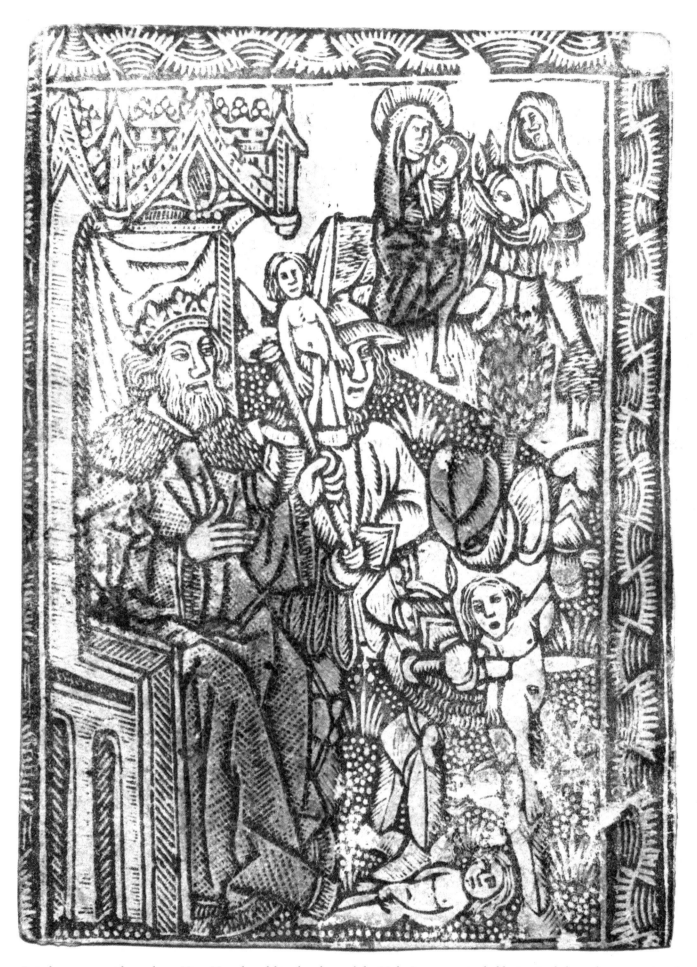

Popular mystery plays about King Herod and his slaughter of the Holy Innocents probably inspired the unknown artist of this fifteenth-century woodcut.

(probably the ox and donkey), as well as both human actors and images, were included in a magi play at the Dominican Church of Sant' Eustorgio in Milan in 1336. (Sant' Eustorgio, incidentally, was the resting place of reputed relics of the magi before they were moved to Cologne.) The "three kings," richly clad, rode through the streets on horseback with a large retinue. When they arrived at the church they dismounted, processed inside and offered their gifts to what were apparently statues of Mary and the Child Jesus. In addition, there were wooden figures of the ox and ass, either their entire bodies or just their heads looking out from their stalls. The Confraternity of the Magi, a pious association of noblemen headed by Lorenzo de Medici, staged a similar pageant at the Dominican Priory of San Marco in Florence in the 1500s.

The slaughter of the Innocents, the boys under the age of two ordered killed by King Herod, was sometimes an added dramatization to the magi plays. The Innocents, usually played by choir boys, entered singing and carrying a lamb. They were "slain" by soldiers and their "bodies" (sometimes embellished with fake blood) were strewn around the sanctuary.

Such dramatic excesses disturbed many Church authorities. In 1210, Pope Innocent III wrote a letter denouncing the excesses of the liturgical dramas, but he seems to have stopped short of banning them altogether. In many places, in response to the displeasure of Pope and bishops, the dramas were moved outside the church and were enacted either on large stationary stages in town squares or on a series of

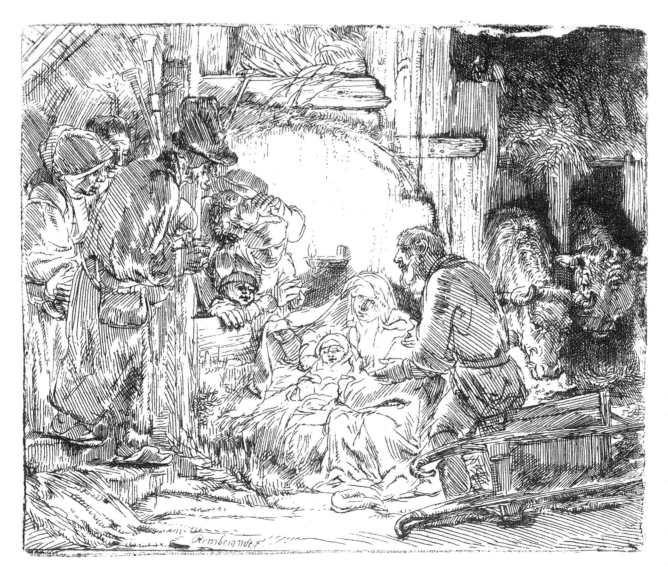

"The Adoration of the Shepherds with the Lamp" by Rembrandt Van Rijn.

movable "pageant" wagons that could be taken to various locations in the city. In other places, statues or puppets replaced human actors and similar dramatic ceremonies continued. In some places, however, the dramas continued in the church buildings and as part of the liturgy.

A Sienese manuscript of the fourteenth century tells us that a curtained hut was built inside the church to house the shepherds and their sheep and dogs who were present for the entire Mass. During the Mass a star appeared above the hut and, instead of the priest, a boy impersonating an angel intoned the *Gloria in Excelsis*. When Mass was over, the angel announced the beginning of the performance and Mary and Joseph appeared on their way to Bethlehem. Mary and Joseph disappeared behind the curtain of the hut and when the curtain was drawn back it revealed Mary with the Baby Jesus, wrapped in swaddling clothes with the angels and shepherds singing. We do not know whether real animals were used or whether the Child was a real baby or an image.

In 1451, the cathedral authorities in Rouen, France, decided that priests must wear proper vestments for the annual Nativity ceremonies. Opposition was evidently so strong that in 1452, though irreverence and extravagance were forbidden, the priests were again allowed to participate dressed as shepherds.

At the cathedral in Zaragoza, Spain, in 1487 a *Misterio de la Natividad* was presented in honor of the royal family. The cast included God the Father, seven angels, the Old Testament prophets, the Holy Family and the shepherds. In the sanctuary stood a hut or cave with stars and clouds above it.

A Christmas play was presented in the cathedral of Valencia, Spain, from the middle of the fourteenth century to the middle of the sixteenth century. It also was a lavish production that used elaborate stage machinery. God the Father sat surrounded by twenty-four children dressed as angels. A dove flew from heaven to the stable and a beam of fire followed. Then an angel with a lily was lowered from above. Angels and shepherds serenaded Mary and the Child. The final climax was a figure of Mary and the Child, suspended above the cathedral as if in heaven.

Nativity plays continued to flourish outside the churches as well. The hardships of an Apennine winter echo in a charming play from the Abruzzi region of Italy in which the shepherds offer the Madonna their cloaks to warm her, and apologize if the capes smell of goats. They address the audience with the words, "Think how the Blessed Virgin had not so much as a sack or cloth to protect her, nor fire to warm the icy air." In the plays in Tuscany the shepherds and even their dogs received names. They bring cheeses and chestnuts and wood to the Holy Family while Randallo, a musician, plays the bagpipes and offers a tiny flute to the Child. In some versions the shepherds on their way to the manger meet the devil, who tries to turn them away. Sometimes as they are leaving the stable, they conveniently meet the arriving magi.

Humor became an important element in the Nativity plays as it was in most medieval religious dramas. *The Second Shepherds' Play* from the Wakefield, England, cycle, the best known medieval Nativity play, centers around the antics of shepherds putting a stolen lamb in a cradle and trying to pass it off as a baby. In another play, the shepherds presume to give advice on child-rearing to the new mother, Mary.

Many of the noble families of Italy—the Gonzagas in Mantua, the Viscontis in Milan, the d'Estes in Ferrara, and the Montefeltros in Urbino—competed with each other for the most spectacular Nativity pageants.

In Naples, street-corner puppet shows of the Nativity were popular at Christmastime. Throughout Europe, religious dramas performed by puppets developed from the Christmas-crib plays performed by live actors. They came to have an important part in the religious instruction as well as the entertainment of the people. Later with the decline, and in some places complete disappearance, of religious drama, puppet shows continued to present biblical stories, since these, in addition to being Sacred Scripture, were the popular traditional stories of the people. It is no coincidence that the Neapolitans referred to their bendable Nativity figures as *pupazzi*—puppets.

Priests used puppets to perform an Easter play in Witney in Oxfordshire, England, until the Reformation. The puppets portrayed Christ, the three Marys, and the watchman. The watchman, named Jack Snacker, provided the comic relief; he was so frightened by the rising of Christ from the tomb that he shook and made a continual noise, like bones knocking together.

On Palm Sunday in Bavaria in the sixteenth century, an almost life-size wooden statue of Jesus seated on a donkey and mounted on four wheels was sometimes drawn around the church. The statue was probably a replacement for an actor on a live donkey which had been forbidden by Church authorities.

Sometimes puppets were used alongside actors. The script for the Passion Play of Mons in what is now the Flemish city of Bergen, Belgium, in 1501 called for 350 characters; 150 parts were played by actors and the rest by marionettes.

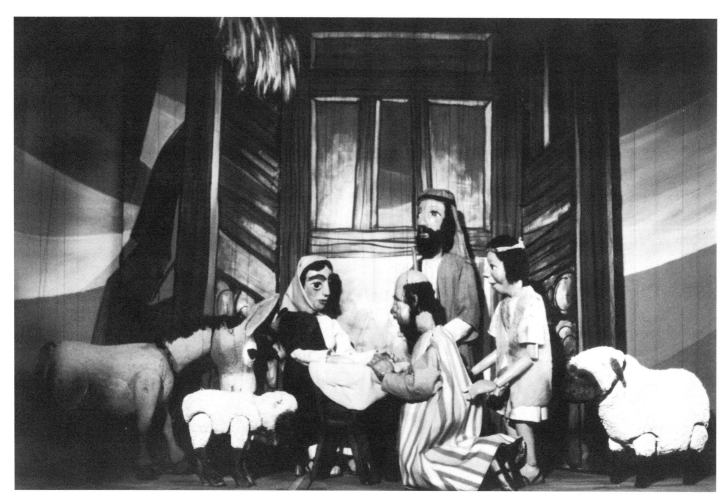

A Nativity marionette play by puppeteer Roland Sylwester of the Little Marionette Theater of the Word of Granada Hills, CA, follows a tradition going back to the Middle Ages.

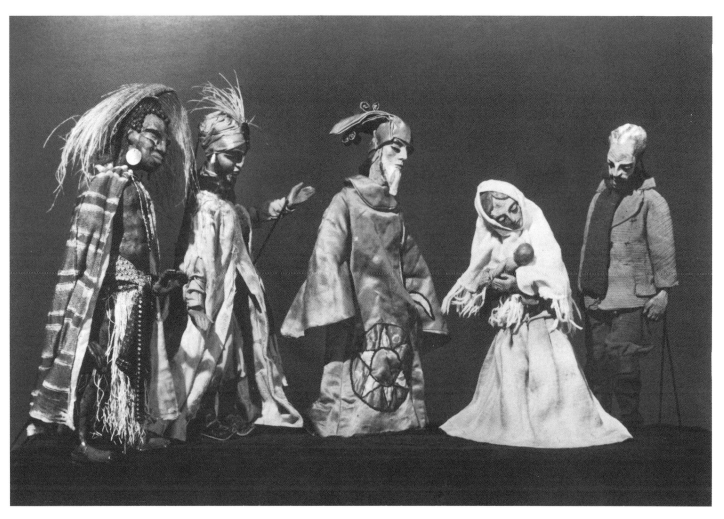

American puppeteer Paul McPharlin followed a centuries-old tradition in portraying his three magi as a European, an Asian, and an African.

A play about the Assumption of the Virgin Mary was performed at Dieppe, France, from 1443 to 1647. Actors played most of the roles, but life-size marionettes represented God the Father and the angels. The angels descended from the ceiling of the Church of Saint Jacques, flew about flapping their wings, swung their censers and blew trumpets. At the end of the play the angel-marionettes took the actress playing Mary into their arms and carried her up to "heaven" to be received into the arms of God the Father.

Protestant Reformers banished the religious puppet plays wherever they could. Religious puppets were burned in London in 1538. In 1545, even the Council of Trent denounced the use of movable figures in Catholic churches. As late as the seventeenth century, however, the Theatine Fathers in Paris annually set up a Christmas crib with movable wax figures, probably similar to puppets, in the entrance of their cloister. Nativity plays performed by puppets still continue (though outside churches) in Flanders, Hungary, and elsewhere in Eastern Europe. Puppet historian George Speaight believes that Nativity plays performed by puppets strongly influenced the development of the Christmas crèche.

In the sixteenth century the religious drama began to decline for two reasons. One was the growth and popularity of secular drama. The other was the Protestant Reformation. Some Protestants, espe-

cially the Puritans, opposed all forms of theater. Others objected to various doctrinal implications of the plays. For example, Corpus Christi, a celebration of the Real Presence of Christ in the Eucharist, was often accompanied by plays with a Eucharistic theme. In England, where religious drama had become a source of theological controversy, Queen Elizabeth I banned all but secular drama in 1559. Religious drama continued only in countries relatively untouched by the Reformation, such as Italy and Spain. And the Spanish brought their religious drama with them to the Americas.

Nativity plays are still staged in many countries and have been re-established in others. In Germany, the *Herbergsuchen* (Search for an Inn) dramatizes the fruitless efforts of the Holy Family to find shelter in Bethlehem. A weary Mary and Joseph knock on door after door, asking for a place to stay. Realizing that they are poor, the owners turn them away with harsh words. Finally the holy couple decide to seek shelter in a stable. The performance is usually sung and is often followed by a tableau of the Nativity scene.

Latin Americans perform a similar drama, called *La Posada* (The Inn). On an evening between December 16 and 24, a man and woman dressed as Joseph and Mary, and often with a donkey, travel from house to house seeking shelter. Householders turn them away. All involved sing songs and recite prayers at each stop. At the final stop, where a shrine to Mary and Joseph has often been set up, they are welcomed with joy. A gala party follows, usually with a *piñata* for the children.

Nativity pageants have been an almost unbroken tradition since the Middle Ages in central and southern Italy. Extravagant outdoor dramas with live animals occur in Rivisondoli, Cerqueto, and Pianola in the Abruzzi region. Others are held at Venafro in Molise, Castelmadama in Lazio, and Benevento in Campania. Magi plays are an annual tradition in Lizzano and Mesagne in Puglia.

As mentioned previously, statues replaced human actors in many places. In these cases the statues serve not just as objects of veneration, but as inanimate participants in a ceremonial religious drama. They function in a similar way to the marionettes of earlier religious drama. In fact, in Latin America one still encounters religious statues with jointed limbs that can be positioned in a variety of poses.

In Taranto, in the Puglia region of Italy, a statue of the Sorrowful Mother, dressed in black, sways slowly through the streets each Good Friday, borne on the shoulders of penitents. The slow procession takes twelve hours and symbolizes Mary searching for her Son. She finally "finds" the image of the crucified Christ in the church.

In several other villages in Italy, *Gl'inclinati* (Those Who Incline) occurs on August 15, the Feast of the Assumption. Two processions, one carrying a statue of Christ and another of the Virgin Mary, leave from different ends of the town. When the processions meet in the center, the bearers tilt the two statues toward each other, as if bowing. The drama represents Christ welcoming Mary into heaven at her Assumption.

In Sulmona in Abruzzi, Italy, people enact the *Madonna Che Scappa* (The Madonna Who Runs) on Easter morning. Six bearers race as fast as they can through the streets with the statue of Mary. The ceremony represents Mary racing to greet the Risen Lord on Easter morning. In several villages in Italy tableaus of statues depicting events in the life of Christ are carried through the streets during Holy Week. These immobile scenes are known, interestingly, as *misteri* (mysteries), the same name used for the medieval biblical plays.

In Poland and Polish-American parishes it is a custom to take the corpus (body of Christ) down from the cross on Good Friday and place it in a representation of the tomb until Easter.

Two other simple customs are practiced in many countries. At Midnight Mass the priest carries a statue of the Infant Jesus in procession and then, amid singing, places it in the manger. In other places, the statues of the three magi are placed a great distance from the rest of the crèche on Christ-mas Eve. Each day they are moved a little closer until they "arrive" at the crib on the Feast of the Epiphany.

This use of statues for dramatic purposes, which continues to this day, was an added impetus to the development of the Christmas crèche where the Nativity scene takes on theatrical qualities. In fact, the noted crèche historian Dr. Rudolf Berliner, referred to the Christmas crib as "frozen theater."

SAINT FRANCIS AND DEVOTION TO THE INFANT JESUS

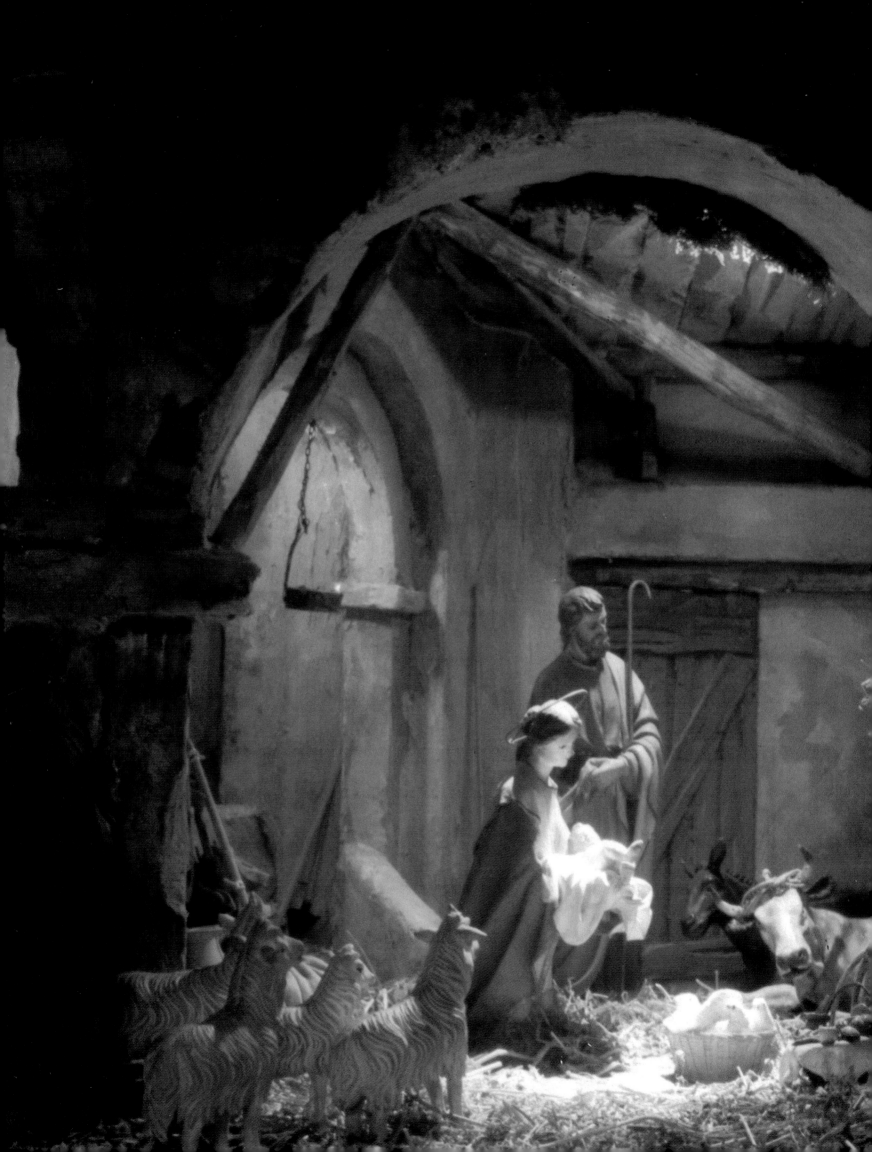

Devotion to the infancy of Jesus was relatively unknown in the early Church. Emphasis had been on Jesus Crucified and the Risen Lord. Devotion to the Infant Jesus developed in the Middle Ages. One contributing factor was the advent of the Crusades, military expeditions organized by the Church for the "liberation" of Moslem-held Christian shrines in the Holy Land. The five major Crusades, which occurred between the late eleventh and early thirteenth centuries, caused widespread development of pilgrimages whose role in the religious life of medieval Europe was considerable. Thousands of Christians visited the significant places of Christ's earthly life and brought back stories, relics and renewed religious fervor. Included was a renewed devotion to the events surrounding Christ's birth and childhood. Saint Bernard of Clairvaux, who had preached the Second Crusade,

The crèche in the Servite Friars' Church of Santa Maria in Via in Rome makes dramatic use of lighting.

wrote eloquently on devotion to the Child Jesus. (The writings of Saint Bernard would later have great influence on the spirituality of the Franciscans.)

The needed spark for the spread of devotion to the Infant Jesus came with Saint Francis of Assisi. Saint Francis had visited the shrines in the Holy Land in 1220. Biographers tell us that Francis held a special devotion to Christmas and celebrated the feast with great joy. If Christmas occurred on a Friday, he dispensed with all fasting and ordered double rations for everyone—even the animals, especially oxen and asses. Saint Francis was the composer of a Christmas hymn in Latin, *Psalmus in Nativitae*, and the first Franciscan friars wrote a number of lovely Christmas carols in Italian.

In 1223, Francis asked the permission of Pope Honorius III for a special observance of Christmas that he had in mind. Francis apparently asked permission because he was familiar with Pope Innocent III's letter expressing displeasure with religious dramas. Having received the Pope's consent, Francis held his observance on Christmas Eve, 1223, in Greccio, a village about midway between Rome and Assisi. The word "crèche" is probably a French derivative of Greccio (pronounced Grecho).

Saint Francis of Assisi provided the needed spark for devotion to the Infant Jesus and popular re-creations of the Nativity story.

Saint Francis got a manger, a live cow and donkey, and a wooden or plaster image of the Infant Jesus (though a living child or simply an "imagined" baby may have been used; the texts are not clear). Only five years later, in 1228, one of Francis' biographers, Thomas of Celano, wrote:

It should be recorded and held in reverent memory what Blessed Francis did near the town of Greccio, on the feast day of the Nativity of our Lord Jesus Christ, three years before his glorious

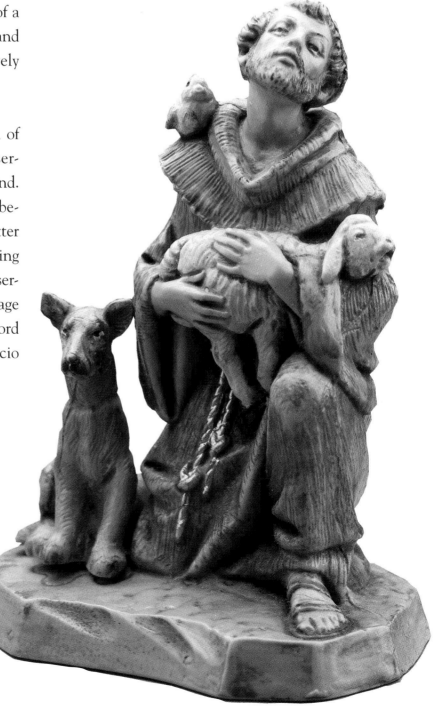

death. In that town lived a certain man by the name of John (Messer Giovanni Velitta) who stood in high esteem, and whose life was even better than his reputation. Blessed Francis loved him with a special affection because, being very noble and much honored, he despised the nobility of the flesh and strove after the nobility of the soul.

Blessed Francis often saw this man. He now called him about two weeks before Christmas and said to him: "If you desire that we should celebrate this year's Christmas together at Greccio, go quickly and prepare what I tell you; for I want to enact the memory of the infant who was born at Bethlehem, and how He was deprived of all the comforts babies enjoy; how He was bedded in the manger on hay, between an ass and an ox. For once I want to see all this with my own eyes." When that good and faithful man had heard this, he departed quickly and prepared in the above-mentioned place everything that the Saint had told him.

The joyful day approached. The brethren [Franciscan friars] were called from many communities. The men and women of the neighborhood, as best they could, prepared candles and torches to brighten the night. Finally the Saint of God arrived, found everything prepared, saw it and rejoiced. The crib was made ready, hay was brought, the ox and ass were led to the spot.... Greccio became a new Bethlehem. The night was made radiant like the day, filling men and animals with joy. The crowds drew near and rejoiced in the novelty of the celebration. Their voices resounded from the woods, and the rocky cliff echoed the jubilant outburst. As they sang in praise of God, the whole night rang with exultation. The Saint of God stood before the crib, overcome with devotion and wondrous joy. A solemn Mass was sung at the crib.

The Saint, dressed in deacon's vestments, for a deacon he was [out of humility, Saint Francis never became a priest, remaining a deacon all his

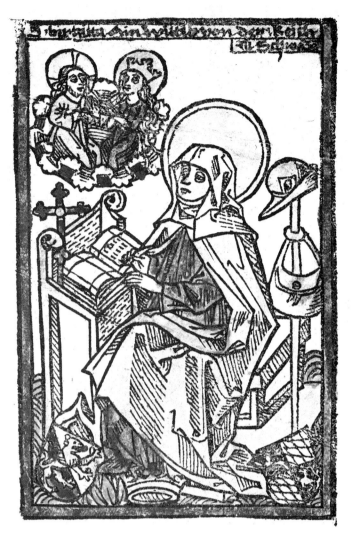

Saint Bridget of Sweden writes an account of her journey to the Holy Land. The staff, knapsack and cap identify her as a pilgrim.

life], sang the Gospel. Then he preached a delightful sermon to the people who stood around him, speaking about the Nativity of the poor king and the humble town of Bethlehem.... And whenever he mentioned the Child of Bethlehem or the name of Jesus, he seemed to lick his lips as if he would happily taste and swallow the sweetness of that word (*Saint Francis of Assisi: Omnibus of Sources*, pp. 299-300).

Saint Bonaventure gives a similar description in his biography of Saint Francis, written in 1263:

Three years before he died, Saint Francis decided to celebrate the memory of the birth of the Child Jesus at Greccio, with the greatest possible solemnity. He asked and obtained the permission of the

pope for the ceremony, so that he could not be accused of being an innovator, and then he had a crib prepared, with hay and an ox and an ass. The friars were all invited and the people came in crowds. The forest re-echoed with their voices and the night was lit up with a multitude of bright lights, while the beautiful music of God's praises added to the solemnity. The Saint stood before the crib and his heart overflowed with tender compassion; he was bathed in tears but overcome with joy. The Mass was sung there and Francis, who was a deacon, sang the Gospel. Then he preached to the people about the birth of the poor King, whom he called the Babe of Bethlehem in his tender love (*Saint Francis of Assisi: Omnibus of Sources*, pp. 710-711).

Francis was undoubtedly familiar with Christmas observances at Bethlehem and in Rome and was certainly influenced by the Nativity plays. Thomas of Celano quotes Francis as saying, "I want to *enact* the memory of the Infant who was born in Bethlehem." Francis' intention was to create the real atmosphere of the stable of Bethlehem in order to touch effectively the emotions of the people. Saint Francis is often credited with the establishment of the Christmas crèche, even though we cannot really point to any one person or event as beginning the tradition. Actually Francis' living Nativity had more in common with the liturgical drama than it did with subsequent stationary manger scenes. However, the saintly friar did see clearly the need to visualize in a tangible manner the events surrounding Christ's birth. He knew the need people have to see, and not just to hear about, the sacred events of their salvation. What Francis definitely did do was to spark renewed devotion to the Nativity and special devotion to the Infant Jesus.

Nesta de Robeck notes in *The Christmas Presepio In Italy* (pp. 13 and 15):

Saint Francis brings us to a turning point in the history of the *presepio* [crèche] for, though popular tradition is mistaken in thinking of him as its originator, nevertheless it was he who took the old custom and gave it the stamp of his own irresistible genius.... But the *Presepio of Greccio* was not only an echo; by his emphasis on the human and pathetic side of the Gospel story Francis stirred his fellow men to new, more ardent devotion. The least lettered of men could understand his *presepio* as well as any doctor of theology; his realism made the Nativity of the Eternal Word as real to those Umbrian peasants as the birth of their own children; he gave into the arms of his followers that most precious of all Babies, the Bambino Gesu.

In her other work, *The Christmas Crib* (pp. 50-51), de Robeck adds:

From that moment the cult of the Christ Child is intensified: in the Franciscan world the Son of God becomes the loveliest of earth's children, the dear Little Lord Jesus who is everybody's Brother. We see Him throwing His arms round His Mother's neck while artists dwell caressingly on the perfect Baby's body that lies kicking in the straw or opening His eyes in delight at the sight of a bird held out by Saint Joseph. The angels become lovingly dimpled babies too, play-fellows who sing and play and offer Him fruit when they are not kneeling round the manger all "reverent, timid, and obedient."

A new spring of poetic imagination had been released, and at its source stood Francis.

As early as the eleventh century Saint Anselm of Canterbury had counseled worshipers to reflect on the mystery of Christmas by calling to mind's eye the events in the cave at Bethlehem. However, two medieval spiritual books helped in spreading devotion to the Infant Jesus. One was the previously mentioned *Golden Legend* by Blessed James of Voragine, with its colorful stories of the birth and childhood of Jesus. The other was *The Hundred*

The Portuguese have devotion to the Menino Jesu di Natal, the Infant Jesus of the Epiphany, who raises his hand in greeting and blessing.

Meditations on the Life of Christ, probably written in the early fourteenth century by an unknown Franciscan friar. Though intended only for the private spiritual meditation of a Poor Clare nun, it was read all over Europe. It is full of legends of tender human details, such as the statement that the painful circumcision of Jesus caused Mary to cry. The author encourages the Poor Clare to imitate the adoration of the shepherds and to imagine herself reverently holding, caressing and kissing the Divine Child. He also tells her that during the Christmas season not a single day should go by without Christians visiting Jesus and Mary in the stable and meditating on their poverty, humility and dignity.

An added example of devotion to the Christ Child are the revelations of Saint Bridget (Birgitta) of Sweden (1303-1373). Already known for her mystical experiences, Bridget made a pilgrimage to the Holy Land in 1372, and at the Grotto of the Nativity in Bethlehem she experienced a vision of all of the events of the night of Jesus' birth. It was Bridget who saw Jesus, not in the manger, but lying naked on the ground, a visual affirmation of his Incarnation. Her vision influenced many artists who later depicted the Nativity. Bridget dictated this and other visions in vivid detail and they were widely read throughout Europe.

Spiritual directors encouraged people, especially nuns, to meditate on the infancy of Jesus. The account of a Dominican nun in fifteenth-century Alsace illustrates how well the imagination worked in this connection. In her meditation, she transformed her cell into the cave of Bethlehem and imagined Mary with the Child Jesus lying in one corner and Saint Joseph sitting in the other. The door and windows represented the roads to Bethlehem taken by the shepherds and magi. A devotional exercise called "spiritual manger building" emerged,

especially among cloistered nuns, in South Germany. Instructional booklets with prayers and meditations gave the nuns concrete guidance on how to prepare a spiritual "stable" or "manger" for the Child Jesus in their hearts.

Before real beginnings of the crèche as we know it (individual statues of the Holy Family, shepherds and magi) veneration of small statues of the Child Jesus was common. The Crusades may have encouraged this practice. Returning pilgrims often wanted to erect models of sights they had seen. Models of the Holy Sepulcher, for example, became popular. In Naples, nearly every church still erects a model sepulcher made of shafts of wheat for Good Friday and Holy Saturday. The Franciscans would later spread the devotion of the Stations of the Cross, representations of actual events on Christ's journey to Calvary. The primary intention of these practices seems to have been to offer a physical substitute for the actual holy place or event for people who were un-

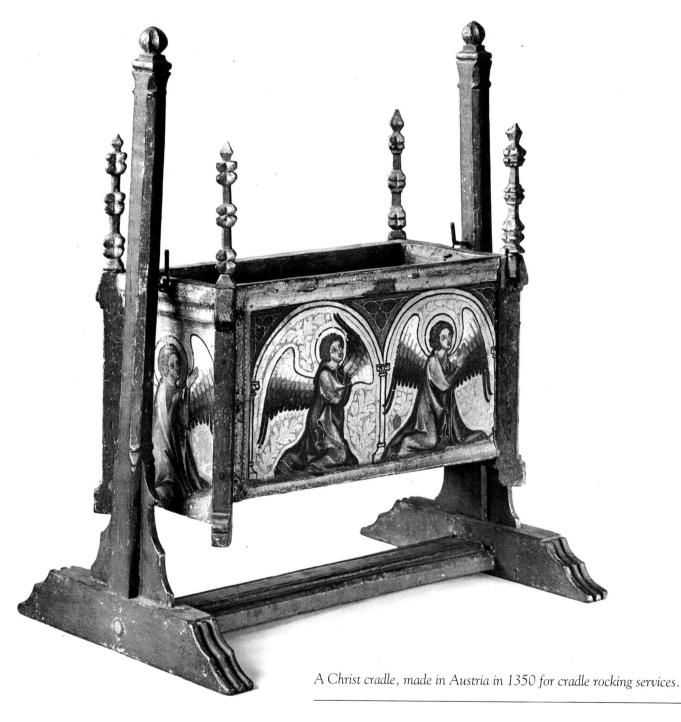

A Christ cradle, made in Austria in 1350 for cradle rocking services.

able to make the trip to the Holy Land. They were intended to aid in meditation on a sacred event. And, of course, statues had long been used in the medieval religious plays.

In 1344, Blessed Margaret Ebner, the famous German Dominican mystic, wrote in her "Revelations" that she received from Vienna a Christ Child in a cradle with four little golden angels. The ceremonies of the Dominican nuns near Zurich in the middle of the fourteenth century illustrate the emphasis on the person of the Child Jesus. During Advent, the nuns prepared a small house for the Infant with everything needed to care for a baby. We know that the nuns bathed the statue in a tiny bathtub before dressing it and placing it in a cradle on Christmas Eve. The great Spanish Carmelite reformer Saint Teresa of Avila (1515-1582) encouraged devotion to the Infant Jesus and apparently had simple crèches erected at Christmas in the convents she founded. In the Franconia region of Germany in the sixteenth century it was the custom at Christmas to place a statue of the Child on the altar and have children dance around it, accompanied by the singing of the adults.

Pre-Reformation England had its own crib custom, that of baking the Christmas mince pie in an oblong manger shape to cradle an image of the Child Jesus.

The custom of *Kindelwiegen* (Rocking of the Child) originated in Germany and Austria in the fourteenth century as a substitute for the Nativity plays, which had been banned. A priest would carry to the altar a cradle containing a figure of the Infant Jesus. The cradle was then rocked while the congregation sang a lullaby-like hymn. The service ended with the devotional kissing of the Christ Child at the altar rail, similar to the veneration of the cross on Good Friday. The oldest recorded German Christmas carol ("Joseph, dearest spouse of mine, help me rock the little Child"), written by the poet-monk Hermann von Salzburg in the late fourteenth century, was intended for Cradle Rocking. The custom was also carried on in homes. Hermann von Weinsberg, a councilman of Cologne, wrote in his diary for December 25, 1581: "I, Hermann, had my brother and his wife and my sister Sibilla and others in my house...then in the evening...we rocked the little Child among us; we sang and were joyful with the little Jesus" (in Gockerell, p. 12).

Veneration of small statues of the Christ Child apparently continued in some Protestant churches as well. In 1608, the Lutheran Church of Saint Michael in Hof, Bavaria, purchased a new painted and clothed statuette of the Divine Infant to place upon the altar at Christmas. The church's previous statue had been marred by children since it was the custom to take it from house to house. The parishioners considered its visit a consecration. The older statue was repaired and given to another Lutheran church.

While veneration of statues of the Infant Jesus was one of several influences on the development of the Christmas crèche, it also blossomed into an independent devotion. Santo Niño de Atocha is said to have originated in Antioch in Syria. (Atocha may well be a corruption of Antiochia.) Santo Niño (Holy Child) is an image of the seated boy Jesus dressed in a long robe, short cape, frilled collar and cuffs and hat. Whatever its origins, the statue surfaced in Toledo, Spain, in the twelfth century. Devotion to the Santo Niño de Atocha rapidly spread throughout Spain and later to Latin America. People in the Philippines, under Spanish rule for over 300 years, fostered a similar devotion to the Santo Niño de Cebu, named after a

shrine on the southern island of Cebu. The small statue of the Infant Jesus at the shrine was reportedly brought to the island by the Portuguese explorer Ferdinand Magellan in 1521.

The Bambino Gesu (Baby Jesus) of Aracoeli in Rome is an olive wood statue of the Infant, said to have been carved by a Franciscan in the Holy Land in the fifteenth century. Now clothed in rich robes and jewels, it resides in the Franciscan Church of Santa Maria in Aracoeli. Many people have associated miracles and favors with the statue. Unlike other Infant Jesus statues, this has remained primarily an Italian devotion.

Devotion to the Infant Jesus of Prague can be traced to 1556, when a Spanish noblewoman marrying into the Czech nobility brought with her a precious family heirloom, a statue of the Infant Jesus. One hand of the statue is raised in blessing; the other holds a miniature globe topped by a cross. The statue is usually crowned and dressed in fabric clothes. Initially the Discalced Carmelite Friars of Prague encouraged veneration of the statue; devotion has now spread throughout the world.

The Portuguese have devotion to the MeNiño Jesus di Natal (the Baby Jesus of Christmas), a standing statue of the Christ Child. Though displayed throughout the Christmas season, he is the Child of the Epiphany, represented as being one and a half to two years old, since the visit of the magi probably occurred a year or two after the Nativity. (In Matthew 2:16 Herod orders all the males *under the age of two* killed.) It is he who brings gifts to children on the Epiphany. In his left hand he holds a small globe; his right hand is raised in greeting and blessing the visiting magi. He is usually naked except for a wide cloth ribbon. MeNiño Jesus was generally displayed by poorer people, who could not afford the several figures of the crèche. Today, even people of means continue the custom.

Life-size statues of the Infant Jesus resting in wooden mangers filled with straw are still sold in religious good stores and are particularly popular in Italy, Spain, Portugal, and Latin America. They are often set out at Christmas without any accompanying figures.

Veneration of statues of the Christ Child down through the centuries has been an expression of devotion to the infancy of Jesus. And the infancy of Jesus clearly points to his true humanity. Jesus did not descend from the Father fully grown; his body developed in Mary's womb and he grew like any other normal human baby. Many people who might have been struck with awe and terror at the image of God the Father have opened their hearts to the tiny Divine Infant in the manger. Although viewed as overly sentimental by some, the image of the Infant Jesus has done what only the mystery of the Incarnation can do: it has made God more approachable for us humans, so limited in our knowledge and understanding.

THE DEVELOPMENT OF THE CRÈCHE: FOURTEENTH CENTURY TO THE PRESENT

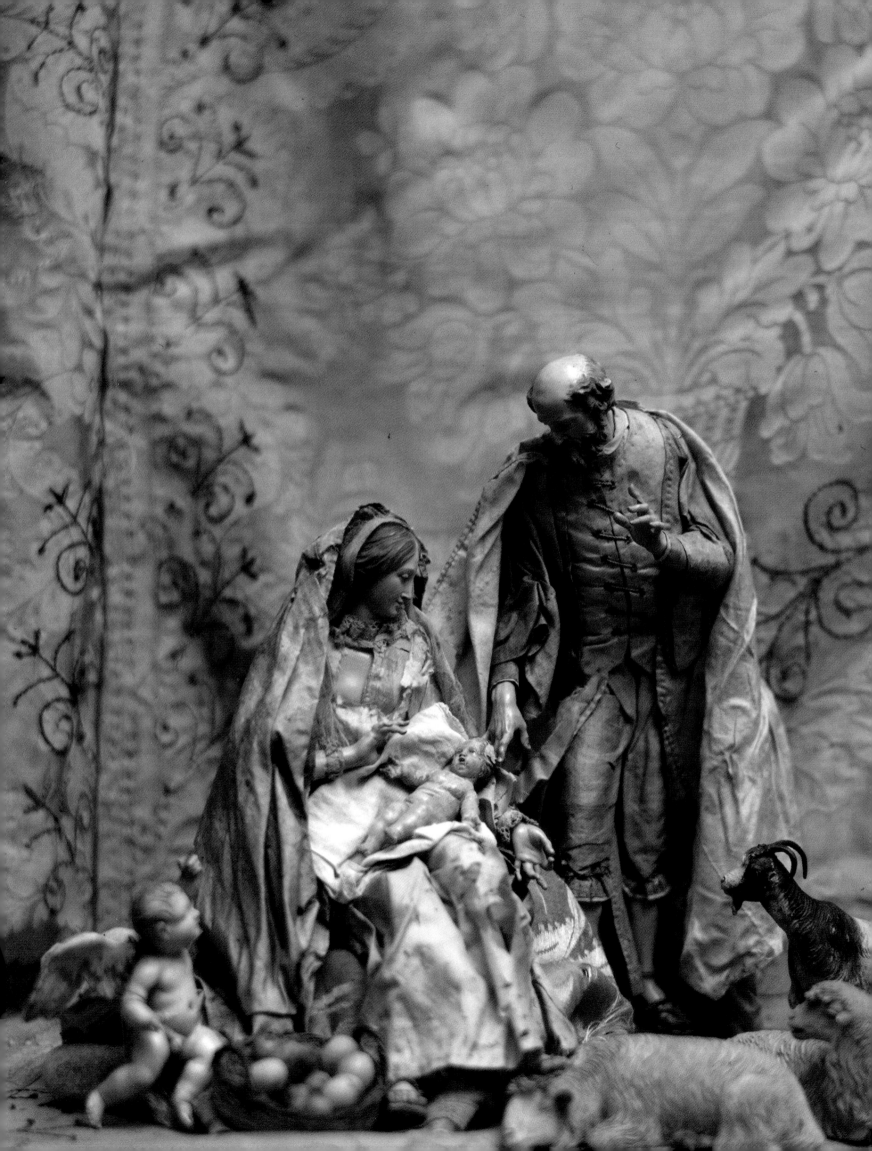

It is impossible to credit the Christmas crèche to any one person or event. It would be more accurate to say that the crèche was the result of several influences—that it was a hybrid or assimilation that developed gradually. At least seven factors contributed to the blossoming of the crèche.

First, though Easter was a more ancient feast and commemorated another great salvation event, by the Middle Ages Christmas had become the most popular Christian celebration. It was the most joyful time of year, and each area developed its own expressions and customs.

The second factor was certainly the long tradition of art in the Christian Church. The most ancient surviving examples we have of Christian art are from the early second century, when Christianity was still illegal and public expressions of the faith were risky. Christians had been depicting the sacred

Careful attention to the smallest details characterized eighteenth-century Neapolitan Nativity figures.

events of their salvation, despite occasional opposition, for over a thousand years before the advent of the crèche.

Third, the Middle Ages had seen a particular flowering of works of art about the Nativity and Epiphany. Medieval artists created paintings, mosaics, frescoes, reliefs, statues and stained glass windows on the themes of Christ's birth and infancy. The bas reliefs and groups of statues especially appealed to people's desire for greater realism.

Fourth, the Nativity and magi plays fired the people's imaginations and revealed to them opportunities for dramatizing the birth of the Savior. The decline, and in some places complete disappearance, of the plays caused people to turn to and expect more from painted and sculpted images. The use of statues and puppets alongside human actors in many of the liturgical plays had shown them the possibilities.

Fifth, devotion to the Child Jesus and veneration of statues of the Infant were dear to the common people. Adding other figures was only a step away.

Sixth, it had long been the custom for churches, monasteries, convents, and royal palaces to exhibit treasured art objects representing the Nativity during the Christmas season.

And lastly, the events surrounding the birth of Jesus—Joseph's doubts about Mary, Mary and Joseph seeking shelter in a crowded town, the Savior's birth in a stable among the animals, angels in the sky, visiting shepherds, exotic kings, Mary and Joseph fleeing to Egypt, a raging Herod who slaughtered children—made for a story that artists and dramatists relished. It begged for more expression than could be possible with the mere reading aloud of the Gospel. It was a story that needed to be told in more tangible ways—in art and theater.

In addition, the years of the crèche's greatest growth in popularity—the sixteenth and early seventeenth centuries—was also the period of the Counter Reformation. The Counter Reformation was a spiritual revival in the Catholic Church, partly in reaction to Protestantism and partly in response to real pastoral needs in the Church. It culminated in the important reforms of the Council of Trent (1545-1563). This period also saw a renewal of Catholic piety, spurred by the writings of Saint Francis de Sales, Saint Teresa of Avila, Saint John of the Cross, and others. It was a perfect time for the spread of the crib devotion.

Given all these factors, it was inevitable that the events of the Nativity would eventually be expressed with individual, movable, three-dimensional figures in miniature. In the Christmas crèche, religion, art and theater joined together.

The first Nativity composed of moveable individual statues was carved by Arnolfo di Cambio in 1289 for the Chapel of the Manger at Santa Maria Maggiore in Rome. This practice, however, did not immediately catch on.

Three important Nativity altars done in the 1500s might also be considered types of crèches. Antonio Begarelli carved a Nativity for the cathedral in Modena. Federico Brandani did one for the Oratory of Saint Joseph in Urbino and Francesco da Pietrasanta created a stucco group for Santa Maria Maggiore. Although composed of individual statues, the scenes were permanently fixed to altars or carved from a single block of stone; therefore, they could not be rearranged and were on exhibit all year round.

The late 1400s saw the appearance of Bethlehems, small portable representations of the Nativity in metal, usually gold or silver and sometimes enameled and decorated with jewels. Some were also music boxes. In 1489, Bishop David of Burgundy donated a jeweled one that was also a reli-

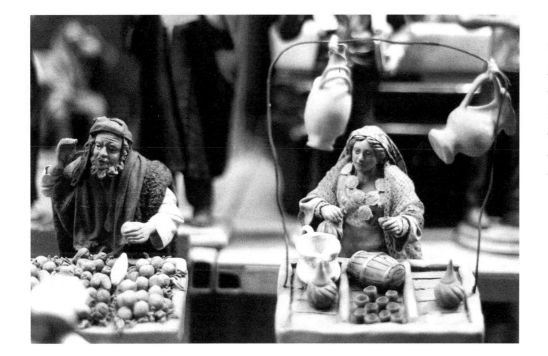

These crèche figures, along with miniature fruits, vegetables and pots, are sold from out door stands during the Christmas season in Naples. The tradition of realistic details and backgrounds goes back almost 400 years in Naples.

This elaborate Nativity scene stands in the main train station in Rome. Christmas cribs in public places are common throughout Italy.

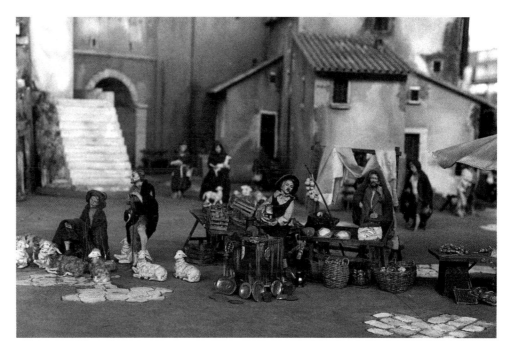

quary to his cathedral in Utrecht, Holland. In 1537, the Carmelite nuns in Bruges in Belgium had one that sat on the altar at Christmas.

The most spectacular, however, were the mechanical Bethlehems. Run by clock mechanisms, the figures moved when wound up. Bernardo Buontalenti built one for his pupil, Francesco de Medici, around 1560. Buontalenti was a theatrical designer and supervisor of entertainment for the Medici court for over fifty years. His fertile genius enriched court spectacles with highly imaginative costumes, scenery, stage machinery, and special effects. Buontalenti's Bethlehem was no less spectacular: when wound up, the heavens opened, angels flew down to earth, and countless figures processed to the stable.

In 1589, Sophia of Saxony commissioned watchmaker Hans Schlottheim of Augsburg to create a mechanical Bethlehem as a gift for her husband, the Protestant Elector Christian I. It was three-tiered and, when it had been wound up, a globe opened to reveal God the Father surrounded

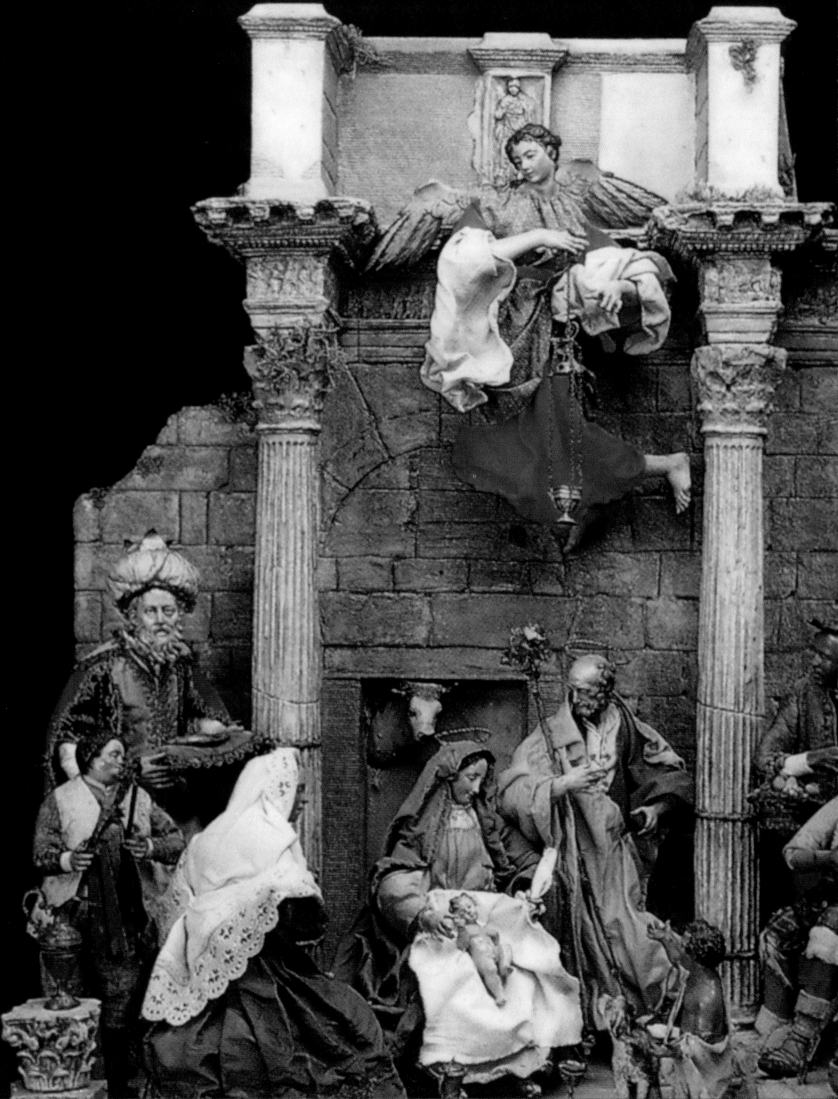

by angels, while part of the second tier slid back and the manger scene appeared. Angels then descended from heaven and Saint Joseph rocked the cradle of the Baby Jesus to a well-known carol tune. The ox and ass fell to their knees, while shepherds and kings passed by the manger!

It was in Naples, however, that the art of the crèche as we know it first flourished. In Naples the crèche acquired the name eventually used throughout Italy—*presepio* (from the Latin *praesepe*—stable).

Sometime after 1311, Sanchia, wife of Robert of Anjou, ordered an elaborate crèche for the Poor Clare nuns at the convent of Santa Chiara. Unfortunately, little remains of it, but from a description we know that an altar stood between an ox and an ass at the foot of the Nativity group. In 1438, Martino de Jadena carved eleven figures for the Church of Sant' Agostino Maggiore. In 1478, Giacomello Pepi bargained with the artists Pietro and Giovanni Alemanno for a Nativity for the Church of San Giovanni dei Carbonari. Pepi stipulated that the *presepio* must include the Christ Child, our Lady wearing a crown, Saint Joseph, an ox, an ass, three shepherds, twelve sheep, two dogs, four trees, eleven angels, two prophets and two sibyls (ancient Greek or Roman prophetesses or oracles). Since medieval times Old Testament prophets and even pagan oracles had appeared in the Nativity dramas to prophesy the birth of the Messiah.

In the 1500s, many other Neapolitan churches and religious houses added *presepi*. The arrangement of figures in the one made by Giovanni da Nola for San Giuseppe dei Falegnami recalls the levels of the stages used for the mystery plays. Annibale Caccavello made a crèche with fourteen figures for the Dominican Nuns of the Convent of La Sapienza (Wisdom). The Dominican friars commissioned Pietro Belverte di Bergamo to create twenty-eight figures for San Domenico Maggiore. These they placed in a grotto made from stones said to be from Bethlehem.

These Nativity figures, the work of an eighteenth-century Neapolitan artist, stand in front of miniature Roman ruins in the museum of the Italian Friends of the Crèche in Rome.

ometime after 1517, Saint Cajetan of Thiene (1480-1547), co-founder of the Theatine Order, is believed to have erected a *presepio* in the priests' common room every Christmas. Cajetan's practice apparently stemmed from a vision he had on Christmas Eve in 1517 in Santa Maria Maggiore in Rome, just a year after his first Mass there. Kneeling and praying before the reputed relics of the manger, he had a vision in which the Virgin Mary placed the Child Jesus in his arms. After that he always took special joy in the celebration of Christmas.

Saint Cajetan, who later worked among Naples' poor, also fostered the crèche devotion and often invited shepherds to play their bagpipes at the crib. In 1533, the Theatines set up a beautiful crèche in their Neapolitan church, appropriately named Santa Maria della Stalletta (Saint Mary of the Little Stable).

Annually from 1622 on, the Piarist Fathers (Fathers of the Pious Schools) built a *presepio* in their chapel. According to one record, the crèche was especially impressive because of its location near a window which capitalized on the monastery garden as a background.

The first known crèche in a private home also appeared in Naples. It belonged to Constanza Piccolomini di Aragona, Duchess of Amalfi, and was probably made before 1567. It included 167 figures that depicted the adoration of the Christ Child, shepherd scenes, and a large and exotic retinue for the magi.

The next two centuries saw the *presepio* become almost a mania for Neapolitans. The Neapolitan crèche grew into a unique and wondrous creation, a spectacle teeming with life and endowed with splendor by the major artists and craftsmen of the day. And Naples did not lack for fine artists and craftsmen. In the seventeenth and eighteenth centuries, the city was one of the cultural capitals of Europe, where opera, theater, architecture, and the figurative arts flourished.

A simple technical innovation in the course of the seventeenth century allowed greater realism and vitality in the *presepi*. The large wooden statues were replaced by smaller mannequins, whose bodies were made of hemp wrapped around wire armatures. This made it possible to bend the figures in a variety of poses and gestures. The mannequins were dressed in clothes made of real cloth. The heads, hands, and other exposed parts of the bodies were modeled in terra-cotta or carved in wood, then delicately and realistically painted. The Neapolitans referred to these movable figures as *pupazzi* (puppets), although the term *pastori* (shepherds), could also be applied to all the figures except the Holy Family. The Holy Family group was called *il mistero* (mystery), a term from medieval drama. With these *pupazzi* crowded into ever larger settings, the Neapolitan crèches became elaborate and extensive miniature scenes. The flexibility of the bodies and limbs allowed the scene to be arranged with the eye of a stage director. In fact, wealthy Neapolitans often hired theater artists to create their *presepi*.

he crèches became as common in private homes as they were in churches. And although the *presepio* never lost its religious significance, it also became a holiday delight. With the wealthy it became a status symbol, with homes competing with each other for the most spectacular Nativity scenes. Some families spent enormous sums on their Nativities. The richer the family, the richer the *presepio*. Fine silks were used for the clothing and female figures were adorned with real, miniature jewelry created especially for crèches. Some took up several rooms and consisted of imaginative settings, artistically carved figures, buildings, piazzas, monuments, streets, processions of kings and noble personages,

laborers of every occupation, scenes of daily peasant life, landscapes and waterfalls. Attention was given to the smallest detail, such as musical instruments and censers made to scale for the angels. A few wealthy families even hired musicians to play when their *presepi* were open to the public. In fact, composers like Domenico and Alessandro Scarlatti, Giovanni Battista Pergolesi, Niccolo Jommelli, Leonardo de Leo, and Giovanni Paisiello all wrote Christmas cantatas, motets and pastorals intended to be sung in front of the crèche.

The greatest sculptors of the day, such as Giuseppe Sammartino and Francesco Celebrano, supplemented their incomes by creating *pastori*. Some artists found creating *prespio* figures more lucrative than doing other art work, such as designing for the Capodimonte Royal Porcelain Factory. Many of the *figurari*, as they were called, became famous. In addition to Celebrano and Sammartino, Giuseppe Gori, Lorenzo Vaccaro, Matteo Bottigliero, Lorenzo Mosca and others gained renown and received orders for their *pastori* from all over Europe. Artists even specialized. Some painted realistic scenic backgrounds in perspective. Nicola and Saverio Vassallo were renowned for their animals. Francesco Gallo made the first elephants to appear in crèches, modeling his after the one in the royal zoo. Giuseppe De Luca created miniature baskets of fruits and vegetables. Fruit was the prized agricultural product of the kingdom of Naples and as such was often given as a gift. Of course, it should be given to the Holy Family! Other food stuffs included wine, macaroni, cheeses, fish, eggs and cured meats. Some crèches included tiny bowls of minestrone and pieces of torrone, the almond nougat candy. Specially made plates and bowls were ordered from Castelli, the famous ceramics producing town in Abruzzi. In the Abruzzese towns of Pescocostanzo and Scanno,

tiny copper pots and pans were made especially for crèches.

The greatest of all *presepio* artists was undoubtedly Giuseppe Sammartino (1720-1793). His achievement as a sculptor can be seen in his figure of the dead Christ in the Church of San Severo. The fact that a man of his fame and talent should devote so much time to creating crèche figures shows in what high esteem the art was held. Nesta de Robeck points out (*The Christmas Presepio in Italy*, pp. 28-29):

> Not one of his figures is stereotyped, each feature, each gesture is eloquent of a human personality and only when he wishes it does the characterization become caricature. Sammartino was an acute psychologist, intent to portray the people of Naples as he saw them, his "pupazzi" are alive with exuberant southern vitality. The great Presepio in the museum of San Martino is by Sammartino and his pupils, the scene is as crowded as a Neapolitan street, it is an Allegro con Brio from a settecento opera. At first sight it is difficult to seize the details, the extreme care in the arrangement of the different groups, to notice the realistic highlights, the genuine feeling under the rhetoric.

The Neapolitan crèche traditionally included several areas. One was the cave or stable with the Holy Family and a few shepherds. Shepherds and animals dotted the nearby hillside. Ruins of Greek or Roman temples were almost always included to indicate the demise of the pagan world. The magi were usually en route to the stable with a large retinue of camels, horses, elephants, soldiers, servants, monkeys and parrots. The kings were sometimes accompanied by a cavalcade of beautiful princesses, called "Giorgine," dressed like dazzling beings from some exotic fairy land. They were called "Giorgine" because they were said to be from Georgia, a country between Russia and Armenia, a location that Nea-

The Perrone crèche in the Museo di San Martino.

FOLLOWING PAGES IN ORDER:

The opulent eighteenth-century Ricciardi crèche in the Museo di San Martino in Naples. Note the ruins of a pagan temple in the center.

The Cuciniello crèche in the Museo di San Martino exemplifies the elaborate and extensive Nativities of eighteenth-century Naples.

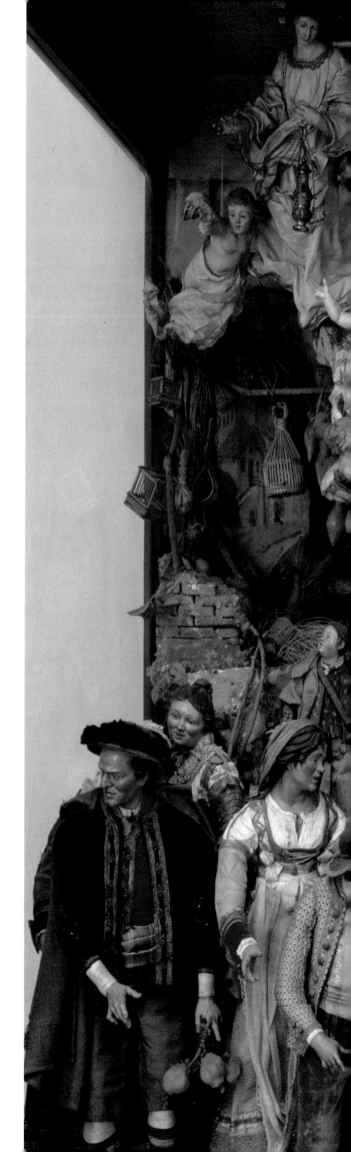

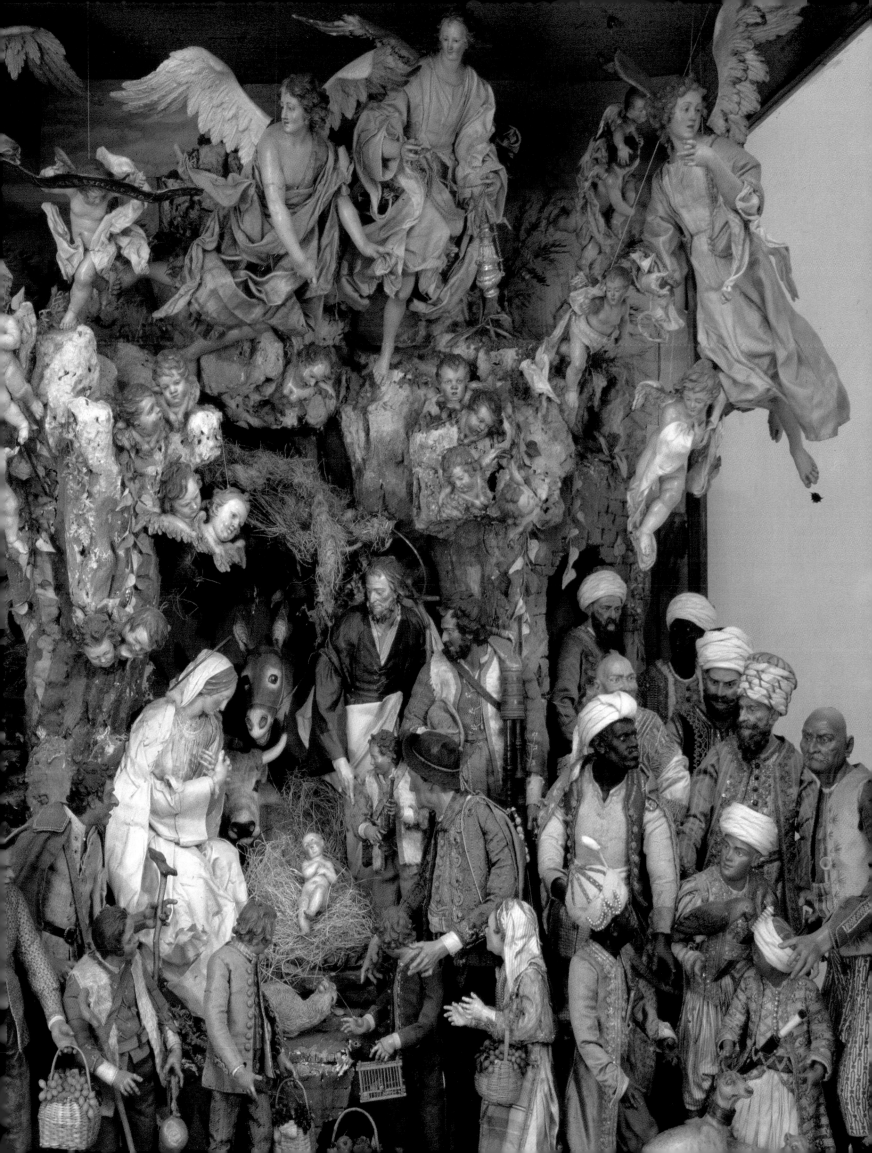

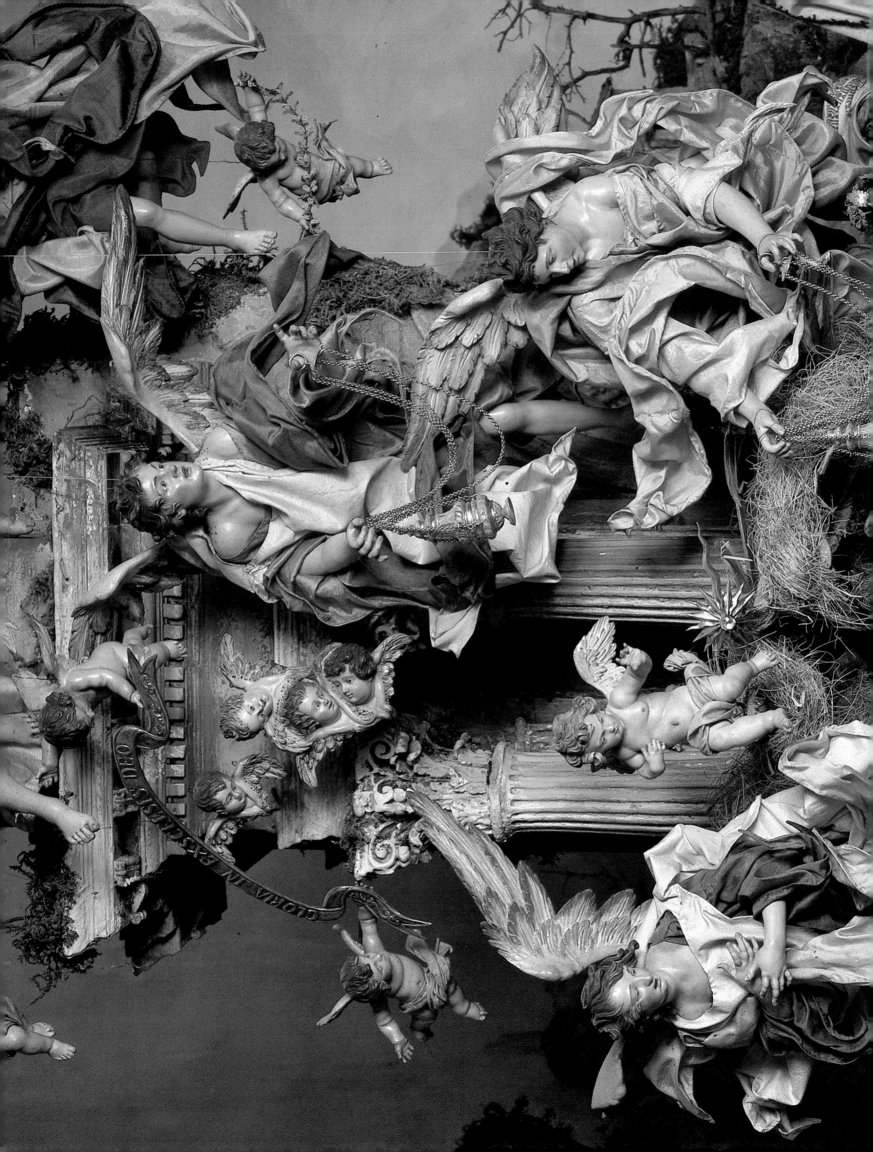

GLORIA IN EXCELSIS DEO

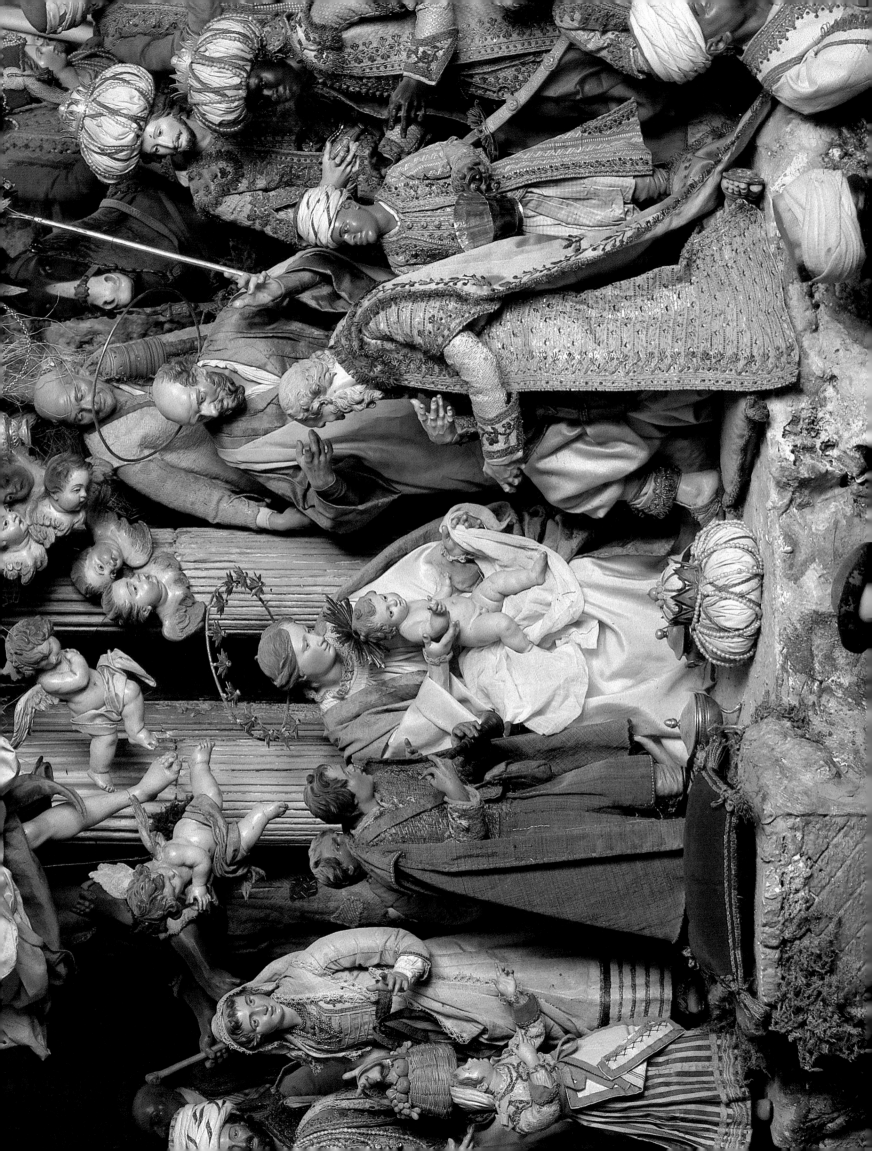

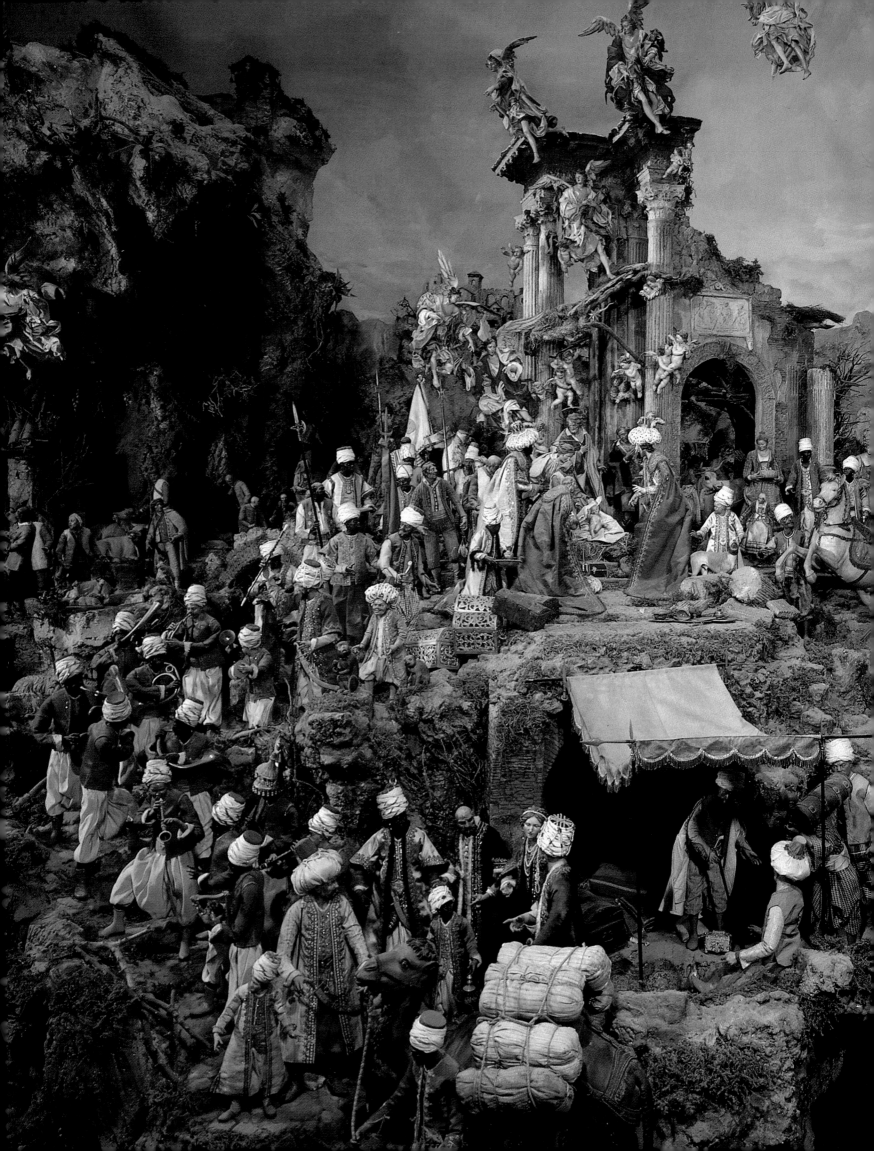

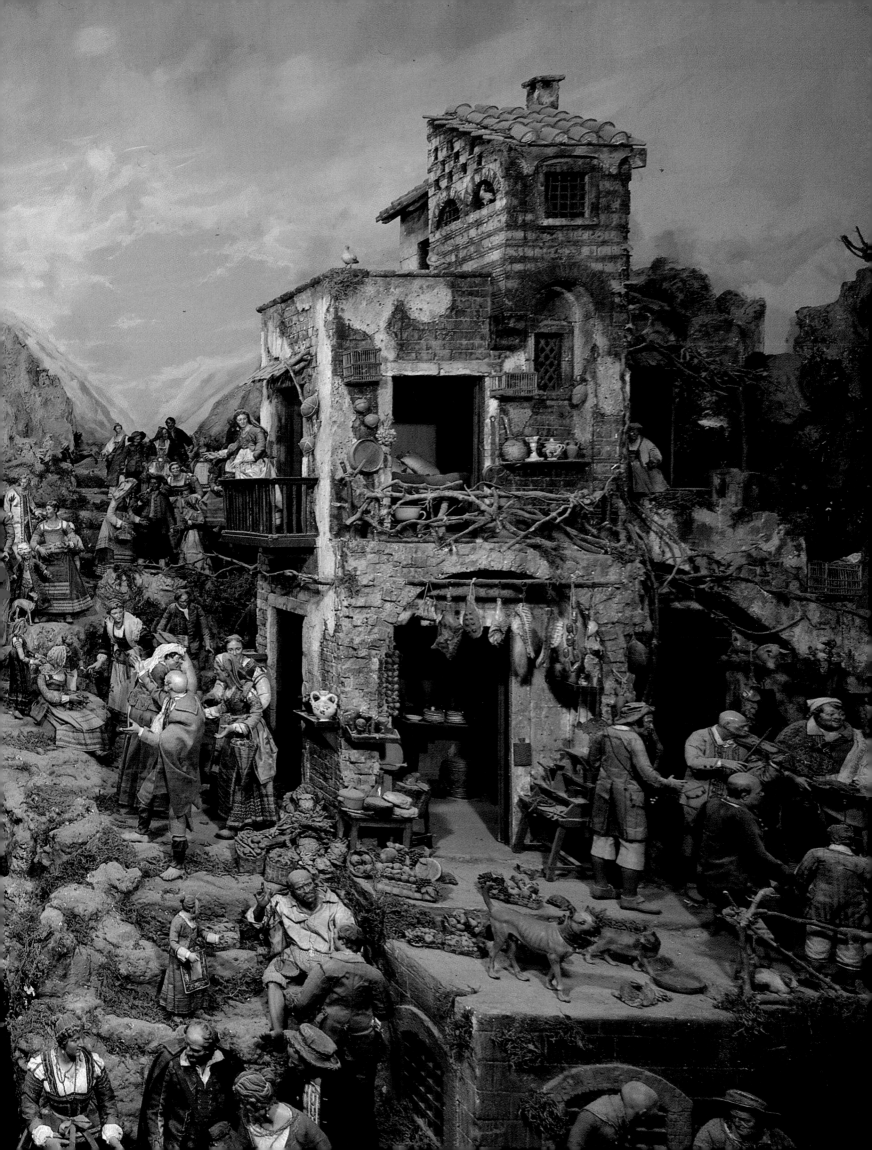

politans considered exotic. Nearby, in imitation of the one where Mary and Joseph had been refused lodging, was a typical Neapolitan inn, complete with vendors of every kind and peasants eating, drinking, dancing, and even gambling. People with various physical deformities also appeared in the crèches, an additional effort to include all aspects of Neapolitan society. Goiter, a swelling of the thyroid gland that causes enlargement of the neck, was a common ailment in Naples. Figures with goiter were frequently included in *presepi*.

Over 400 churches in Naples displayed crèches and vied with other parishes for the most outstanding Nativities. A popular activity during the Christmas season was visiting, admiring and criticizing crèches in churches and private homes. The crowds that came to visit the *presepio* of lawyer Rafaello Sorvello were so large that he had to hire guards to keep order.

During the reign of the Bourbon monarchs, the position of Stage Director of the Royal Christmas Crèche was granted to a distinguished artist of the city. The first Bourbon king of Naples, Carlo III, who ascended the throne in 1734, is reported to have had a collection of 5,950 figures for his *presepio*!

While tiny figures of shepherds were being placed in *presepi*, real shepherds from the mountains of Abruzzi appeared in the streets of Naples, and later Rome. The *zampognari* (pipers) played their flutes and bagpipes for donations. They also went around to the shrines of our Lady to serenade her and to "console her for all that she suffered on the road to Bethlehem." *Zampognari* from Abruzzi can still be seen in the streets of Rome and Naples at Christmas time.

In the eighteenth century, a Dominican friar, Padre Gregorio Rocco (1700-1782), preached devo-

tion to the *presepio* among the common people, who used inexpensive clay figures. As a novice he built a crèche in his cell; he kept a *presepio* in his room throughout his life and prayed before it daily. Padre Rocco, who worked among Naples' poor and even ministered to the city's criminal element, saw the crèche as a visual means for teaching important aspects of the faith to the people. He also saw the *presepio* as a family-strengthening activity that could involve all family members. It was Rocco's friendship with Celebrano that got the renowned court sculptor and painter involved in the making of Nativities.

Although the Neapolitan crèches seem extravagant by today's standards, they reveal more than just a concern for sumptuous display. The *presepi* were an effort to bring Neapolitans to Bethlehem and Bethlehem to Naples. All ages, races, occupations, levels of society, and even disabilities and diseases were represented at the manger. Everyone saw himself or herself at Bethlehem witnessing the birth of the Savior. What medieval painters had done in placing contemporaries at sacred events, Neapolitans did with the crèche. Neapolitans saw no incongruity that some *presepi* showed the Archbishop of Naples carrying the reliquary of the blood of San Gennaro, martyr patron of the city, through the streets during an eruption of Mount Vesuvius. Or that the "Hebrews" at the inn were dressed as seventeenth century Neapolitans and were eating *prosciutto*, Italian cured ham! They saw themselves at Bethlehem. And the singing, eating, drinking and dancing peasants at the *presepio's* inn certainly looked like people who had been redeemed!

Art historian Gennaro Borrelli, who has made a study of the *presepio*, speculates that the Neapolitan devotion to the crèche stems from the fact that in

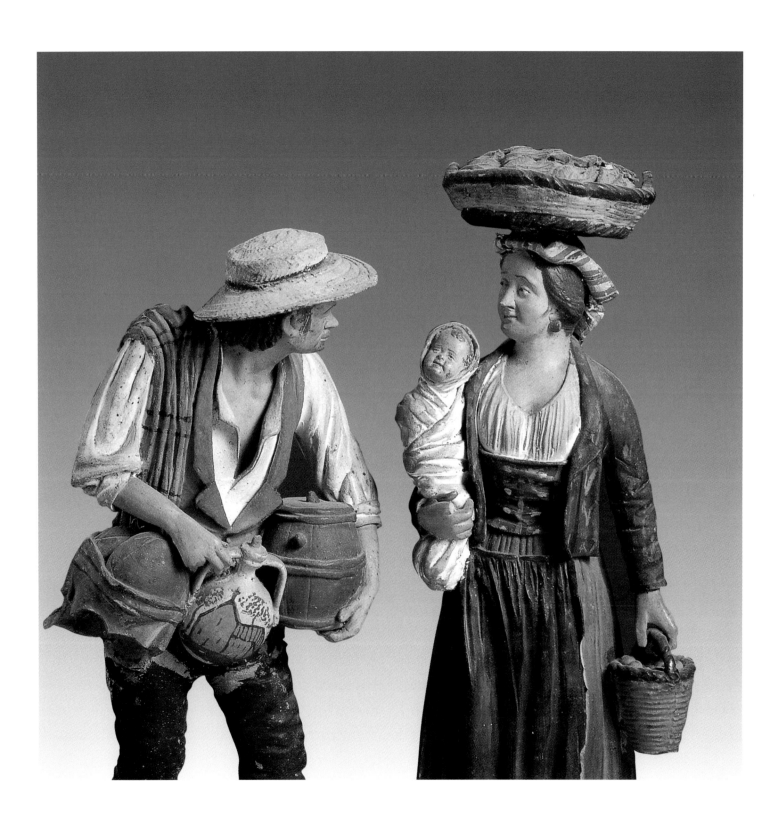

Crèche figures dressed as nineteenth-century Sicilian peasents by the workshop of Vaccaro-Buongiovanni.

Naples, probably more than anywhere else in the world, children are considered a gift from heaven. If the birth of every child is worth celebrating, then how much more the birth of the Savior of the world.

In Rome, Santa Maria Maggiore, with its replica of the manger and the Nativity groups by Arnolfo di Cambio and Francesco da Pietrasanta, continued to be the chief center of Christmas devotion. Rome lagged somewhat behind Naples in the popularity of the crèche, but caught up in the seventeenth century. The first extensive Neapolitan-style crèche in Rome is that of the Carmelite friars. They created one for the Church of San Martino dei Monti in 1648. However, crèches were already popular in Roman homes. Santa Maria in Aracoeli (home of Santo Bambino), San Francesco della Valle, Sant' Antonio, Santi Cosma e Damiano, and Santa Maria in Trastevere were only a few of the churches with outstanding presepi. A unique characteristic of the Roman crèche was the "glory," a scenic device borrowed from Renaissance theater. The glory, a mechanism of wood, ropes and pulleys, allowed angels and other celestial figures to descend from the heavens.

In some ways, the cribs of Sicily resembled those of Naples, since the influence of religious dramas was apparent there too. However, Sicilians never adopted the scene at the inn, but depicted others, such as the massacre of the Holy Innocents by Herod's soldiers, the flight into Egypt, and the carpenter shop at Nazareth. By the seventeenth century nearly every church and family had its presepio. Palermo even had a street called the Via dei Bambini (Street of the Infants), where shops selling Nativity figures were located. In 1609, the Jesuits at the Collegio Mamertino in Messina erected a crèche on a stage in the manner of a theatrical presentation. The Collegio Mamertino had been the site of the first production of a play by Jesuit students in 1551, and the college had a long theatrical tradition. (The Jesuits developed an outstanding tradition of drama in their schools.)

The bendable pupazzi were not as popular in Sicily. Instead, Sicilian figures were made of carved and painted wood or terra-cotta. They wore linen clothes that had been dipped in a special type of plaster called gesso, which could be modeled to the exact folds the artists wished. Caltagirone and Trapani became centers of crèche art. Crèche making was often a family pursuit, and names like Salvatore and Giacomo Buongiovanni; Giovanni, Francesco, and Rosario Matera; and Francesco, Giuseppe, Mario and Vincenzo Vaccaro have been handed down to us as with distinction.

Crèches became popular in Austria and the Catholic areas of Germany in the second half of the sixteenth century. Here they were known as Krippen (cribs). In 1577, a Bavarian princess, Maria, married and living in Graz, Austria, wrote to her brother, Duke Wilhelm V, in Munich to thank him for the Saint Joseph, three kings, four shepherds, one servant, eight angels and "old Simeon" that he had sent for her Krippen. Two years later she wrote to order a Jesus, a Virgin Mary, and the twelve Apostles. She stipulated that the figures must be jointed and able to stand, sit and kneel, "which should be quite easy if they are properly made of wire." It is apparent, then, that the German figures were similar to the bendable and cloth-covered pupazzi of Naples. In the winter of 1594, Maximilian, the eldest son of Wilhelm V, sent a beautiful Christmas manger to his three younger brothers who were studying at the University of Ingolstadt. He also sent along a carpenter to insure that the crèche was properly erected!

In the seventeenth century no one understood the value of the crèche devotion better than the

Jesuits. Wherever they went in Europe, their churches had cribs which were sometimes extended to include scenes from the life of Christ for the whole Church year, similar to the *sacri monti* of Italy.

The crèche fit in perfectly with Jesuit spirituality, which is based on the *Spiritual Exercises*, a systematic series of meditations composed by Saint Ignatius Loyola and considered one of the greatest classics of Christian spirituality. One of the important techniques of the Exercises is to mentally visualize the subject on which one will meditate. In the application of the senses, the person making the exercises is encouraged to mentally see, hear, taste, smell and touch the situation or event being meditated upon. An excerpt from the contemplation on the Nativity illustrates the approach (in Fleming, pp. 74-76):

First Prelude. The first Prelude is the narrative and it will be here to see how Our Lady went forth from Nazareth, about nine months with child, as can be piously meditated, seated on an ass, and accompanied by Joseph and a maid, taking an ox, to go to Bethlehem to pay the tribute which Caesar imposed on all those lands.

Second Prelude. The second, a composition, seeing the place. It will be here to see with the sight of the imagination the road from Nazareth to Bethlehem; considering the length and the breadth, and whether such road is level or through valleys or over hills; likewise looking at the place or cave of the Nativity, how large, how small, how low, how high, and how it was prepared.

First Point. The first point is to see the persons; that is, to see Our Lady and Joseph and the maid, and, after His Birth, the Child Jesus, I making myself a poor creature and a wretch of an unworthy slave, looking at them and serving them in their needs, with all possible respect and reverence, as if I found myself present; and then to reflect on myself in order to draw some profit.

Second Point. The second, to look, mark and contemplate what they are saying, and, reflecting on myself, to draw some profit.

Third Point. The third, to look and consider what they are doing, as going on a journey and laboring, that the Lord may be born in the greatest poverty; and as a termination of so many labors—of hunger, of thirst, of heat and of cold, of injuries and affronts—that He may die on the Cross; and all this for me: then reflecting, to draw some spiritual profit.

The crèche could be a valuable aid in meditating on the holy Nativity.

The first definition of the crèche is found in a book published in 1619 by a Jesuit, Philippe de Berlaymont. His brief discussion is perceptive in recognizing that the purpose of the crèche is to bring to life the events of the Nativity so that all who view the scene may personally share the wonder of those who originally beheld it. He wrote:

> It is common knowledge that the Jesuits are observing the pious custom of their predecessors in the Order, by arranging Christmas crèches to represent the stable in Bethlehem. The manger with the Infant is standing between the Virgin and Joseph in a structure with a roof of straw to which the star is affixed. Shepherds and angels are in attendance, the whole being so cleverly arranged that the devotion of the beholders is vigorously stimulated. They feel themselves to be participating in this so miraculous event, hearing with their own ears the crying of the Child and the heavenly music, touching with their own hands the swaddling clothes, and experiencing a pious awe (Berliner, *Gazette*, p. 250).

The Jesuits erected a crèche in their church in Prague in 1562. It was said to be a realistic representation of the Nativity and was constructed especially

for the Christmas season. In 1582, a crèche stood in the center of Holy Savior, the new Jesuit church in Prague, and was probably of the realistic style. The Jesuits set up a realistic crèche with a cave containing statues of all the persons associated with the Nativity in their church in Altoetting, Bavaria, in 1601. Saint Michael's, the Jesuit church in Munich, followed suit in 1607, with figures dressed in cloth. In both cases the Bavarian Nativities included several different scenes associated with the Christmas-Epiphany story. The Jesuits erected a manger scene in Innsbruck, Austria, in 1608. The Franciscans in Innsbruck, not to be outdone by the Jesuits, hurriedly ordered one for their church the same year. The Jesuits at Monreale, near Palermo, evidently followed the example of the Messina Jesuits and erected a similar theatrical crèche in 1611.

In 1611, the College in Fribourg, Switzerland, erected its first crèche, replacing a simpler manger that contained only the Christ Child and had been the site of a student recital of a dialogue of the shepherds. In Salzburg, Austria, at Christmas 1616, the first crèches with changing scenes (Annunciation, Visitation, Nativity, Adoration of the Magi, Flight into Egypt, etc.) were exhibited; these stood in the churches of the Franciscans, Capuchins and Augustinians.

Financial records of the period show crèche entries: clothes for different figures and wages paid to seamstresses, carvers and painters. Munich became the center of crib art. Like the Neapolitan and Sicilian artists, some German and Austrian crèche makers became famous. Blasius and Johann Giener, Hans Kager, Johann Pendl, Johann George Kieninger, several members of the artistic Schwanthaler family, and an artist known only by the single name of Niklas were renowned for their Nativity figures. Roman Boos gained fame for specializing in animals.

This nineteenth-century crèche by the workshop of Vaccaro-Buongiovanni is typical of Sicilian Nativities made from painted terra-cotta and hardened fabric.

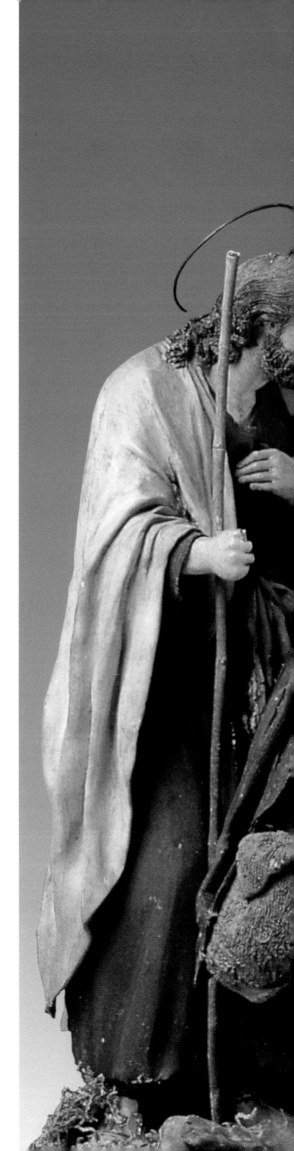

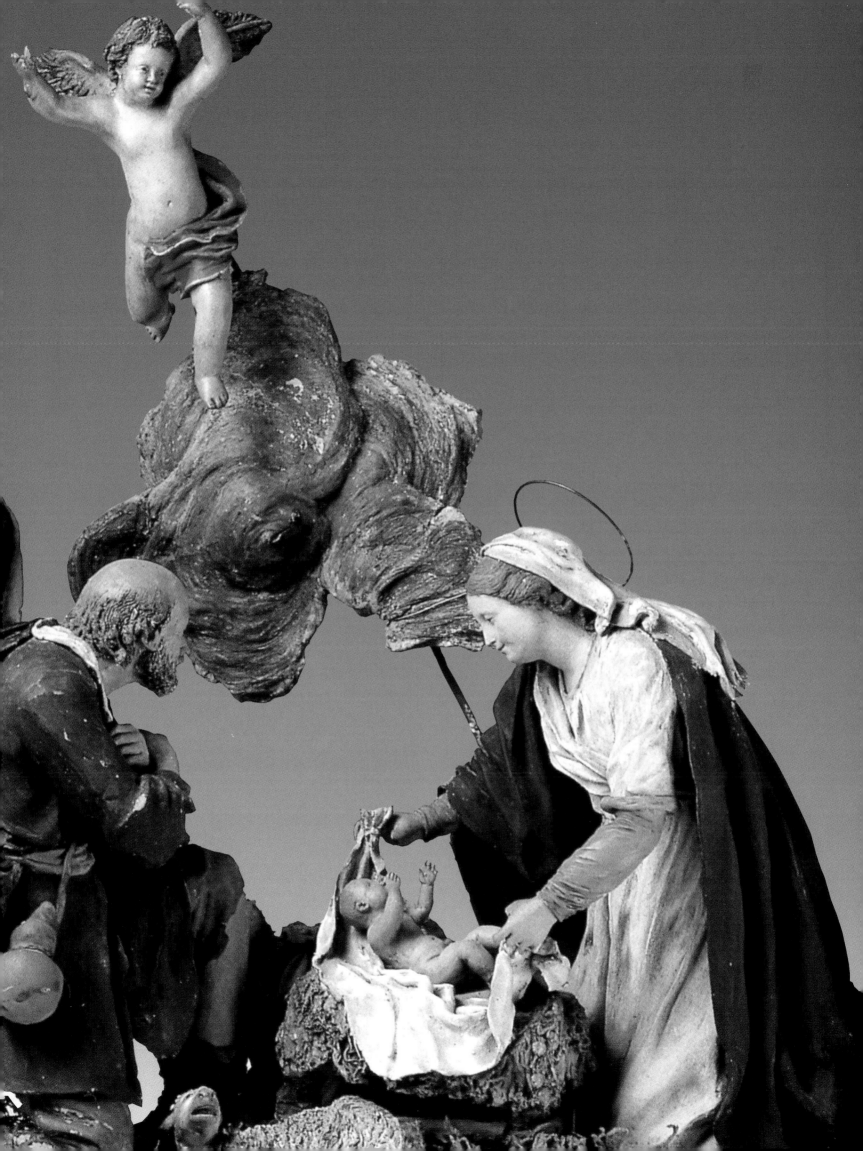

The Germans also made Nativity altars with doors to shut like cupboards; when opened they revealed the Nativity scene. In Germany and Austria, longer than anywhere else, the Christmas marionette show, the *Krippenspiel*, drew crowds at fairs. The audience was probably unaware that they were witnessing a vestige of the medieval mystery plays.

Wood-carved figures became popular in Germany when farmers and herders, especially in Bavaria, began to spend the leisure of their winter evenings carving figures, first for the family manger and later for the city markets. In the late eighteenth century, starting in Augsburg, printers began producing paper cutouts with manger figures on them. With the invention of lithography, such cutouts flourished. They were prepared on heavy paper or cardboard in both color and black and white (to be hand colored). Since they were inexpensive, they were sold by the thousands in markets and shops. Peddlers even went from door to door during the Advent season, sometimes with over a hundred different figures to choose from. Graphic artists like Joseph von Fuhrich and others created designs of high quality. Von Fuhrich influenced German crèche art by emphasizing Middle Eastern and Asian locales and characters in his paper crèches.

In his book, *The Festive Year*, written in 1863, Baron von Reinsberg-Duringsfeld gives us a vivid description of the German *Krippen*:

> In a dark grotto the Child is resting, the Mother of God is kneeling by his side while Joseph is standing at the entrance, and the shepherds, mostly in traditional Tyrolian garb, kneel in front of the cave or on the meadow of moss, on which little lambs graze and angels with golden wings talk with the shepherds. One shepherd is usually portrayed rubbing the sleep out of his eyes with his hand, and in the foreground there is a well from which a cow is drinking. On the mountains which rise above the cave, there are houses and castles, herds are grazing tended by shepherds, and hunters are roaming with rifles to shoot hares and chamois. Some people are pulling wagons down the mountain, a butcher leads along a calf, a farmer's wife brings eggs and butter, while a forester climbs down with a rabbit to bring as a present to the Child. In front of a farmer's house wood is being cut, nearby the entrance of a cave there is a chapel, before which a holy man is kneeling, while another hermit is coming down a steep path; miners are working and pull heavily laden carts from the mine, a bear steps out of a cave, a ragged beggar holds his empty hat toward the viewer (in Gockerell, p. 17).

The natives of the Provence region of southeastern France have had a special affinity for Saint Francis of Assisi. Francis' mother, Pica Bernardone, was a native of Tarascon in Provence. She named her son Francesco, not then a common Italian name, because of her love for things French. From the Middle Ages the people of Provence staged Nativity plays and on Christmas Eve had the custom of marching in procession to offer the gift of a live lamb to the priest who would present it to the statue of the Baby Jesus. The priest traditionally pinched the lamb's tail so that its bleat would be heard by the divine Infant.

Large wood and stone statues representing the Nativity group appeared in French churches soon after they did in Italy. However, the custom of erecting crèches in the home did not become popular in France until the early 1700s. Then Italian peddlers appeared in the streets of Marseille in Provence, selling small painted terra-cotta Nativity figures which they called *santi belli* (beautiful saints). The natives of Provence immediately fell in love with the figures and started making their own small clay

figures which they called *santons* (little saints). Those who made *santons* were called *santonniers*. Unlike women in Italy and Germany, those in Provence had an equal opportunity with men to make *santons*. Louise Pagano, Marguerite Gastine, Rose Pagano, Madame Aicardi, Madame Puccinelli and Madame Sicard became prominent *santonniers*. *Santons* are brightly painted figures, usually two and a half to four inches high, though some are less than an inch high and others as tall as ten inches. The larger *santons* are sometimes dressed in clothes of real cloth, but the painted figures are more popular.

Like the Italians, the Provencals wanted everyone represented at the stable of Bethlehem; more than 150 different figures were made by various *santonniers*. In addition to shepherds and magi, a crèche might include the parish priest, the gendarme, gypsies, the garlic vendor, a blind man, and Vincent and Mirieo, the young lovers. Often included are Saint Anne, Saint Martha (patron of the household), Napoleon and the Pope. Even the local highway robber and village gossip are sometimes present! Additionally included are figures based on local legend. For example, there is often a goose because, according to legend, when the animals came to adore the newborn Jesus the goose had a cold and woke the sleeping Infant with his hoarse honking. Since then he has had the dubious honor of serving as Christmas dinner!

On Christmas Eve it is the custom in Provence for children to gather around the crèche and recite a prayer that should include all the figures in the family's Nativity. A typical prayer would begin:

> Little Jesus of the crib:
> Make us philosophical as the fishermen,
> Carefree as the drummer,
> Merry as the troubadour exploring the world,
> Eager for work as the bugler,

patient as the spinner,
Kind as the ass,
strong as the ox that keeps you warm...
(Foley, p. 36).

The larger the number of figures in the family's crèche, the longer it takes to say the prayer because in the appeal to the Christ Child each character has to be represented.

On the island of Corsica in 1779, even little Napoleon Bonaparte played with a crèche. It is said that he removed the magi's crowns and placed them on his brothers' heads. He adorned himself with the star!

Spain developed *pesebres* (crèches) of many varieties. There were cribs of gold, ivory, carved and painted wood and clay, in all sizes. The playwright

The szopkas of Krakow, Poland, had their origins in elaborate settings for Nativity puppet shows.

Lope de Vega had one containing wax figures. As in other countries, some crib artists became famous. Pedro Roldan made a crèche of which some figures still exist. Jose Gines made one with several scenes for King Carlos IV. Some of the figures were life size. Nicola Salzillo and his son, Francesco, came from Italy and became famous both for their cribs and for their large groups of figures representing the passion and crucifixion of Jesus. The Spanish carried the crib custom to the Americas and to Asia, particularly to the Philippines.

The Dominican nuns in Lisbon built the first crèches in Portugal in the early seventeenth century, reportedly because one of the nuns had a vision directing her to do so. The Portuguese crib descended from the same traditions as those of Spain, though the Portuguese restricted their crèches (called *Belems*—Bethlehems) to scenes of the Nativity and the adoration of the magi. They also included in the manger aspects of local life—a farmer slaughtering a pig, for instance. The rooster was always included in the *Belem*, both because he was a symbol of good luck and also because it was the rooster who awakened people by announcing the birth of Christ and early Mass. In fact, Midnight Mass is still called *Missa do Galo* (Mass of the Rooster). Another distinctive characteristic of the Portuguese crib was the figure of God the Father as an elderly bearded king, sometimes placed above the Nativity scene. Crib artists followed a long-standing Portuguese folk art tradition and fashioned their figures in brightly painted terra-cotta. These figures sometimes appeared alongside human actors or puppets in *auto populares* (popular religious plays). The two great centers of crib art were Lisbon and Mafra; the outstanding artists of the form were Antonio Ferreira and Machado da Castro. Ferreira and his assistants made 500 figures for the Basilica of Coraçao de Jesus.

The Portuguese developed the custom of growing wheat sprouts in a small dish in the house during Advent. These wheat sprouts, called *trigo*, are picked on Christmas Eve and placed in the manger as a bed for the Infant Jesus. Sometimes corn is also grown; the custom represents the growing of feed for the animals to repay them for giving up their manger. This custom can also can be traced to similar eucharistic symbols associated with the Nativity in the Middle Ages.

The crèche custom eventually made its way to Eastern Europe. The Czechs developed a more rustic crèche of the countryside and a more sophisticated crèche of the city. The towns of Iglau, Zwittau and

Vivid colors and minute details characterize the elaborate szopkas of Krakow, Poland.

Schlucknau became centers of the art and some craftsmen were given to inserting replicas of famous buildings into the backgrounds of their crèches. Like the Germans, Austrians and Poles, Czechs were fans of the *Krippenspiel* (Nativity show), a descendant of the medieval mystery stage and puppet theater. The typical *Krippenspiel* had three stages, one above the other. On the lowest was the stationary Nativity scene. On the second the activities of the guilds and trades were shown. And on the top was the *Krippenstadt* (Nativity stage) on which a Christmas puppet play, containing scenes of rowdy fun, was enacted.

In Poland, the *szopka*, a similar three-tiered crèche for both plays and stationary scenes, developed from small wooden cribs called *Betlejki* (Bethlehems). Traditionally the *szopka* played an important role in Polish Christmas customs. Beginning on Christmas Day, groups of boys and young men would carry the *szopka* from house to house singing Christmas carols. Often the *szopka* stood taller than the boys and served as a backdrop or stage for *jaselkas*, Nativity plays performed either by the young actors or by puppets. As in other places, over the course of time the *jaselkas* developed into elaborate productions embellished with comic relief and contemporary characters, both real and fictional. In 1736, Bishop Teodor Czartoryski forbade the presentation of Nativity plays with either actors or puppets inside churches, permitting only immobile scenes of the biblical Christmas story. *Jaselkas*, though, continued to thrive outside the churches.

In the late eighteenth and early nineteenth centuries artisans in two Polish cities began to create *szopkas* based on architectural elements of actual buildings. In the area around Warsaw *szopkas* were composed of elements from historic architecture, but frequently with no exact counterpart in existing buildings. In Krakow, on the other hand, *szopka*-makers found their inspiration in actual structures existing in the city—the churches with their steeples and onion domes, Wawel Castle, Florian Gate, the mansions of the nobility and other buildings. To this day the people of Krakow can easily recognize the building which inspired a particular *szopka*. Artisans covered every inch of these *szopkas* with thin colored foil or paper and, using candles on the inside to light them up, simulated stained-glass windows. In the second half of the nineteenth century a guild composed predominately of bricklayers dominated *szopka* building. The seasonal character of their work inclined them to make *szopkas* as a way to earn additional money during the winter months. The *szopka* tradition went into decline during the

Krakow's szopka artists place the figures of the Nativity along with local characters in a setting based on an actual building in the city. The Holy Family stands between two Krakovian characters on the second level of this szopka.

First World War when Austrian occupation forces prohibited house-to-house caroling with the *szopka*. An annual *szopka*-building competition, initiated in 1937 and held in Krakow's main square, rejuvenated the art form.

The *szopka*, which can stand as tall as six feet, is usually composed of three levels, the upper two levels containing stationary figures of the biblical story. In the past the lower level might have a space for a puppet show. Today the lower level might contain characters from Polish history, folk tales, or contemporary life. Sometimes the figures on the lower level are mannequins dressed in clothes of real fabric, reminiscent of the puppets of the past.

The Jesuits took the crèche devotion with them on their missionary journeys to the Far East and America. In their college at Cochim, Indochina, between 1589 and 1592, an entire chapel was transformed into a representation of the Nativity. There are records that Jesuit churches and schools featured crèches in Arima, Japan, in 1595, in Goa, India, in 1596, and in Lahore, India, in 1599. In 1642, a Jesuit missionary in Canada wrote back to France that Christmas crèches were a great success with the Native Americans. The French Jesuit Saint Jean de Brebeuf (1593-1649) wrote the first Christmas carol in a native American language (Huron), *Jesous Ahatonnia* (Jesus is born), to be sung in front of a manger scene.

The Spanish made their first expedition into what is now the southwestern United States in 1540. With them they brought the Catholic faith and devotions, including the crèche, which came to be called *Nacimiento*. While the missionary friars adapted the architecture of the Indians for the new churches, they retained their European-style crèches. It was not until the mid 1700s that Native Americans began creating religious art and placing their own unique stamp on Christian images. These *santeros* (literally "makers of saints") carved religious images in wood or painted them on wood panels or animal hides. These figures are the *santos* (saints) of Latin America, which include the various figures of the Nativity scene. The creation of *santos* by native artists flourished in the southwestern United States until the coming of the railroads in the 1880s. Then religious articles could be imported easily from church goods stores in the eastern United States. These factory-made religious articles became more popular than the local *santos* and the art of *santos* making was not revived until the 1950s.

It was a small Protestant sect that introduced the Christmas crib to English-speaking America. Among the German Protestant groups that kept the custom of the Christmas crèche even after the Reformation were the United Brethren or Herrenhuter (Lord's Watchers), more commonly called the Moravians. A small group of Moravians came to America and founded the town of Bethlehem, Pennsylvania, on Christmas Eve, 1741. The people of Bethlehem, and later those of other Moravian settlements in Pennsylvania, brought the crib custom with them. They called it *putz* (from the German *putzen*—decorate). The *putz* included not only the Nativity scene, but all the details of German village life: dozens, sometimes hundreds of figures, fanciful landscapes, waterfalls, houses, fences, bridges, fountains, villages and gardens. Emmanuel Venter, a tinsmith noted for having the best *putz* in Nazareth, Pennsylvania, in the 1880s, had barrels of water stored on the second floor of his house for the purpose of producing waterfalls, brooks and lakes. Since his barrels had to be filled by hand, the water "ran" only when guests were admiring his *putz*. The Moravian crèche sometimes included dozens of animals, marching two by two, onto Noah's ark.

In November, Moravian families still customarily go into the woods to dig up large clumps of moss. They then transplant the moss in the cool, damp ground of cellars and a few days before Christmas they carefully dig it up again. With occasional sprinkling, the moss becomes the living green ground of the *putz*. An Advent star hung on the porch of a house is a sign that the family welcomes visitors to view its *putz*.

During the second half of the nineteenth century large numbers of Italian, Polish, Czech and Portuguese Catholics and German Catholics and Lutherans immigrated to the United States and brought with them their crèche customs. The German immigrants in Pennsylvania, for example, are credited with the custom of placing the crèche under the Christmas tree. Often their American neighbors borrowed their customs. By the 1890s American stores were selling plaster and lead Nativity figures as well as all the materials needed for crèche making—moss, artificial grass, cotton batting and mica crystals for snow. The Da Prato Company of Charlestown, Massachusetts, founded by Italian immigrants, was one of the first American companies to see the market and to begin manufacturing Nativity figures. In 1908, *Scientific American* published an article with plans for building a Pennsylvania German-style Nativity scene. The twentieth century has seen the Christmas crèche become a well established custom with large numbers of American Christians.

Missionaries in the nineteenth and twentieth centuries took the crèche with them to Africa and Asia. Native peoples universally fell in love with the manger and were soon creating their own versions of the stable at Bethlehem. No longer were the Infant Jesus, Mary, Joseph, the shepherds and the magi Italian or German or Portuguese, but also Filipino, Chinese, Ibo and Kikuyu.

THE CHRISTMAS CRÈCHE TODAY

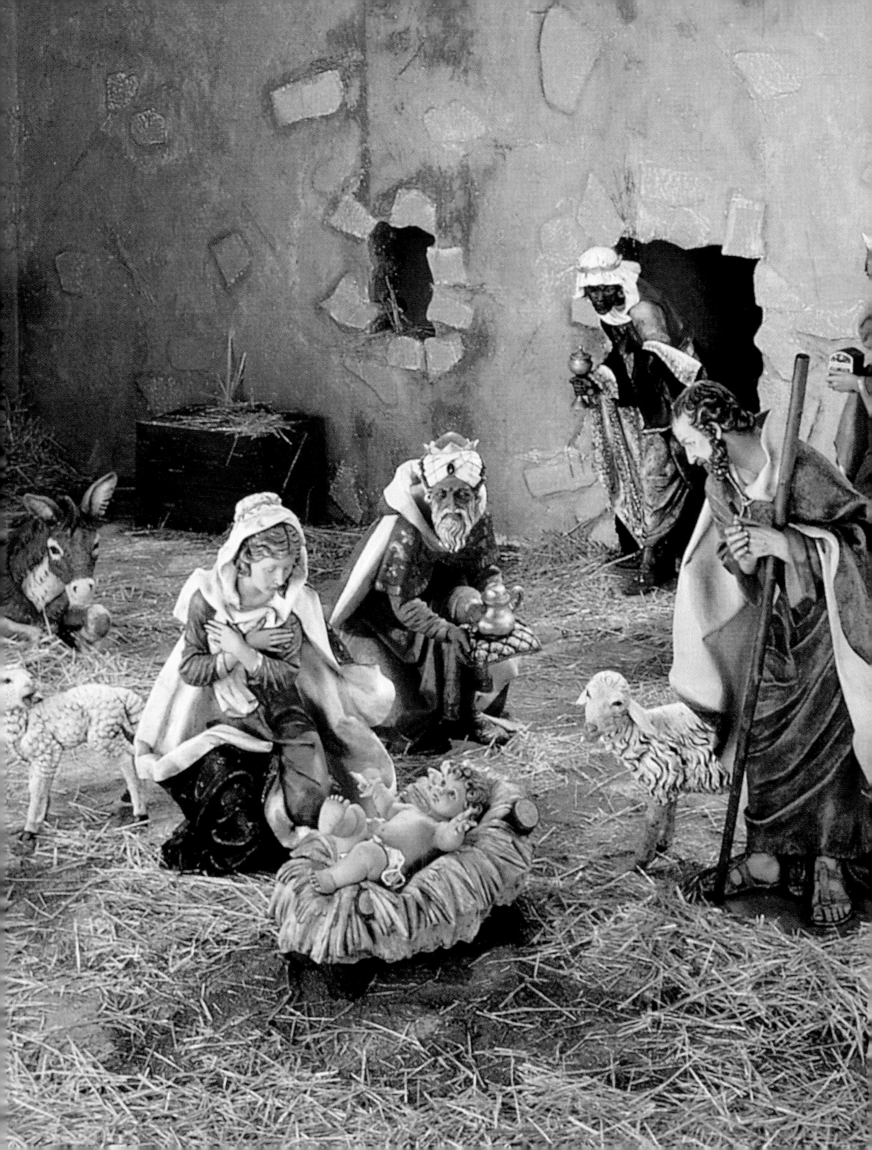

The custom of erecting crèches at Christmas has become almost universal in Latin Rite Catholic churches and is a common practice in Catholic homes. In predominately Catholic countries, like Italy, crèches even appear in such public places as train stations. Many Lutherans and Moravians continue the custom in their churches and homes. Other Christian churches have also adopted the Christmas crib. Since the Oxford Movement, the revival of Catholic practices in the Church of England in the early 1800s, crèches have reappeared in many Anglican churches. The manger is now a frequent sight at Christmas in Episcopal churches in the United States, especially those in the Anglo-Catholic tradition. Many communities of the United Church of Christ, a merger of the Congregational Church and the Evangelical and Reformed Church, have also rediscovered the Christmas crib. Some churches display crèches of stationary figures, but "living crèches" with human

This crèche from the House of Fontanini stands in the Pope's private apartment.

actors and even live animals have become popular on Christmas Eve in UCC churches. The Puritan ancestors of the Congregationalists would certainly have disapproved, but the German immigrants who founded the Evangelical and Reformed Church would recognize a familiar tradition.

The Eastern Orthodox and Eastern Rite Catholic Christians have not adopted the crèche devotion, primarily because Eastern Christians avoid the use of three-dimensional images. In Eastern Christian spirituality the two-dimensional icon, rich in symbolism, is venerated because it represents transformed humanity. According to Eastern Christian thought, the three dimensional figure actually limits a concept to present reality. Instead of the crèche, on the Vigil of Christmas, an icon of the Nativity is ceremoniously brought out and displayed in the church until January 1, the Feast of the Circumcision. A similar custom takes place in Eastern Christian homes.

ABOVE RIGHT:

Master Sculptor Elio Simonetti works on a model of a new Nativity figure for home crèches at the House of Fontanini in Bagni di Lucca in the Tuscany region of Italy. A member of the founding Fontanini family looks on.

Signor Simonetti places the final touches on a large statue of Saint Joseph that will be placed in a crèche for a church or chapel.

The crèche devotion became so wide spread among Western Christians, however, that in 1952 enthusiasts in Barcelona, Spain, founded the *Universalis Foederatio Praesepistica* (General Crèche Federation). Shortly thereafter in November, 1953, Professor Angelo Stefanucci founded the *Associazione Italiana Amici del Presepio* (Italian Association of the Friends of the Crèche) in Rome. That organization, headquartered at the Church of Saints Quirico and Giulitta, has many local chapters and publishes a quarterly magazine, *Il Presepio*. The General Crèche Federation, canonically erected in 1967 under the patronage of Saint Francis of Assisi, is now also headquartered at Saints Quirico and Giulitta and serves as an umbrella organization for national crib societies. It maintains photographic and historical archives and a museum. The Federation also sponsors an international convention every four years. There are active chapters in Italy, Spain, Germany, Austria, Switzerland, Liechtenstein, the Netherlands, the Czech Republic, Malta, Venezuela,

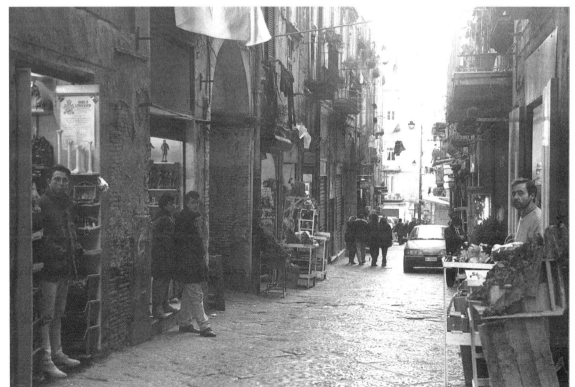

ABOVE LEFT:

Two residents of the closely-knit community of the Via San Gregorio Armeno in Naples.

A vendor stands in front of his small presepio shop in the Via San Gregorio Armeno.

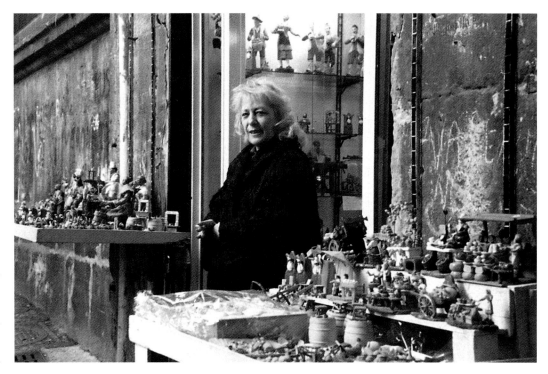

A vendor stands outside her tiny shop selling crèche figures and accessories in the Via San Gregorio Armeno in Naples.

Two zampognari, dressed as shepherds from the Abruzzi, play their bagpipes for donations during the Christmas season in Rome. Zampognari traditionally play in front of crèches and shrines of our Lady.

and Argentina. (The Argentine group has the charming name of the *Hermandad del Santo Pesebre*—Brotherhood of the Holy Crèche.)

In Britain in 1984, Countess Maria Hubert von Staufer founded a multi-denominational group, the English-speaking Union of Nativitists. Under Countess von Staufer's leadership, the Union was incorporated into the *Universalis Foederatio Praesepistica* in 1988. However, circumstances forced the group to disband in 1992.

Father Aloysius Horn, a priest of the Toledo, Ohio, diocese, was for many years the director of the American Christmas Crib Society and did much to promote the crèche in the U.S. Unfortunately, after Father Horn's death in 1971, the American chapter became inactive. Interest in the manger in the U.S. has by no means waned, however. Roman, Inc., of Roselle, Illinois, the American distributor of the Fontanini Nativity figures made in Lucca, Italy, sponsors a Fontanini collectors' club which has over 5,000 members.

The making of Nativity figures and stables has become an almost world-wide phenomenon. Wherever one finds Christians, one is likely to find locally-made crèches. Artists use every possible medium: stone, plaster, wood, lead, porcelain, plastic, tin, glass and state-of-the-art polymer resin. There are Nativity figures made from papier-maché, stiffened fabric, straw, wax, corn husks, cardboard and hardened and painted bread dough. Tiffany's, the famous jewelry center of New York, has created gold and silver crèche figures studded with jewels!

Italy remains the largest manufacturer of Nativity figures, as well as the largest exporter of figures to the U.S. and Canada.

A small street in Naples is probably the manger capital of the world. The Via San Gregorio Armeno is a narrow street of small family-run shops that make and sell Nativities. A few shops still create the movable figures dressed in fabric clothes with porcelain or wooden heads, hands and feet, reminiscent of the golden age of the Neapolitan *presepio*. Most sell the less expensive terra-cotta figures. It is the custom for Neapolitans to add a figure or two to the family crèche every Christmas, and often the Bethlehem scene may take up a whole room. Young couples usually receive Holy Family figures as a wedding gift to start them on their way. Consequently the shops in the Via San Gregorio Armeno do a brisk business from mid-November until Christmas. Shops stay

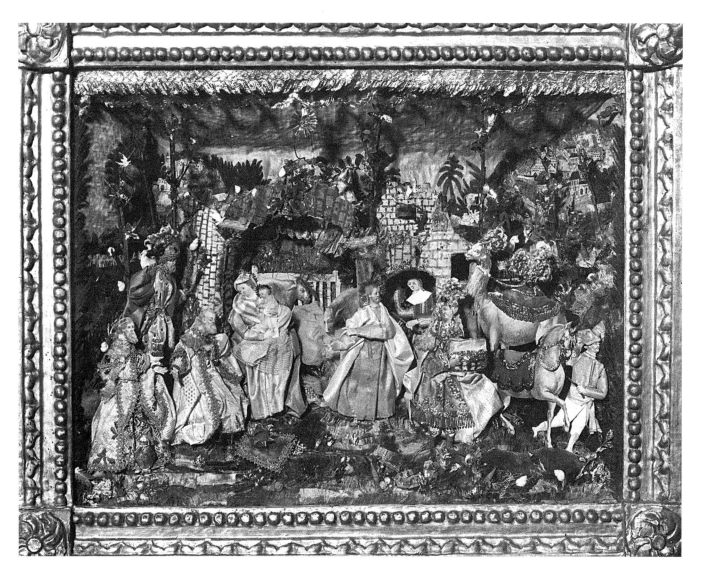

An unknown Bavarian or Austrian folk artist created this crib scene in a box out of paper, foil, fabric, tin and glass.

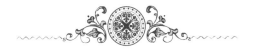

A gold-leaf crèche created by the House of Fontanini, the largest exporter of Italian Nativity figures to the United States.

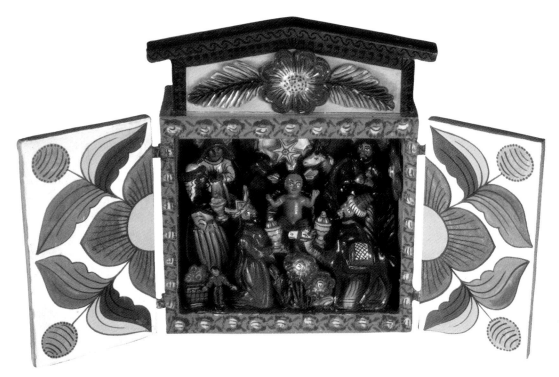

Inca artists used potato paste to form the Nativity figures inside this wooden retablo from Peru.

open late into the evening and the vendors eat their meals standing at their stalls. The rest of the year the shop keeper-artists are busy getting ready for the next Christmas. However, every third weekend of the month as many as twenty vendors set up stalls in the park of the Villa Communale to sell figures to tourists and to Neapolitans unable to wait until Christmas to improve their *presepi*. There is never an end, since the artists are always creating new figures.

After Italy, Latin America has become a large exporter of Nativities. This is especially true of Mexico, Peru, and El Salvador. Bavaria, particularly the village of Oberammergau, site of the famous passion play, is a source of wood-carved figures. Spain, Germany, Poland, Ireland, Portugal and Slovakia also export Nativity figures to the U.S. and Canada, though, of course, not in nearly as large quantities as Italy. The Philippines and Sri Lanka are two Asian countries that create unique crèches. Crèches from such African countries as Nigeria, Kenya, Tanzania, Malawi, and Burkina Faso can now be found in museum shops and ethnic gift shops in the U.S. and Canada. Even Communist China produces Christmas cribs, primarily for export to the West, though members of the government-approved Patriotic Catholic Church set up crèches at Christmas. The famous porcelain houses such as Goebel, Lladro, Boehm, and Lemoge have all depicted the Nativity.

Santons remain very popular in the Provence region of France and a few select American shops sell them. Quebec has its own version of the *santon*. The *santons-de-Charlevoix*, created in the Charlevoix region, are charming, brightly painted terra-cotta figures based on rural Quebec characters.

Palestinian Christians of the West Bank of the Jordan—particularly, of course, in Bethlehem—carve crèches from wood left after the pruning of olive trees. In 1989, Archbishop Michel Sabbah, Latin Rite Patriarch of Jerusalem, initiated a program to help the local carvers to acquire a more adequate income for the support of their families in the depressed economy of the occupied territories. The Catholic Near East Welfare Association has

assisted the project. The wood carvers create Nativity figures and other religious articles out of olive wood for themselves, for tourists, and for export. The carvers are thus able to preserve their religious heritage while helping the local economy.

The *santos* of the American Southwest are the only religious art historically derived from American tradition—a religious art that Americans can call part of their own heritage. Beginning in the 1950s, Pueblo, Navajo, Hopi and Papago Indians of New Mexico and Arizona revived the art of the *santos* and began making *Nacimientos* (Nativities). These works of art in terra-cotta and wood combine the Nativity story with the expression of native American cultures.

The striking thing about crèches is that they reflect both a common faith and the unique culture of the people who created them. Cochiti Indian artists, for example, fashion Nativity figures that resemble their people, decorating them in the warm colors that characterize the Southwest. The Ibos of Nigeria carve thornwood figures that are unmistakably African, with a stable that resembles a clay and thatch dwelling of the bush. Figures made in China have distinctively Asian features. Italian figures still resemble eighteenth-century Neapolitan peasants. The manger scene continues to proclaim that all people are welcome at the stable of Bethlehem.

In addition to contemporary crèches, people have come to value the Christmas cribs of the past and to recognize them both as works of art and as records of religious and cultural heritage. Antique Nativity figures that only a few years ago would have found their way to flea markets are now cherished in museums.

One of the most spectacular collections of crèches is, of course, in Naples—the Museo di San Martino. The museum's centerpiece is a *presepio* do-nated in 1877 by Michele Cuciniello, an architect, playwright, and actor. The Cuciniello scene includes 180 shepherds, forty-two angels, twenty-nine animals and 339 small accessories. The museum also boasts the Ricciardi and Perrone crèches, the surviving figures of the group made for the Poor Clare Convent of Santa Chiara in 1311, and the nineteen remaining wooden statues created by Pietro and Giovanni Alemanno in 1478 for the Church of San

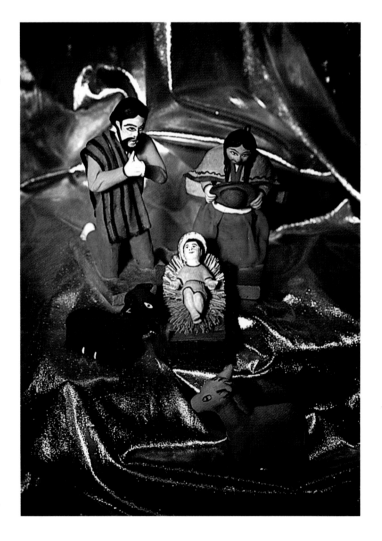

The Holy Family is portrayed as a typical Inca family in this crèche from Peru.

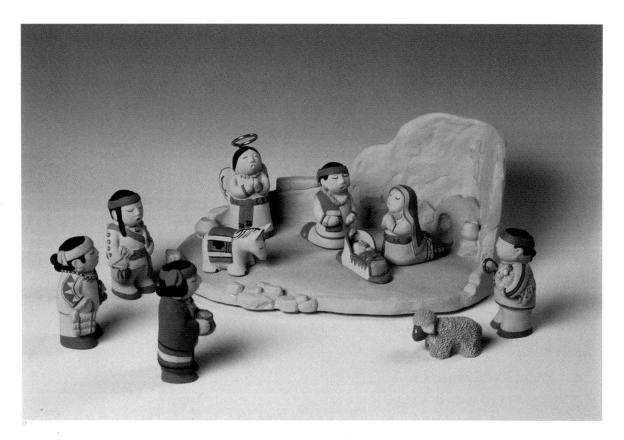

Arizona artist, Cleo Tessedre, used the Indian pueblos of the American Southwest as her inspiration for this charming crèche.

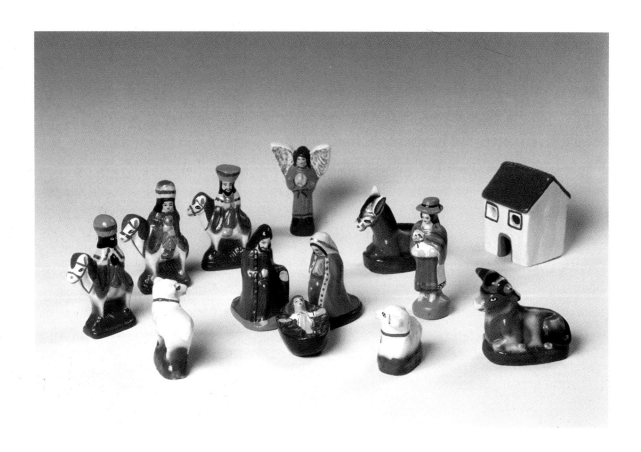

The three magi arrive mounted on horses in this colorful ceramic crèche from Ecuador.

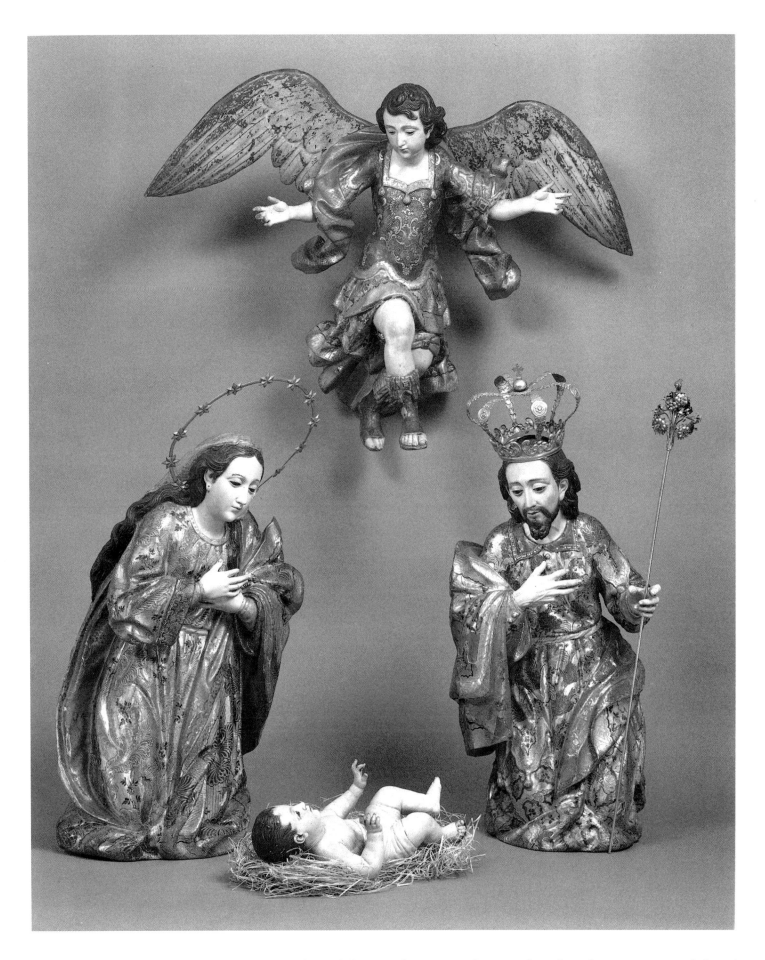

An unknown Guatemalan artist carved and polychromed these wooden Nativity figures in the eighteenth century. Mary's halo and Saint Joseph's crown and lily are silver. The crown identifies Joseph as a member of the royal house of David.

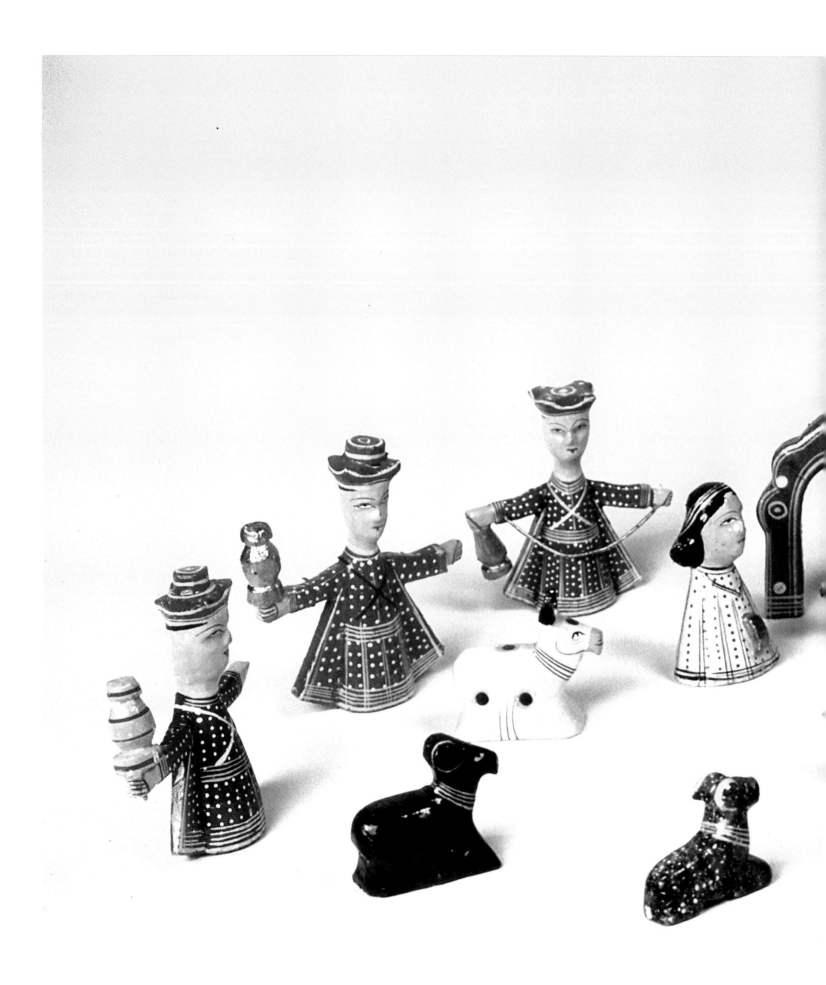

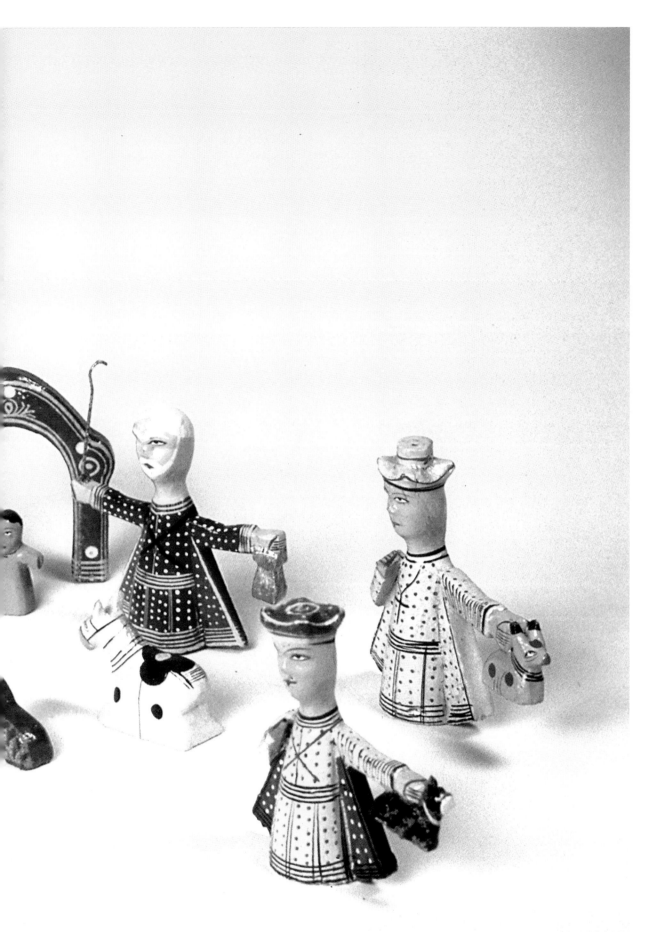

Brightly painted wooden Nativity figures from India.

Giovanni dei Carbonari. The Reggia, in nearby Caserta, is a museum that was formerly the palace of the kings of Naples. The Reggia possesses the extensive and elaborate *presepio* that belonged to the kings. There are several other crèche museums in Italy, but one of them worth mentioning is the Museo del Presepio in Brembo di Dalmine, located near Bergamo near the Swiss border. Founded by Father Giacomo Piazzoli, it is dedicated to the Italian crèche and contains, spread over two floors, over 800 of every size, type, and historical period.

The Bavarian National Museum in Munich holds an extensive—and perhaps unrivaled—collection of seventeenth, eighteenth and nineteenth-century crèches from Bavaria, the Tyrol, Naples and Sicily. Max Schmederer, himself a collector and expert on antique crèches, began the collection in 1897. Dr. Rudolph Berliner, probably the world's foremost historian of the crèche, later worked with the collection. Dr. Nina Gockerell, also a noted expert, is now curator. The crèche museum

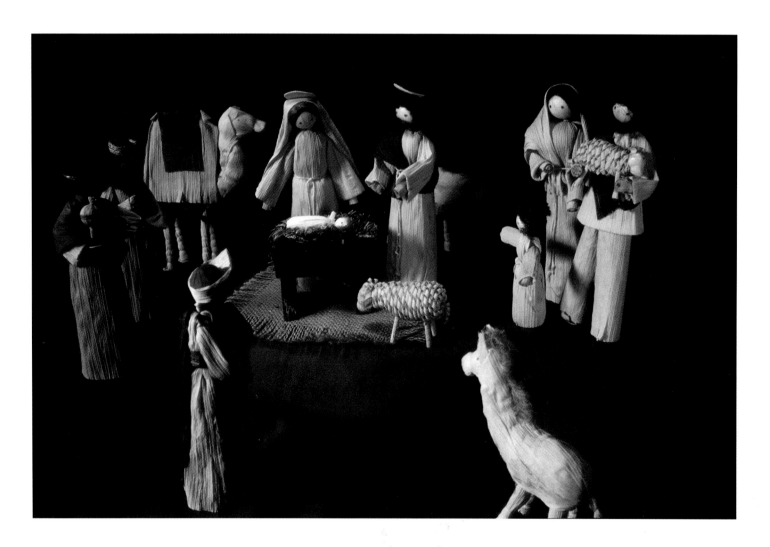

Even the simplest and cheapest materials such as corn husks, can be used to make crèches as evidenced by this one from the Czech Republic.

FACING PAGE:
Quebec artist Bernard Boivin portrayed the figures of the Nativity as rural Quebecois from the Charleviox region in this wintery crèche.

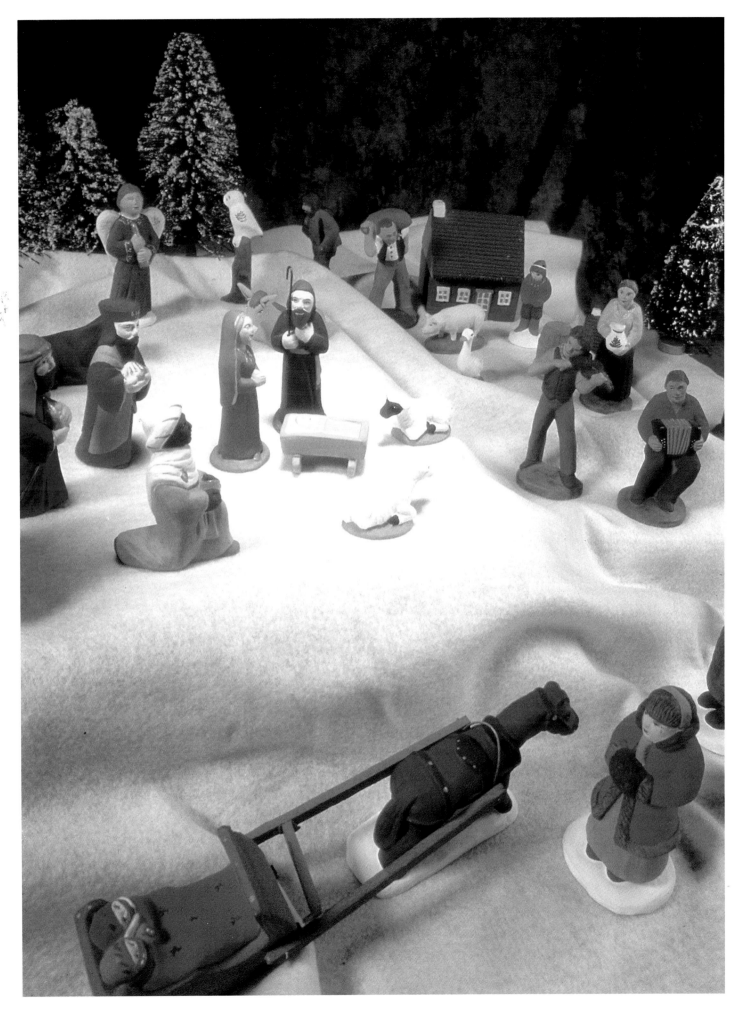

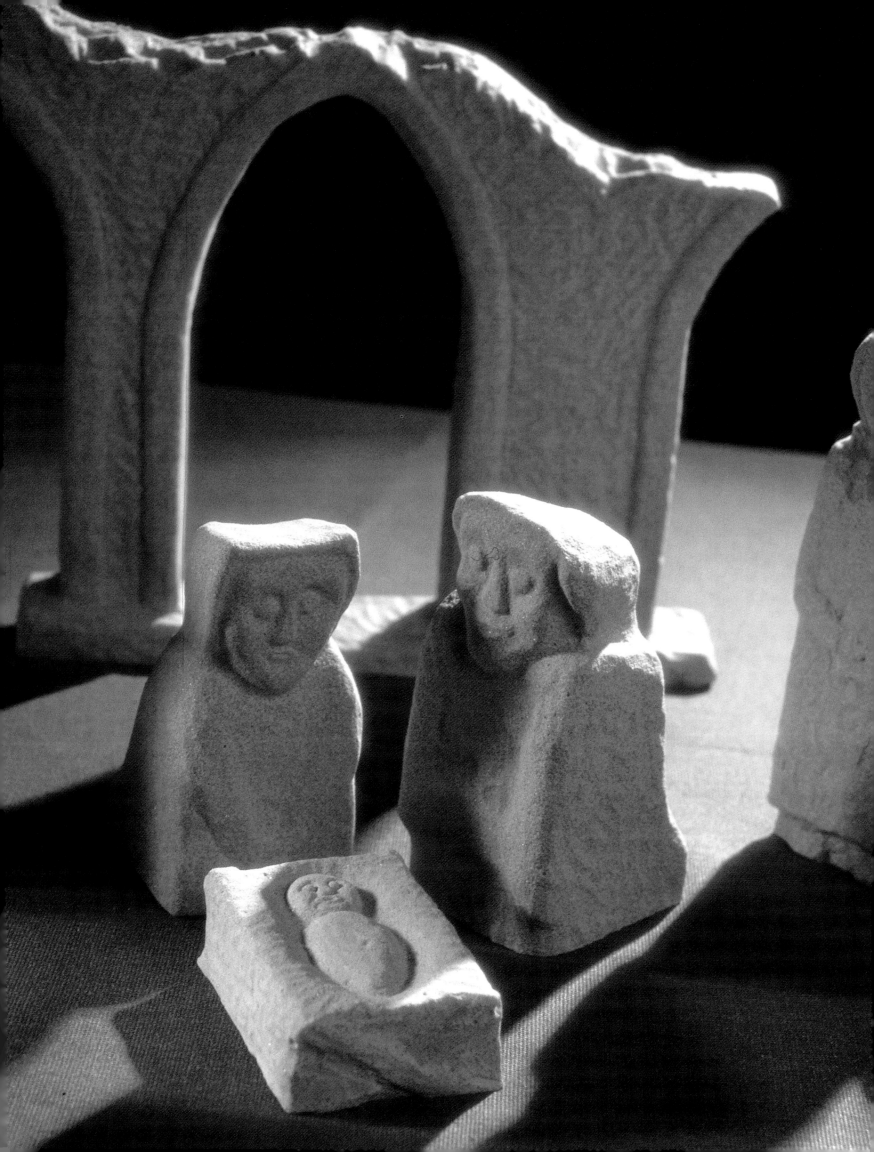

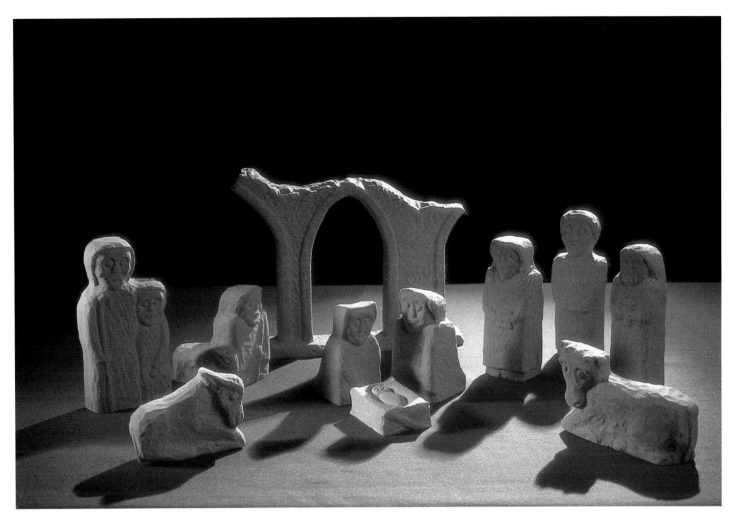

Irish sculptor Kieran Ford used ancient Celtic statues and ruins as the inspiration for his stone Nativity.

(Krippenmuseum) located in Telgte, near Munster, Germany, occupied a new three-story building in 1994. The Austrian Museum of Folklore in Vienna holds the more than 400 eighteenth-century Nativity figures of the crèche that formerly belonged to the Jaufental family. The Museum of Folk Art in Innsbruck, Austria, has a small, but beautiful collection, mostly Tyrolean.

The finest collection of antique crèche figures in the United States belongs to the Metropolitan Museum of Art in New York. More than 150 eighteenth-century Neapolitan figures were collected by Mrs. Loretta Hines Howard over a forty-year period. In 1964, she donated her collection to the Metropolitan, which displays the figures every year around the museum's Christmas tree. In 1972, Mrs. Howard

donated a smaller, but no less splendid crèche to the Albright-Knox Gallery in Buffalo, New York. The Carnegie Museum of Art in Pittsburgh possesses a collection of antique Neapolitan figures that rivals the Metropolitan's. Purchased from the massive collection of Neapolitan Commendatore Eugenio Catello, with the advice of Dr. Berliner and with funds provided by Mr. and Mrs. George Magee and their children, the scene is composed of eighty-eight human and angelic figures, twenty-nine animals and over one hundred accessories and props.

The Benedictine Nuns of Regina Laudis Abbey in Bethlehem, Connecticut, have an eighteenth-century Neapolitan crèche said to have belonged to Victor Amadeus II, King of Sardinia. It was supposedly presented to him at his coronation in 1720 and,

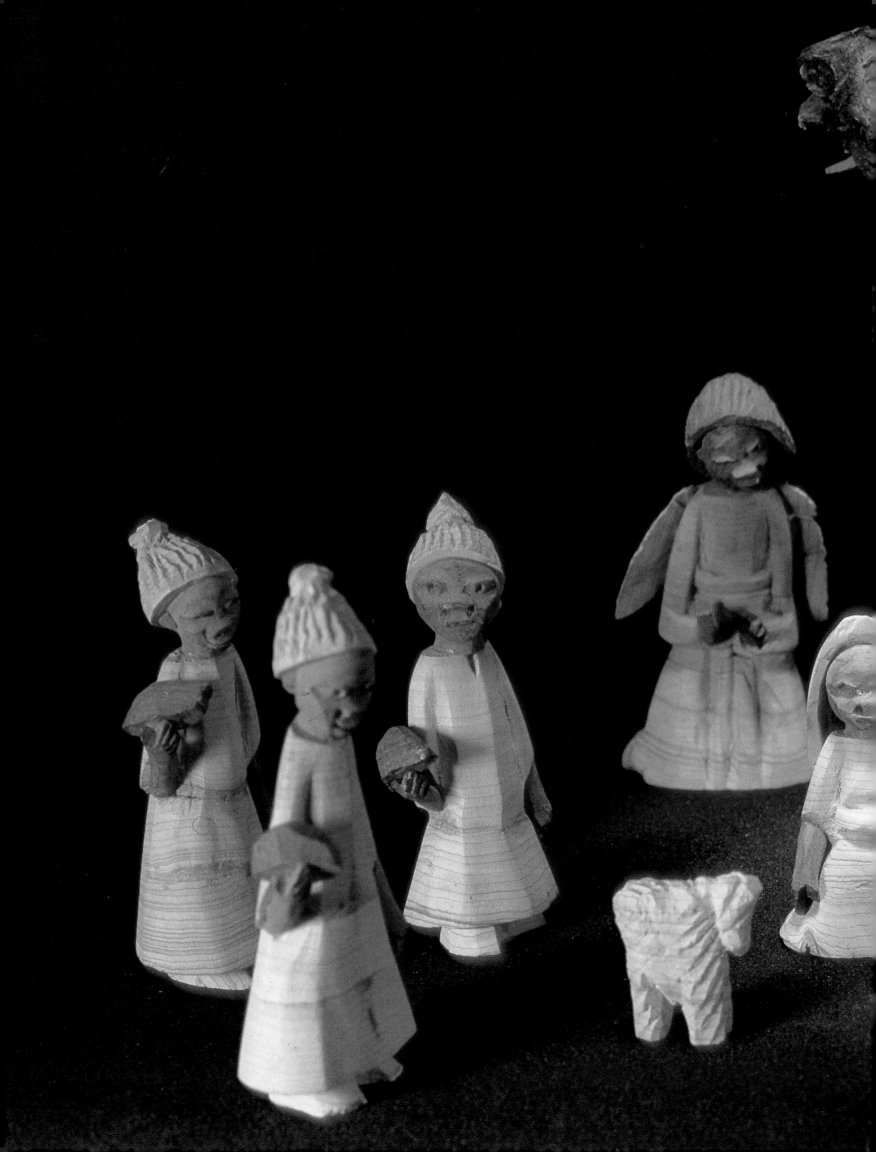

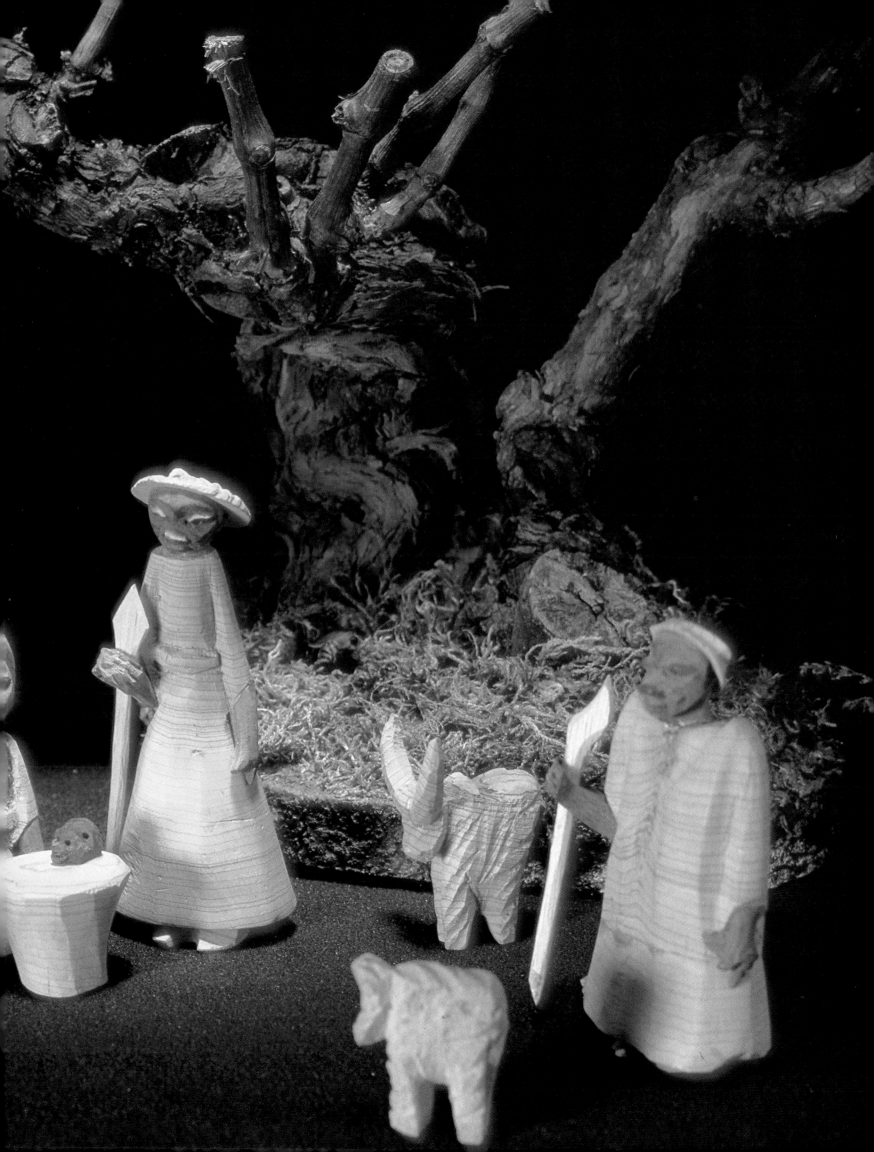

PRECEDING PAGE:
The Nativity scene re-created in thorn-wood by artists of the Ibo tribe of Nigeria.

Kikuyu artists used wood and dried banana leaves to create this crèche from Kenya.

African-American children performing a Nativity play is the theme of this crèche by artist Sarah Schultz.

Nativity figures carved by an Inuit (Eskimo) artist of Canada.

after he died in 1732, it became the property of another Italian noble family. Mrs. Loretta Hines Howard brought it to the United States in 1948 and donated it to Regina Laudis in 1949. The crèche is sixteen feet long and six feet deep and consists of sixty figures. The scene is on permanent display in a barn on the abbey grounds and is open to the public during the Christmas season. The Mission of San Carlos Borromeo in Carmel, California, founded in 1770 by Junipero Serra (commonly known simply as the Carmel Mission), also has an eighteenth-century Neapolitan crèche on permanent display in the basilica.

Thirty-one eighteenth-century Italian Nativity figures were donated to the White House in Washington, D.C., in 1967 through the interest and encouragement of Mrs. Lady Bird Johnson. Noted Broadway scenic artist Donald Oenslager designed the original setting for the figures and Father Aloysius Horn, then president of the American Christmas Crib Society, was invited to the dedication ceremony for the crèche in December of 1967. It is now displayed every Christmas season in the East Room of the White House.

Washington's National Cathedral annually exhibits about one hundred Nativities from the extensive collection of Mrs. Beulah Sommer. Mrs. Francesca Perez de Olaguer y Angelon, originally from Spain and now residing in Ohio, owns an outstanding Baroque Neapolitan crèche which she occasionally displays at the Taft Museum in Cincinnati.

The Central Moravian Church in Bethlehem, Pennsylvania, continues the Moravian crèche tradition of the *putz* every year from the first Sunday of Advent to December 31. The church's *putz* tells the entire Christmas story and consists of eighteen scenes, beginning with the prophecy of Isaiah and

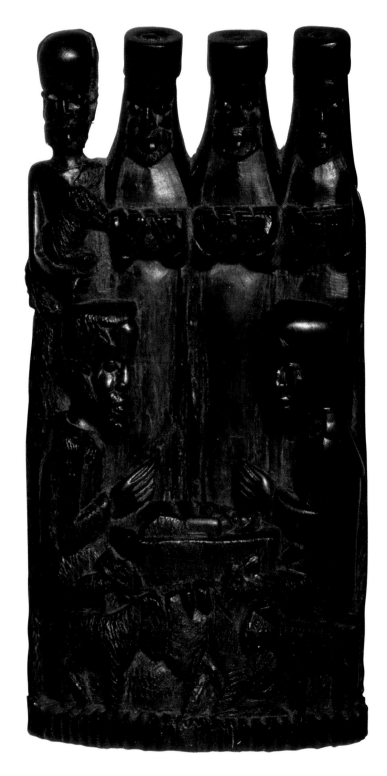

Tanzanian artist, January Benedkito Mkalapa, carved this Nativity relief from a single piece of ebony.

ending with the return to Nazareth of Jesus, Mary and Joseph after their exile in Egypt. The scene, composed of carved wooden statues, some of which may be 200 years old, is lighted and accompanied by taped narration and music. It rests on a moss-covered platform twenty-eight feet long and twelve feet wide. Each year approximately 14,000 people view the *putz*, which members of the church have come to consider a ministry. The East Hills and Edgeboro Moravian Churches in Bethlehem have similar displays at Christmas.

The Museum of International Folk Art in Sante Fe, New Mexico, houses the Girard collection. Alexander Girard, a noted designer and architect, had one of the largest private collections of folk art in the country, including many Nativities from all over the world. In 1978 he donated his collection to the museum.

FACING PAGE:

Wooden figures from China are carved for export and for members of the Chinese Patriotic Catholic Church.

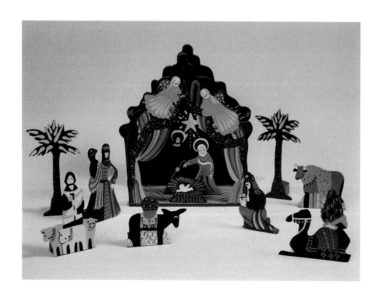

Enameled flat wood figures, Sri Lanka.

Certainly the most diverse collection of crèches is the one held by the Brother Andre Museum of the Oratory of Saint Joseph in Montreal. The museum owns over 600 Nativities from more than 100 countries, though only about 250 are put on display each year. In 1979, during the seventy-fifth anniversary of the Oratory, Father Andre Bergeron, C.S.C., curator of the museum and an accomplished artist, inaugurated the collection with a modest exhibit of twenty-five crèches from five countries. One of these was a set of *santons* donated by noted *santonier* Marcel Carbonel of Provence. The number of cribs as well as the number of visitors to the exhibit have grown annually; in 1993 more than 70,000 people traveled to the Oratory to view the Nativities. The Brother Andre Museum displays its crèches each year, usually from mid-November to early February.

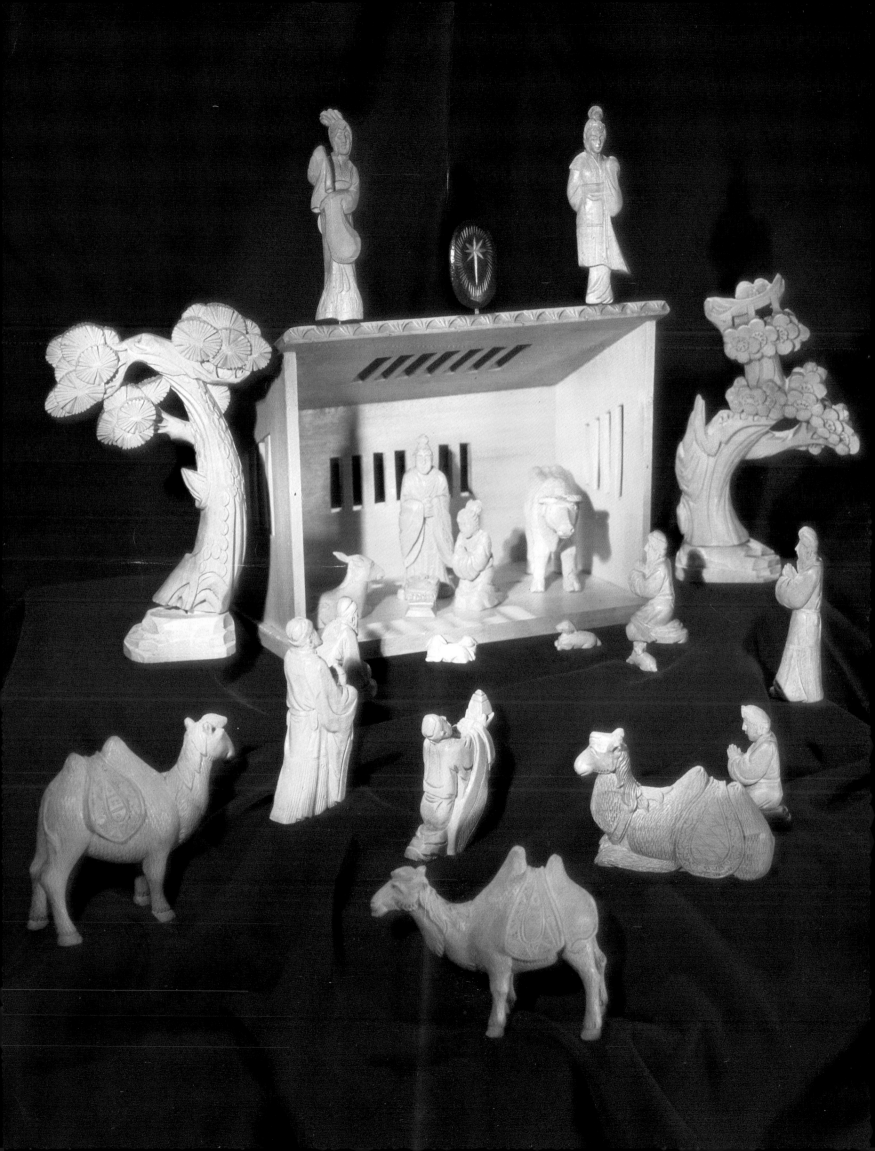

Zeesnagel's Italian Alpine Village in Frankenmuth, Michigan, has on display over 400 handcrafted figures created by owners Dave Zeese and Don Nagel.

In 1987, *Italy, Italy*, a bimonthly magazine of Italian culture, commissioned master craftsman Giovanni D'Agostino to create a Neapolitan-style crèche. The *presepio* consists of exact miniature replicas of buildings and scenery in Naples and is animated by over 300 figurines in hand-painted terra-cotta, the material commonly used today. However, the figures of Mary and Joseph are, as in the eighteenth century, hemp and wire mannequins dressed in clothes of real fabric . The figures and the myriad of tiny objects and foodstuffs were all made by a group of artisans from the Via San Gregorio Armeno in Naples. Every year during the Christmas season *Italy, Italy* displays the crèche in a different American city.

Exhibits of crèches flourish around the Christmas season. Krakow, Poland, has been holding an annual *szopka* (crèche) building competition in its main square with spectacular results since 1937. Crèche displays abound in Italy during the Christmas season. Assisi and Greccio are obvious locations. Another prominent site is Caltagirone, near Catania, once the center of crèche making in Sicily in the eighteenth century. The Caltagirone exhibit includes cribs of all sizes, Nativity pageants and concerts.

The crèche is more popular today than at any other time in its history. Christians treasure it as a visual reminder of important elements of their faith. It is frequently valued for its beauty as an object of art. It can also be a wonderful memento of cultural or ethnic heritage.

THE CRÈCHE AS
CHRISTIAN ART
AND SACRAMENTAL

The Christmas crèche fits into the long tradition of the Christian use of images.

Christians began to use visual art to express their faith almost as soon as the New Testament was written. The earliest examples appeared on Christian tombs in the catacombs of Rome around A.D. 100. The favorite subjects were the Good Shepherd, Daniel in the lions' den, and the *orant* (praying) woman, who stood for either the praying Church or the departed soul. Later, Old Testament stories were depicted with Christian symbolism—Jonah as a symbol of the resurrection and Noah in the ark as a symbol of the hope of salvation from the deluge of sin. In the second century, frescoes of the miracles of Jesus appear, especially the multiplication of the loaves and fishes and the healing of the paralytic.

The Edict of Milan in 313 legalized Christianity in the Roman Empire and Christian art came out into the open. Now Christians were able to publicly build houses of worship and to decorate them with religious art and symbols.

Some groups, such as the iconoclasts of the early eighth century, opposed the use of artistic images for Christians. Those who condemned the making and veneration of images based their opposition on Exodus 20:4-5:

> You shall not make for yourself a graven image, or any likeness of anything that is in heaven above or that is in the earth beneath, or that is in the water under the earth; you shall not bow down to them and serve them.

However, the Church has always interpreted this text as prohibiting the worship of false idols. This is indicated by the words, "You shall not bow down to them and serve them." The text is also preceded by, "You shall not have strange gods before you" (Exodus 20:3). Five chapters after this passage God gives specific instructions to the Israelites for the two golden cherubim he has commanded them to make for the ark of the covenant (Exodus 25:18-20). Later, in Numbers 21:8, God orders Moses to make a bronze serpent so that the people may gaze upon it and be cured of their snake bites. We know also from excavations of first-century A.D. Jewish

synagogues and tombs that they contained mural decorations. It is clear, then, that Exodus 20:4-5 is a prohibition, not of all images, but of the worship of false gods and of the making of images of the invisible God (Yahweh). Through this precept God was teaching Israel that he is entirely outside and above nature.

In 787, the Second Council of Nicaea condemned the iconoclasts and re-affirmed the usefulness of the proper veneration of icons and statues "to raise the mind of the spectator to the objects which they represent." The Eastern Father Saint John Damascene (675-749) had earlier defended the use of religious art against those who opposed it. He stated: "Let them hear that in the beginning God created man according to his own image. On what grounds then, do we show reverence to each other, except that we have been made according to his image?" (in Cavarnos, p. 6). John Damascene wisely grounded his defense of images on two important principles: the doctrine of the Incarnation—that God himself has become human in the person of Jesus Christ—and that art could be an aid, though not a substitute, for Sacred Scripture.

> ...who can make an imitation of the invisible, in-corporeal uncircumscribed, and formless God? To give, therefore, form to the Deity is the height of madness and impiety. Hence, in the Old Testa-ment the use of icons was not common. But after God in his deep compassion became, in truth, a man for our salvation, not as seen by Abraham in the form of a man, nor as he was seen by the Prophets, but truly in essence man, and after he lived upon the earth and associated with men, worked miracles, suffered, was crucified, rose again and was taken to Heaven; since all these things did in fact take place and were seen by men, they were written for the remembrance of us who were not living at the time, in order that

> though we did not see, we may, by hearing and believing, obtain the blessing of the Lord. But since not every one is literate, nor has the leisure for reading, the Fathers agreed these things should be represented on icons, as being acts of supreme heroism, in order that they should serve as a concise memorial.

> Many times, doubtless, when we do not have in mind the Passion of our Lord, upon seeing the icon of Christ's crucifixion, we recall his saving suffering and fall down and worship, not the ma-terial, but that which is represented—just as we do not venerate the material of the Book of the Gospels, nor the matter of the Cross, but that which these represent (in Cavarnos, pp. 6-7).

Sacred images are not objects that we worship (this we owe to God alone), but representations of Christ's humanity and of those humans who most clearly reflected his presence. Since we were created in the image and likeness of God (Genesis 1:26), sacred images merely portray God's image as it is re-flected in Christ and his saints. For that reason we honor and venerate them.

As John Damascene recognized the foundation of Christian art in the Incarnation, Father J. Michael Miller, C.S.B., points out that "the very fact of the Incarnation tells us that the material cosmos is not evil. It is the means through which God has chosen to share his life with us" (Miller, p. 9). The Incarnation, Father Miller continues, reversed the fall of Adam and brought the flesh and the spirit together again.

Right from the beginning the Church de-nounced those who held that they could be saved independently from anything created. The Mani-chaeans of the third century, for example, taught that from all eternity reality consisted in two (dual) absolutely antagonistic realms of being, one good and one evil, always in conflict. That which is spiri-

tual, they said, is good and that which is material is evil. These early heretical dualists believed that God was hostile to creation. The Christian response was a loud affirmation that all creation is good since it was made by God, and that there is no abyss between God and his created world. The Church stressed that the created world is, in fact, a sign of God's presence. Had not God chosen to save the world by having his Son take on human flesh? And Christ chose to continue the work of salvation by instituting sacraments which made use of physical matter—bread, wine, water, oil. Christ, in fact, continues his real presence on earth in the Holy Eucharist under the form of bread and wine. God knew that we humans cannot conceive of things divine without the things of the earth. For Christians, bodily and created reality can mediate the divine.

Likewise, the Church has always used created material—paint, clay, iron, marble, wool—to make paintings, sculptures, metalwork and vestments for the glorification of God and the spread of the Gospel. The Church has wisely seen art as an important aid, though not a replacement, for Sacred Scripture. In the past, art has provided a vehicle for teaching the elements of the faith to those who could not read. But even for those who are literate, art can express faith in a way that words cannot. True Christian art does not merely recreate external reality—the external appearance of a person or event from the past—but represents the faith of the person or persons portrayed, the truth of the sacred event, and the faith of the artist who created the image. Laurence F. X. Brett notes: "Photographs of modern saints are curious things at best; rarely do they capture the very soul of the person whose soul was moved by grace" (Brett, p. 128). The Christian artist can often do what the photographer cannot.

Though Christian artists always saw God as their ultimate source, in twelfth-century France the artists and theologians of the so-called School of Chartres formulated and articulated a view of God as the source of all beauty, and therefore of all art. They saw beauty as present most fully in God, and then as shared by God with his creatures, so that the beauty of created things was seen as stemming from God and as likely to raise the mind of the viewer to the contemplation of God. To see beauty as a divine perfection is to stress its spiritual nature, they said. Created beauty was, for them, a sharing in the perfection of the Creator. Further, they exalted the beauty of the humanity of Christ as the supreme beauty of the created world and regarded that beauty as shared and manifest in varying degrees in the rest of creation. Beauty, and hence art, was linked more closely to God and valued because of that link. Artists saw the Incarnation as an exemplar that elevated all created and visible forms of beauty. This Christian teaching on beauty strengthened and helped to deepen the vision and enhance the function of the Christian artist.

A true example of the Christian artist was the Dominican friar, Blessed Fra Angelico (1387-1455). As a member of the Order of Preachers, Angelico considered his painting as another means of preaching. He was convinced that to paint Christ one must first know Christ, and he always spent time in prayer before picking up his brush. It is no coincidence that many have referred to his paintings as visual sermons. Some have said that Fra Angelico in art and Saint Thomas Aquinas in the *Summa Theologica* each presented the same truth in different ways. Angelico preached with an artist's brush as eloquently as the other friars did with the voice or the pen. Today, when many other voices have fallen silent, his paintings still proclaim the Gospel.

Like Angelico's paintings, many crèches, especially those of the seventeenth and eighteenth centuries, are preserved in museums and treasured as works of art. A single eighteenth-century Neapolitan figure can sell for thousands of dollars at an art auction. Crèche artists such as the Neapolitan Guiseppe Sammartino and the Sicilian Giovanni Antonio Matera are recognized as talented sculptors. Their work is still admired by art critics and art historians and is sought after by collectors. One does not need to be a person of faith to appreciate the beauty of the figures they created. However, we must remind ourselves that, while the creators were true artists, they were also persons expressing their faith. And while the original viewers certainly must have admired the beauty of the figures, they also saw them as visual reminders of a sacred and miraculous event and were probably aware that their beauty is only a faint reflection of the ultimate beauty which is God. The contemporary viewer can only understand these works fully in the context of both art and faith.

Besides being a true example of Christian art, the crèche, properly used, can also be a sacramental. *The Catechism of the Catholic Church* defines sacramentals as:

> sacred signs which bear a resemblance to the sacraments. They signify effects, particularly of a spiritual nature, which are obtained through the intercession of the Church. By them men are disposed to receive the chief effects of the sacraments, and various occasions in life are rendered holy (n. 1667).

Laurence F. X. Brett offers a similar definition. He states:

> Sacramentals are the goods of creation which the Church receives with thanksgiving, made holy by God's word and prayer and which, like the sacraments they resemble, proclaim to the world the grace of Redemption which transforms the world (p. 43).

Sacramentals flow from the sacraments and should, in some way, lead the faithful to the reception of the sacraments. Though they resemble the sacraments, they are different in two important ways. While sacraments were instituted by Christ, sacramentals are created or approved by the Church. And sacramentals "do not confer the grace of the Holy Spirit in the way the sacraments do, but by the Church's prayer, they prepare us to receive grace and dispose us to cooperate with it" (*Catechism of the Catholic Church*, n. 1670).

A sacramental can be any object, prayer, or action that can put us in touch with God's grace in Christ. Common sacramentals are holy water, ashes, palms and candles. Underlying this understanding of sacramentals is the notion that Christ, the primary sacrament of encounter with God, renders the whole of creation new and redeemed. The Second Vatican Council pointed out that there is scarcely any proper use of material things that cannot be directed toward the sanctification of people and to the praise of God (Flannery, p. 20).

These sacramentals or "little sacraments" are as integral to an incarnational-bodily Christianity as are the seven major sacraments. Not just optional "add-ons," they are essential to experiencing the world. All creation speaks of God. Time and seasons will have their place in our devotion since we are beings who live in history. Spaces, places, and special clothing are also indispensable. "That's why we build beautiful cathedrals, set aside sanctuary areas, wear religious habits, and buy our children First Communion outfits" (Miller, p. 10).

The *Catechism* also points out that use of a sacramental must always include prayer (n. 1668). It is, in fact, through personal prayer and through the intercessory prayer of the Church that sacramentals

can be occasions of grace. This is why blessings are first among the Church's sacramentals; through blessings the Church invokes God's protection and beneficence. An object, such as a crucifix or a crèche, is a sacramental because it has been blessed by this intercessory prayer and is itself an occasion of prayer. Sacramentals are primarily prayers directed to God and secondarily, through God's response, a sanctification of persons or objects. A blessing sets apart a particular object for God, withdraws it from everyday use and consecrates it to God and his service. The prayer offered asks that the object be a bearer of blessings for those who use it or view it and that it may be an occasion for encountering God. The Church's official *Book of Blessings* includes a blessing for the Christmas manger. This prayer requests God's blessing on all who look upon the crèche with faith, and asks that "it may remind us of the humble birth of Jesus and raise up our hearts to him" (p. 418).

Without faith and prayer the crèche can remain merely a beautiful work of art or a Christmas decoration. With faith and prayer, it can be an important help in contemplating some of the fundamental truths of Christianity. Father Andre Bergeron of the Oratory of Saint Joseph in Montreal recounts that during the annual exhibits he often finds people kneeling in prayer before the crèches in the Oratory's museum.

The crèche can never be completely separated from its roots as a dramatization of a sacred event. In a landmark case residents and members of the American Civil Liberties Union sued the city of Pawtucket, Rhode Island, for placing a crèche on public property. The crèche stood alongside a Santa Claus house, reindeer pulling Santa's sleigh, candy-striped poles, a Christmas tree, carolers, and cutout figures of a clown, an elephant and a teddy bear.

Lower courts ruled that the presence of the crèche on public property violated the Constitution and that the city of Pawtucket must remove it. However, in 1984, the Supreme Court, in *Lynch vs. Donnelly*, ruled in favor of the city, stating that the crèche could have "a legitimate secular purpose," the celebration of the holidays. The court added, "the display engenders a friendly community spirit of good will in keeping with the season" (in Gunther, *Lynch vs. Donnelly*, pp. 483-484).

Ironically, it was Justice William Brennan writing the dissenting minority opinion, who saw the true nature of the crèche. Arguing against the crèche as merely a secular symbol, Justice Brennan wrote:

> The Nativity scene…is the chief symbol of the characteristically Christian belief that a divine Savior was brought into the world and that the purpose of this miraculous birth was to illuminate a path toward salvation and redemption. For Christians, that path is exclusive, precious and holy.

He went on to call it "the symbolic reenactment of the birth of a divine being who has been miraculously incarnated as a man." Later in his opinion he added:

> Unlike such secular figures as Santa Claus, reindeer and carolers, a Nativity scene represents far more than a mere "traditional" symbol of Christmas. The essence of the crèche's symbolic purpose and effect is to prompt the observer to experience a sense of simple awe and wonder appropriate to the contemplation of one of the central elements of Christian dogma—that God sent His son into the world to be a Messiah. Contrary to the Court's suggestion, the crèche is far from a mere representation of a "particular historic religious event." It is, instead, best understood as a mystical re-creation of an event that lies at the heart of the Christian faith (*Lynch vs. Donnelly*, in Gunther, pp. 489-490).

BLESSING OF A CHRISTMAS CRÈCHE FOR THE HOME

Mary's Magnificat

The father or mother of the family recites the antiphon and then the Magnificat, alternating verses with the rest of the family.

Antiphon: The Lord has regarded humble persons and places,
 therefore all generations shall call them blessed.

Leader: My soul magnifies the Lord,
 —and my spirit rejoices in God my Savior.

Leader: Because he has regarded the lowliness of his handmaid;
 —for behold, from henceforth all generations shall call me blessed;

Leader: Because he who is mighty has done great things for me,
 —and holy is his name;

Leader: and his mercy is from generation to generation,
 —on those who fear him.

Leader: He has shown might with his arm,
 —he has scattered the proud in the conceit of their heart.

Leader: He has put down the mighty from their thrones,
 —and has exalted the lowly.

Leader: He has filled the hungry with good things,
 —and the rich he has sent away empty.

Leader: He has given help to Israel, his servant,
 —mindful of his mercy.

Leader: Even as he spoke to our fathers
 —to Abraham and to his posterity forever.

Leader: Glory be to the Father, and to the Son, and to the Holy Spirit,
 —as it was in the beginning, is now, and ever shall be, world without end. Amen.

First Reading

Mother or father:

The eternal Son of God having become man out of love for us, chose to be born in a lowly stable, rather than in the greatest palace of kings. Being rich, he became poor for our sake to show us how greatly he loves poverty and humility. But the presence of the King of Kings made this lowly shelter the most honorable and noble of royal palaces. Herein he was pleased to be adored by his virgin mother and father, by the poor shepherds, and by the wealthy wise men. As a man among men Christ came for all people, of all times and all places; unless we say "there is no room," he will come into our home this Christmas night and will make it a place of splendor, of love and of great joy.

All answer: Thanks be to God.

Mother or father: The Word was made flesh, Alleluia.

All: And dwells among us, Alleluia.

Second Reading
From the holy Gospel according to Saint Luke

One of the children:

At that time the shepherds were saying to one another, "Let us go over to Bethlehem and see this event that has come to pass which the Lord has made known to us." So they went with haste, and found Mary and Joseph, and the Babe lying in the manger. And when they had seen, they understood what had been told them concerning this child. And all who heard marveled at the things told them by the shepherds. But Mary kept in mind all these words, pondering them in her heart. And the shepherds returned, glorifying and praising God for all they had heard and seen, even as it was spoken to them.

Each member of the family kisses the Gospel text.

Prayer

Parent: O Lord, hear my prayer.

All: And let my cry come to you.

Parent: The Lord be with you.

All: And also with you.

Parent: O God, out of your love for us you sent your dearly beloved Son to become man. You willed that he be born in a humble stable in order to give us an example of humility. We ask you now to bless this crib, a representation of the scene of his birth; may it draw us closer to him. By imitating the humility of Jesus may we become a worthy dwelling place for his rebirth. We ask this through Jesus Christ, your Son and our Lord.

All: Amen.

All sing: "O Come All Ye Faithful," "Silent Night," or another appropriate Christmas carol.

(Reprinted with the kind permission of the Benedictine Monks of Conception Abbey.)

A VISIT TO THE CRIB:
PRAYERS BEFORE
A CHRISTMAS CRÈCHE

In the Name of the Father, and of the Son, and of the Holy Spirit. Amen.

Let us pray.

O Lord Jesus Christ, brought by your love to the lowliness of childhood and to the poverty of the manger, we worship you who live and reign with the Father and the Holy Spirit, ever one God, world without end. Amen.

Glory be to the Father...

Our Father...

Jesus, who came down from heaven for our salvation and, taking upon yourself the form of a servant, set us an example of true humility,

Have mercy on us.

Jesus, born in Bethlehem of Mary, ever Virgin, wrapped in swaddling clothes, laid in the manger, announced by angels, visited by shepherds,

Have mercy on us.

Jesus, called by your glorious name of Jesus, and at once by your name foreshown as the Savior of the world,

Have mercy on us.

Jesus, made known to the Wise Men by a star, adored in the arms of your Mother, presented with the gifts of gold, frankincense, and myrrh,

Have mercy on us.

Jesus, presented in the temple by your Virgin Mother, embraced by Simeon, and loved by Anna,

Have mercy on us.

Jesus, whom wicked Herod sought to slay but who was preserved from death and glorified by the blood of the Holy Innocents,

Have mercy on us.

Jesus, who went into Egypt, and then returned to dwell in Nazareth, enduring many hardships along the way,

Have mercy on us.

Jesus, who in your home at Nazareth subject to Mary and Joseph, set us an example of obedience,

Have mercy on us.

Holy Child Jesus, *hear us.*

Holy Child Jesus, *bless us.*

Holy Child Jesus, *grant our prayers.*

V. The Word was made Flesh. Alleluia.

R. And dwelt among us. Alleluia.

Let us pray.

Almighty God, Lord of heaven and earth, who revealed yourself to children, grant, we beseech you, that, honoring your Son, our Savior Jesus Christ, and day by day growing more like him, we may come to the kingdom of heaven, promised to those who become as little children, through the same Jesus Christ our Lord. Amen.

May the Holy Child Jesus bless and keep us. Amen.

(Reprinted with the kind permission of the Society of Saint John the Evangelist, Cambridge, MA.)

Museums and Other Locations
of Creches in the United States and Canada

This list is not intended to be exhaustive, but merely to serve as a help to the interested reader. In the case of museums and other locations of crèches, some have their Nativities on display all year long, others exhibit them only during the Christmas season. It is suggested that you write or call before visiting.

Abbey of Regina Laudis
Flanders Road
Bethlehem, CT 06751 (203) 266-7727

Albright-Knox Art Gallery
1285 Elmwood Avenue
Buffalo, NY 14222 (716) 882-8700

Brother Andre Museum
Saint Joseph's Oratory
3800 Queen Mary Road
Montreal, Quebec, Canada H3V 1H6
(514) 733-8211

Carmel Mission
(San Carlos Borromeo Basilica)
Rio Road & Lasuen Drive
P.O. Box 2235
Carmel, CA 93921 (408) 624-1271

Carnegie Museum of Art
4400 Forbes Avenue
Pittsburgh, PA 15213-4080 (412) 622-3131

Central Moravian Church
73 West Church Street
Bethlehem, PA 18018 (610) 866-5661

East Hills Moravian Church
1830 Butztown Road
Bethlehem, PA 18017 (610) 868-6481

Edgeboro Moravian Church
645 Hamilton Avenue
Bethlehem, PA 18017 (610) 866-8793

Marian Library
University of Dayton
Dayton, OH 45469-1390 (513) 229-4214

Metropolitan Museum of Art
1000 Fifth Avenue
New York, NY 10028 (212) 535-7710

Museum of Fine Arts
465 Huntington Ave.
Boston, MA 02115 (617) 267-9300

Museum of International Folk Art
706 Camino Lejo
Sante Fe, NM 87504-2087 (505) 827-6350

Nativity Lutheran Church
3312 Silver Lake Road
Saint Anthony Village
Minneapolis, MN 55418 (612) 781-2766

Spencer Museum of Art
University of Kansas
Lawrence, KS 66045 (913) 864-4710

Washington National Cathedral
Massachussetts and Wisconsin Avenues, N.W.
Washington, D.C. 20016 (202) 537-6200

Zeesenagel Italian Alpine Village
780 Mill Street
P.O. Box 118
Frankenmuth, MI 48734 (517) 652-2591

National Museum of San Martino
Largo San Martino 5
80100 Naples, Italy
Palazzo Reale
81100 Caserta, Italy

European Museums with Crèche Collections

Austrian Folklore Museum
Palais Schonborn
Laudongasse 15-18
1080 Vienna, Austria

Bavarian National Museum
Prinzregentenstrasse 3
8000 Munich 22, Bavaria, Germany

Beja Regional Museum
Largo da Conceicao
7800 Beja, Portugal

Museo del Presepio
Via XXV Aprile 179
24044 Brembo di Dalmine
(Bergamo), Italy

Museum of Popular Arts and Traditions
5 Place des Heros
13003 Marseille, Bouches-du-Rhone, France

Museum of Tyrolean Folk Art
Universitatsstrasse 2
6020 Innsbruck, Austria

Crèche Organizations

ANRI Collectors' Club

(for collectors of a variety of wood carvings from the Dolomite Mountains of Northeastern Italy, including Nativity figures)

P.O. Box 2087
Quincy, MA 02269-2087
1-800-763-2674

Associazione Italiana Amici del Presepio
Via Tor de' Conti 31A
00184 Rome, Italy
Fax: 39-06-679-61-46
(also conducts a museum)

Fontanini Collectors' Club
Roman, Inc.
555 Lawrence Avenue
Roselle, IL 60172-1577
(708) 529-3000, Ext. 345

Bibliography

Berliner, Rudolf. *The Christmas Crib: An Introduction to an Exhibition.* Privately printed essay. Brooklyn, NY, 1940.

Berliner, Rudolf. "The Origins of the Crèche." *Gazette Des Beaux-Arts*, October-November-December, 1946.

Bishop, Patrick. "Sacramentals." *New Dictionary of Sacramental Worship*, ed. Peter Fink. Collegeville, MN: Liturgical Press, 1991.

Bohmer, Gunter. *The Wonderful World of Puppets.* Trans. Gerald Morice MacDonald. Boston: Plays, Inc., 1971.

Bolz, Diane M. "Art Imitates Life in the Small World of Baroque Crèches." *Smithsonian Magazine*, December, 1991.

Brett, Laurence F. X. *Redeemed Creation: Sacramentals Today.* Wilmington: Michael Glazier, Inc., 1984.

Bridget of Sweden, Saint. *Revelations.* Classics of Western Spirituality. New York: Paulist Press, 1990.

Cantini, O.F.M., Gustavo. "L'Infanzia Divina Nella Pieta' Francescana." *Studi Francescani*, no. 9 (1923).

Castaldo, Giuseppe. "Christmas in Naples." *Italy, Italy*, November, 1989.

Catechism of the Catholic Church. Boston: Pauline Books & Media, 1994.

Catello, Marisa Piccoli. *The Art of the Presepio: The Neapolitan Crib of the Banco di Napoli Collection.* Napoli, 1987.

Causa, Rafaello. "Miracle Play." *FMR*, December, 1984.

Cavarnos, Constantine (ed. and trans.). *The Icon: Authoritative Texts.* Belmont, MA: Institute of Byzantine and Modern Greek Studies, 1986.

Chambers, Sir Edmund K. *The Mediaeval Stage.* 2 vols. Oxford: Oxford University Press, 1903.

Chesnais, Jacques. *Histoire General des Marionettes.* Bordas, 1947.

D'Antonio, Nino. *San Gregorio Armeno: Pastori Napoletani D'Oggi.* Napoli: Edizioni Stampa et Ars Mario Raffone, 1986.

De Robeck, Nesta. *The Christmas Crib.* Milwaukee: Bruce Publishing Company, 1956.

De Robeck, Nesta. *The Christmas Presepio in Italy.* Florence: Giulio Giannini and Figlio Publishers, 1934.

Fidelfo, Marghereita. "A Naples Crèche Goes to Pittsburgh." *Italy, Italy*, November, 1989.

Flannery, O.P., Austin P. (ed.). *Documents of Vatican II.* Grand Rapids, MI: Williams B. Eerdmans Publishing Co., 1975.

Fleming, David L., S.J. *The Spiritual Exercises of Saint Ignatius: A Literal Translation and a Contemporary Reading.* Saint Louis: Institute of Jesuit Sources, 1978.

Foley, Daniel J. *Little Saints of Christmas: The Santons of Provence.* Boston: Dresser, Chapman and Grimes, Inc., 1959.

Giardino, O.P., Ermanno. *Il Predicatore delle Strade di Napoli: Padre Gregorio Rocco.* Napoli: Editore Domenicana Italiana, 1987.

Gockerell, Nina. *Krippen im Bayerischen Nationalmuseum.* Munchen, 1994.

Habig, Marion A. (ed.). *Saint Francis of Assisi: Omnibus of Sources.* Writings and Early Biographies. Chicago: Franciscan Herald Press, 1972.

Hallett, Paul H. *Catholic Reformer: A Life of Saint Cajetan of Thiene.* Westminster, MD: Newman Press, 1959.

Hardison, O.B. *Christian Rite and Christian Drama in the Middle Ages.* Baltimore: Johns Hopkins University Press, 1965.

Howard, Linn and Pool, Mary Jane. *The Angel Tree: A Christmas Celebration*. New York: Harry N. Abrams, Inc. Publishers, 1993.

Jacobus de Voragine. *The Golden Legend*. Translated and adapted by Granger Ryan and Helmut Ripperger. New York: Arno Press, 1969.

Johnson, Susan C. *The Neapolitan Presepio: Exhibition Catalogue*. Pittsburgh: Museum of Art, Carnegie Institute, n.d.

Koslinski, Dennis. *Krakovian Szopka: Exhibition Catalogue*. Chicago: Polish Museum of America, 1994.

Lombardi, Luigi. *The Holy Land*. Narni-Terni, Italy: Plurigraf, 1980.

Male, Emile. *Religious Art From the Twelfth to the Eighteenth Century*. New York: Farrar, Straus and Giroux, 1949.

McNamara, Robert F. "Crib." *New Catholic Encyclopedia*. New York: McGraw-Hill Book Company, 1967.

Miles, Joan. "A World Made in Miniature." *Italy, Italy*, December, 1990.

Miller, C.S.B., J. Michael. "Sacramentals in Catholic Theology," in Ann Ball. *A Handbook of Catholic Sacramentals*. Huntington, Indiana: Our Sunday Visitor, Inc., 1991.

Monthan, Guy and Doris. *Nacimientos: Nativity Scenes By Southwest Indian Artisans*. Albuquerque: Avanyu Publishing, Inc., 1990.

Morey, C.R. *Christian Art*. New York: W.W. Norton and Co., 1935.

Nagler, A.M. *Sources of Theatrical History*. New York: Dover Books, 1952.

Nitzsche, George E. *The Christmas Putz of the Pennsylvania Germans*. Allentown, PA: The Schlechter Press, 1942.

Pseudo-Bonaventure. *Meditations on the Life of Christ*. Trans. Isa Ragusa and Rosalie B. Green. Princeton, NJ: Princeton University Press, 1961.

Puntillo, Eleanor. "A Craft For Christmas." *Italy, Italy*, November-December, 1993.

Quinn, John R. "Sacramentals." *New Catholic Encyclopedia*. New York: McGraw-Hill Book Company, 1967.

Rosenthal, Erwin. "The Crib of Greccio and Franciscan Realism." *ArtBulletin*, v. 36, (1954).

Shorter Book of Blessings. New York: Catholic Book Publishing Co., 1990.

Simons, Mary. "The Crèches of Naples." *Life*, December, 1980

Spaeth, Eloise. *Two Eighteenth Century Neapolitan Crèches*. New York, 1961.

Speaight, George. *History of the English Puppet Theatre*. Carbondale and Edwardsville, IL: Southern Illinois University Press, 1990.

Syndicus, Eduard. *Early Christian Art*. Trans. J.R. Foster. New York: Hawthorn Books, 1962.

"The Rich Poverty." *Time*. December 28, 1959.

Von Boehn, Max. *Dolls and Puppets*. Trans. Josephine Nicoll. New York: Cooper Square Publishers, 1966

Weiser, S.J., Francis X. *Christian Feasts and Customs*. New York: Harcourt, Brace and World, Inc., 1952.

Wickham, Glynne. *The Medieval Theatre*. Cambridge, U.K.: Cambridge University Press, 1974.

Wood, Jeremy. *The Nativity: Themes In Art*. London: Scala Books, 1991.

Young, Karl. *The Drama of the Mediaeval Church*. 2 vols. Oxford, U.K.: Oxford University Press, 1933.

Young, Karl. "Officium Pastorum: A Study of the Dramatic Developments With the Liturgy of Christmas." *Transactions*. Wisconsin Academy of Science, Arts and Letters, no. 17 (1914).

Zanini DeVita, Oretta. "Gold, Frankincense, Myrrh and Macaroni." *Italy, Italy*, November, 1989.

Acknowledgements

Every effort has been made to determine the ownership of all illustrations and to make proper arrangements for their use. Any oversight that may have occurred, if brought to the attention of Pauline Books & Media, will be gladly corrected in future editions.

The Celebration of Christmas

Page 20: Giovanni di Paolo. *Nativity.* Pinacoteca, Vatican Museums, Vatican State. Scala/Art Resource, NY.

Page 22: Fourteen-point star. Photo by George Martin.

Page 22: Entrance to the Church of the Nativity. Photo by George Martin.

Page 23: Nave of the Church of the Nativity in Bethlehem. Photo by George Martin.

Page 24: Bartolo de Fredi. *Adoration of the Shepherds.* © Metropolitan Museum of Art, The Cloister Collection, 1925.

Page 26: Gentile da Fabriano. *Adoration of the Magi.* Uffizi, Florence, Italy. Scala/Art Resource, NY.

Page 28: Andrea Mantegna. *Adoration of the Magi.* Uffizi, Florence, Italy. Scala/Art Resource, NY.

The Influence of Religious Art on the Crèche

Page 35: Giorgione. *The Adoration of the Shepherds.* Samuel H. Kress Collection, © 1997, Board of Trusteees, National Gallery of Art, Washington, D.C. Photo by Richard Carafelli.

Page 36: The Morning Call, Bethlehem, PA.

Page 37: Albrecht Dürer. *Adoration of the Magi,* © British Museum.

Page 39: Sandro Botticelli. *Mystic Nativity.* National Gallery, Great Britain. Bridgeman/Art Resource, NY.

Page 40: Wax figure of Infant Jesus. Quebec. Photo by M. Emmanuel Alves, FSP.

Page 41: Peter Paul Rubens. *Adoration of the Magi.* Antwerp, Fine Arts Museum. Musee Royal des Beaux-Arts, Antwerp, Belgium. Scala/Art Resource, NY.

Page 42-43: Jacopo Bassano. *Adoration of the Shepherds.* Private Collection. Erich Lessing/Art Resource, NY.

Page 45: Photos by Regina Sansalone.

Page 46: Jacopo Bassano. *Adoration of the Shepherds.* Galleria Borghese, Rome, Italy. Scala/Art Resource, NY.

The Influence of Medieval Religious Drama on the Crèche

Page 52: Denis van Alsloot. *Triumph of the Archduchess Isabella in the Brussels Ommeganck.* Victoria & Albert Museum, London/Art Resource, NY.

Page 54: The Development of the English Playhouse. Richard Leacroft. Reed Consumer Books, Great Britain.

Pauline BOOKS & MEDIA

CALIFORNIA
3908 Sepulveda Blvd., Culver City, CA 90230 310-397-8676
5945 Balboa Ave., San Diego, CA 92111 619-565-9181
46 Geary Street, San Francisco, CA 94108 415-781-5180
FLORIDA
145 S.W. 107th Ave., Miami, FL 33174 305-559-6715
HAWAII
1143 Bishop Street, Honolulu, HI 96813 808-521-2731
ILLINOIS
172 North Michigan Ave., Chicago, IL 60601 312-346-4228
LOUISIANA
4403 Veterans Memorial Blvd., Metairie, LA 70006 504-887-7631
MASSACHUSETTS
50 St. Paul's Ave., Jamaica Plain, Boston, MA 02130
 617-522-8911
Rte. 1, 885 Providence Hwy., Dedham, MA 02026 617-326-5385
MISSOURI
9804 Watson Rd., St. Louis, MO 63126 314-965-3512
NEW JERSEY
561 U.S. Route 1, Wick Plaza, Edison, NJ 08817 732-572-1200
NEW YORK
150 East 52nd Street, New York, NY 10022 212-754-1110
78 Fort Place, Staten Island, NY 10301 718-447-5071
OHIO
2105 Ontario Street (at Prospect Ave.), Cleveland, OH 44115
 610-621-9427
PENNSYLVANIA
9171-A Roosevelt Blvd., Philadelphia, PA 19114; 215-676-9494
SOUTH CAROLINA
243 King Street, Charleston, SC 29401 803-577-0175
TENNESSEE
4811 Poplar Ave., Memphis, TN 38117 901-761-2987
TEXAS
114 Main Plaza, San Antonio, TX 78205 210-224-8101
VIRGINIA
1025 King Street, Alexandria, VA 22314 703-549-3806
CANADA
3022 Dufferin Street, Toronto, Ontario, Canada M6B 3T5
 416-781-9131
1155 Yonge Street, Toronto, Ontario, Canada M4T 1W2;
 416-934-3440